Dear Reader, da Vinci is

Thanks for picki the *Mona*
one of history's ost intense,
Lisa to *The Last* od.
well-known, an hemselves.
 His contri es, such as
Leonardo da gs that were
sfumato and *c* onardo laid
more realistic ainting was
the foundatio
forever char inci's most
 But wai rst bicycle,
famous wor of sketches
helicopter, thing suits,
containing diverse, as
to fortress
were his ta
 Thank

The EVERYTHING Series

Editorial

Publishing Director	Gary M. Krebs
Associate Managing Editor	Laura M. Daly
Associate Copy Chief	Brett Palana-Shanahan
Acquisitions Editor	Paula Munier
Development Editor	Katie McDonough
Associate Production Editor	Casey Ebert

Production

Director of Manufacturing	Susan Beale
Associate Director of Production	Michelle Roy Kelly
Cover Design	Paul Beatrice Matt LeBlanc Erick DaCosta
Design and Layout	Colleen Cunningham Holly Curtis Sorae Lee
Series Cover Artist	Barry Littmann

Visit the entire Everything® Series at *www.everything.com*

THE
EVERYTHING®
DA VINCI
BOOK

Explore the life and times of the
ultimate Renaissance man

Cynthia Phillips, Ph.D., and Shana Priwer

Adams Media
Avon, Massachusetts

To our children Zoecyn, Elijah, and Benjamin.

An Everything® Series Book.
Everything® and everything.com® are registered trademarks of F+W Publications, Inc.

Published by Adams Media, an F+W Publications Company
57 Littlefield Street, Avon, MA 02322 U.S.A.
www.adamsmedia.com

ISBN: 1-59869-101-5

Printed in the United States of America.

J I H G F E D C B A

Library of Congress Cataloging-in-Publication Data
Phillips, Cynthia
The everything Da Vinci book / Cynthia Phillips, Ph.D. and Shana Priwer.
p. cm.
ISBN 1-59869-101-5
1. Leonardo, da Vinci, 1452-1519. I. Title: Da Vinci book. II. Priwer, Shana. III. Title. IV. Series.

N6923.L33P53 2006
709.2—dc22

2006004159

This book is available at quantity discounts for bulk purchases.
For information, please call 1-800-872-5627.

Contents

Acknowledgments

Special thanks to Dr. Marshall Gilula for love and support,
and to Raven for proofreading.

Top Ten Things You Didn't Know
about Leonardo Da Vinci

1. Leonardo was born to young unmarried parents, a notary and a local woman.

2. Leonardo had a habit of never finishing his work. Catholic monks even filed a lawsuit against Leonardo over one painting, the *Virgin of the Rocks*.

3. Leonardo planned to build a twenty-five-foot tall bronze horse in honor of one of his patrons. Unfortunately, Milan was invaded before he had a chance to cast it, and the military took his bronze to make cannons instead.

4. Leonardo was friends with other Renaissance dignitaries, including Niccolo Machiavelli. Leonardo and Machiavelli came up with a scheme to reroute the Arno River.

5. As a young man, Leonardo was jailed for two months over charges of sleeping with a young male prostitute.

6. Leonardo was a prolific inventor, and developed designs for the first car, bicycle, and helicopter. He also invented war machines and weapons.

7. Leonardo came up with a plan to build one of the first mechanical robots.

8. As a painter, Leonardo made substantial improvements to two major painting techniques, called sfumato and chiaroscuro.

9. Leonardo was interested in anatomy, and was one of the first to dissect cadavers and make detailed anatomical sketches of his findings.

10. Leonardo likely had a stroke in 1516, and this event may have caused paralysis of his right hand. Despite this apparent setback, Leonardo remained a prolific left-handed artist in his final years.

Introduction

▶ EVERYONE'S HEARD OF Leonardo da Vinci. He's the master behind the *Mona Lisa*, and that alone would serve to distinguish an artist's career from any other. And when you hear the term "Renaissance man," Leonardo da Vinci is probably the first name to pop into your head. With good reason! Did you know that he was one of the first people to make detailed anatomical drawings? Or that he designed one of the first robots? Leonardo da Vinci was not only an amazing artist, he was also a talented scientist, inventor, and musician. One of his only shortcomings, actually, was that he had more ideas than he could possibly bring to fruition in a lifetime.

By the time he was seventeen, Leonardo's artistic talents were becoming obvious, and his father apprenticed him to a leading artist in Florence. Leonardo quickly proved himself, then went on to surpass his master in terms of both skill and execution. He moved from place to place with ease, always striving to prove himself in yet another field.

Throughout his long career, Leonardo worked for everyone from kings and dukes to warlords. He wasn't just a painter, either—he traveled as a military engineer with the infamous Cesare Borgia, using his genius to create machines of war. During more peaceful times, Leonardo was fond of making mathematical discoveries, investigating the secrets of the human body, and inventing parachutes. In his spare time, he even came up with plans to divert an entire river!

In spite of these other endeavors, Leonardo is mostly famous today for his paintings, though only a handful of his finished works survives. This is no coincidence; Leonardo started countless projects, but finished only a few. Even the paintings he did manage to finish suffered from his constant innovation. In fact, most of Leonardo's inventions weren't ever built; he would come up with an amazing design or idea, work on it for a while, and then he'd move on to something else. Fortunately, Leonardo's detailed notebooks answer many of the questions that his physical works left behind.

Of course, with Leonardo, nothing is ever easy. Not only did Leonardo write in a strange backwards mirror writing, his notes also weren't particularly organized or dated. He planned to arrange and publish them, but he just never got around to it. Leonardo left his notebooks to his student and close friend (and probable lover) Francesco Melzi, but after Melzi's death, many pages were dismissed as scribbles and lost or dispersed. Today, what remains of Leonardo's writings has been carefully collected and the pieces are reverently displayed in museums around the world.

When we look at Leonardo's accomplishments today, the sheer breadth of his talents is even more remarkable than the talents themselves. Not only did he paint one of the most amazing and talked-about paintings of all time, the *Mona Lisa,* he came up with designs for a helicopter, a mechanical loom, a car, a bicycle, and a multi-barreled gun! Leonardo was secretive and he had trouble following through with things, but he still fits the ultimate definition of a Renaissance man. More than simply being good at his job, he was a groundbreaking innovator who excelled at everything he tried. Imagine what he could have accomplished with modern technology!

chapter 1

Early Days of a Genius

As it is said, we shall begin at the beginning. In this case, the beginning is the birth of Leonardo da Vinci, one of history's greatest artists, thinkers, and inventors. See what his hometown was like, and get a glimpse into the lives of his parents and other close relatives. Leonardo's early days had a profound influence on his later life and formed the foundation for his long career.

In the Beginning

One of the Renaissance's favorite sons had a less-than-spectacular start in life. Born the illegitimate son of a notary and a peasant girl in a small town near Florence, Italy, Leonardo da Vinci soon rose to fame as no one else could (or did!). His family, his surroundings in the Tuscan countryside, and the time of his birth all influenced Leonardo's formative years—the early years of the burgeoning Italian Renaissance.

Because of his illegitimate birth, Leonardo actually lucked out: He didn't have to follow in his father's footsteps. As a result, he was able to spend much of his childhood studying exactly what he wanted, rather than what he was told to; he spent years looking at and drawing the world around him.

Later, Leonardo's apprenticeship in Andrea Verrocchio's workshop had an enormous impact on his artistic and scientific works. Once he "graduated" to doing his own projects, he started to incorporate many of the rapidly evolving themes of the Renaissance itself.

At the time Leonardo entered Verrocchio's workshop, Florence was the hub of a bustling new world of intellectual expression, trade, banking, and other innovations. As Europe burst out of the stagnant Middle Ages into a flowering period full of promise, Leonardo da Vinci was at the center.

Where it All Began: Vinci, Italy

Every good story has an eventful beginning, and this one begins with the birth of a child named Leonardo in Italy, on April 15, 1452. In those days, it was customary for Renaissance Italians to take the name of their birth city as part of their full identification. One-word names (like Vitruvius or Plato) worked well, as long as there was only one of each. Some folks were identified by their claims to fame, such as Alexander the Great. Unfortunately, not everyone could be Great, so as populations grew, it was easier to identify

people by their name and town. And so Leonardo, by virtue of being born in Vinci, was known as Leonardo da Vinci (Leonardo from Vinci).

True Origins

Everyone assumes that Leonardo was born in Vinci. But was he? Many scholars agree that he was, indeed, born there. It was certainly a nice place to be born and raised. Vinci is located about fifty kilometers to the west of Florence, deep in the Tuscany region of Italy. Vinci is also near Pisa (home of the famed Leaning Tower), as well as Siena and Lucca.

FACT

Long before the Renaissance, Vinci was home to the Etruscans and contained many ancient castles, including the Castello Guidi (built for the Conti Guidi during the Middle Ages). The town's rolling green countryside must have been a source of inspiration for Leonardo's budding artistic talent. Surrounded by such beauty, who wouldn't be moved to try to draw it?

However, not everyone thinks that Leonardo actually came from Vinci. One theory holds that Leonardo was actually born in Anchiano, a town in Tuscany located about three kilometers from Vinci. Why? For one thing, da Vinci's family supposedly lived there. Anchiano also boasts a farmhouse that many people think is where Leonardo first entered this world, fittingly nicknamed the Casa Natale di Leonardo (which literally means "the birth house of Leonardo").

Today, the farmhouse is home to a permanent exhibit of Leonardo's drawings and other works. Restored in the mid-1980s, the house is decorated with many of Leonardo's landscape paintings—so if nothing else, it's a great place to see Leonardo's work!

The Favorite Son

Even if Leonardo was actually born in Anchiano, he clearly spent much of his childhood in Vinci. Vinci today is the home of the Leonardo Museum,

which occupies part of the Castello dei Conti Guidi. As a bit of background, this castle changed hands a few times, and was finally returned to the city of Vinci in the early twentieth century.

The castle was converted into a museum in 1953 to celebrate the 500th anniversary of Leonardo's birth. The main exhibit includes designs of some of Leonardo's machines, including cranes, winches, clocks, and helicopters. There are even actual models for a number of them! Sketches, notes, sculptures, and other descriptions of how the machines might have worked also accompany the designs and models.

In addition to this museum, there are other points of interest in Vinci. It is home to the Santa Croce Church, which boasts Leonardo's rumored baptismal font. A new museum is also being planned; this facility will be devoted to Leonardo's paintings, as a complement to the existing museum, which focuses on his inventions. Modern-day Vinci continues to hold yearly festivals that celebrate Leonardo and his artistic legacy. Today, the town is home to about 14,000 people.

FACT

While Leonardo may have been Vinci's most famous son, other artists and products have also hailed from this relatively small town. A talented sculptor named Pier Francesco da Vinci was born there in the mid-sixteenth century; he was Leonardo's nephew. The Tuscan region (Vinci in particular) is also home to some of Italy's most famous exports, including olive oil and wine.

The Mamas and the Papas, and Everyone in Between

As we mentioned, Leonardo's parents were not married. So aside from that, what were they like? Who were these people who gave birth to one of the greatest artistic minds of all time? His mother, Caterina, was a sixteen-year-old peasant girl; his father, twenty-five-year-old Ser Piero di Antonio, was a notary. A wedding was forbidden between the two young lovers because of their

class difference, and Ser Piero was quickly married off to a more appropriate mate, Albiera. Caterina also married a few months after Leonardo's birth.

Like Leonardo himself, his mother led a life of mystery. She may have been a slave of Middle Eastern ancestry. Slave ownership was common in the Tuscany region at that time, and slaves who had converted to Christianity from Eastern, pagan, or Jewish religions often took the name Caterina. It's even possible that Caterina was Ser Piero's slave!

Family Profession

While Ser Piero's father was a farmer, Ser Piero's family included lots of notaries. At that time, the position of notary was similar to a lawyer, and Ser Piero had a relatively privileged position in society. Because he was illegitimate, though, Leonardo shared none of his father's privilege. Even if he'd wanted to, he couldn't have followed in his father's footsteps as a notary. Luckily, this turned out to be the best thing that could have happened. Leonardo was free to pursue life as an artist.

Although we don't know much about Leonardo's early days, we do know that his father wasn't rich enough to afford a wet nurse. Consequently, Leonardo probably lived with his mother during his first few years so that she could nurse him. Then, somewhere between the age of three and five, Leonardo went to live with his father and his new wife. Notes from Leonardo's grandfather Antonio show that five-year-old Leonardo was living with his father at his grandfather's house in 1457. But even though he was living with his father, Leonardo spent little time with Ser Piero, who was often away on business in Florence.

Family Influences

So who affected Leonardo as a child? It seems that his greatest influence was his uncle Francesco. (Leonardo and his uncle were so close that Francesco even remembered him in his will.) Ser Piero's brother Francesco

was a farmer, and when Leonardo was with him, he would have gotten to spend quite a bit of time outside. While he probably had to help tend to the animals, he would have also had time to observe and sketch nature and landscapes.

Both Caterina and Ser Piero had a number of other children, eventually leaving Leonardo with a whopping seventeen half brothers and sisters: twelve children from his father and five from his mother. Now that is one big extended family! The births of these other children were spread out over the years—Ser Piero's first legitimate son was born twenty-four years after Leonardo's birth, which explains why Leonardo was treated as a legitimate son of Ser Piero's household.

The Life You're Born Into

Leonardo's illegitimate status wasn't much of a secret: it was evident by a simple examination of his name. Officially, he should have been Leonardo di Ser Piero da Vinci, meaning, "Leonardo son of Ser Piero from Vinci." However, Leonardo didn't use his father's name, as was the custom of the time; he referred to himself only as Leonardo da Vinci and signed many of his works just plain Leonardo. By shortening his name even more, he was probably rebelling against his lack of official status and trying to make his own place in the world.

The Role of Legitimacy

As an illegitimate child, Leonardo's place in the highly stratified society of the Tuscany region was, at best, precarious. Class status was important, especially in the new middle classes. In the upper classes, illegitimate children were treated more or less like legitimate children, and they could inherit property and social status from their fathers. The middle classes were sticklers for proper birth and parentage, though; as the illegitimate son of a peasant woman (and possible slave), Leonardo's status was quite low. And if Leonardo's mother Caterina was in fact a slave, his status would have been even lower.

Even though Leonardo's father raised Leonardo in his household, his illegitimacy disqualified him from the clubs and guilds to which his father

belonged. In fact, Leonardo couldn't get a university education, and he certainly wouldn't have been able to follow in his father's footsteps and become a notary. While his father most likely provided a basic education in reading and writing, Leonardo did much of his learning on an independent basis. Eventually, he would teach himself Latin, mathematics, human anatomy, and physics. At least class structures today aren't nearly as rigid, although money and opportunity are unfortunately still tied to social status.

FACT

While the upper classes in the Renaissance were probably secure enough in their status to accept illegitimate children, those in the middle class likely felt that what they had gained could just as easily be taken away. So, middle class folks like Leonardo's father were much more obsessed with status and would have made it clear that an illegitimate child like Leonardo wasn't really welcome in their ranks.

Free to Be You and Me

With no expectations, Leonardo was free to grow into his full intellect. Because he was not obligated to follow a specific, predefined role, he was able to explore and develop his own personal talents, without anyone pushing him to be something he didn't want to be. His early days on his Uncle Francesco's farm left him with a deep love and respect for nature, as well as a sense of wonder. He explored the mysteries of nature in many of his works—always curious, always looking for answers. Through these experiences, he was also able to discover his talent for drawing and art.

QUESTION?

Was being an artist a respectable profession in Leonardo's time?
Yes! In fact, a career as a court artist was one of the most respected occupations that an illegitimate child could hope to achieve. Perhaps Leonardo's father had this in the back of his mind when he apprenticed his son to one of the most respected artists in Florence, Andrea Verrocchio.

The fact that Leonardo wasn't able to pursue a formal education also meant that he had to develop the skills to learn on his own.

It's All Relative

As previously discussed, Leonardo da Vinci spent a few of his formative years living with his paternal grandparents, Antonio and Lucia da Vinci. Antonio came from a long line of notaries—the first one in his family was Ser Guido di Ser Michele da Vinci, who lived in Vinci in the fourteenth century. His two sons, Giovanni and Piero, were also notaries, and Piero's son Antonio was Leonardo's grandfather. The important point is that Leonardo came from a family of notaries—but wasn't one himself, and that was unusual for the Renaissance. Of course, it's not like Leonardo had any choice in the matter.

The Farmer from Vinci

Leonardo's grandfather, Antonio, broke with family tradition and instead became a farmer. He married Leonardo's grandmother, Lucia (born in 1393), who was the daughter of yet another notary. They had three children: Piero, Leonardo's father, born in 1427; Francesco, born in 1435; and Violante, born sometime afterwards. Leonardo and his father lived in the same house as Antonio and Lucia for many years, until the family moved to Florence. In fact, Leonardo was still living with his father's family when he was seventeen and was already a part of Andrea Verrocchio's studio.

FACT

Fortunately, Antonio kept detailed records about his family's life. From these notes, we know that Leonardo was baptized into his father's family almost immediately after his birth. Tax records show that Leonardo was part of his grandfather's household by the time he was five years old.

Antonio died in 1468 at the ripe old age of ninety-six. Leonardo was also around for quite a few years. Living to such an old age was more unusual

in the fifteenth century, when disease ran rampant and medical care was spotty. Leonardo certainly must have had good genes!

A House in Flux

Leonardo's Uncle Francesco had a strong influence on his young nephew even as a small child. Grandpa Antonio's tax information shows that Francesco lived with the family for a time, though the grandfather wasn't generous with his job description; he wrote that Francesco "stayed home and did nothing." Sounds like he didn't appreciate Francesco mooching off his parents! Francesco would have been twenty-two at the time, certainly old enough to move out. Eventually, Francesco started a career as a farmer and landowner, following in his father Antonio's footsteps, while Piero became a notary like his grandfather.

Siblings of a Genius

Although Leonardo was the first child for both of his parents, he ended up with a total of seventeen half siblings. Leonardo's father was never married to his mother, but he married four other women over the course of his life. This propensity for multiple weddings was one of many characteristics that Leonardo did not inherit from his father.

Ser Piero's first two wives, Albiera and Francesca, both died young and bore no children. His third wife, Margherita, gave birth to two sons, Antonio (Ser Piero's first legitimate heir) in 1476 and Giuliomo in 1479. A girl, Maddalena, was born in 1477, but she died as a toddler in 1480. Soon after, Margherita died as well, and Ser Piero married his fourth wife, Lucrezia. Lucrezia gave birth to two daughters and seven more sons: Lorenzo in 1484, Violante in 1485, Domenico in 1486, Margherita in 1491, Benedetto in 1492, Pandolfo in 1494, Guglielmo in 1496, Bartolomeo in 1497, and Giovanni in 1498.

Leonardo Walton?

Leonardo wound up with nine half brothers and two half sisters on his father's side alone. Quite an extended family! Ser Piero's last son was born

when he was seventy-five years old. While he seems to have been unlucky in the choice of his first two wives, at least his third and fourth wives eventually produced some legitimate children.

In spite of his many options, Leonardo wasn't particularly close to any of his half siblings. By the time Leonardo's first half-brother, Antonio, was born, Leonardo was already twenty-four years old. He was working by this time, and wouldn't have been hanging out around the house anyway. While he was growing up in his father's house, therefore, Leonardo was effectively an only child. Not that his father was around all that much, but at least Leonardo didn't have to share his attentions!

Caterina's Other Children

Not much is known about the five children that Leonardo's mother, Caterina, had after she was married. These children included three half sisters and one half brother (nothing is known about the fifth), who were closer in age to Leonardo than his father's other children.

Records show that two of Caterina's daughters were named Piera (born in 1455) and Maria (born in 1458), and Leonardo notes in his writings that his half brother on his mother's side died from a mortar shot at Pisa. These other kids probably contributed to the distance between Leonardo and his mother. After all, how much attention could his mother have paid Leonardo with so many others to look after? Once Leonardo moved into his father's house, Caterina most likely devoted all her time to her legitimate children, with little to spare for poor Leonardo.

Caterina remained in the Vinci area for most of her life, although she came to live with Leonardo in Milan in 1493. She spent the last two years of her life there with her son, until her death in 1495. Letters from Leonardo to his mother, while Leonardo was away during this period, survive as part of two of his writing collections (codices), and illustrate their growing relationship. Leonardo's notes also document that he paid for Caterina's burial.

Brotherly Greed

After Ser Piero's death in 1504, Leonardo's half brothers got greedy over their father's property. There was much in-fighting, and Leonardo had to

return to Florence a number of times to settle disputes. Apparently, Ser Piero died without a will—not very good planning for a lawyer—which basically led to a feeding frenzy among his offspring. One of Leonardo's half brothers had become a notary like his father, and he took charge of the legal proceedings. He first challenged Leonardo's right to inherit from his father's estate, and then when Ser Piero's brother Francesco died a few years later, he objected to their uncle's will as well. However, he had a good reason to protest—Leonardo was supposed to inherit a sizable piece of land.

The litigation continued for a number of years. Leonardo kept going to Florence to deal with it, but all those trips delayed his work in Milan. While all this was going on, Leonardo wasn't exactly resting on his laurels; he was the court painter to King Louis XII of France (who happened to live in Milan). Leonardo had many paintings to complete, and the king probably wasn't too happy with all these interruptions to Leonardo's work. In fact, both the French king and Charles d'Amboise, among others, wrote letters to the Florentine authorities, asking them to speed up Leonardo's legal battle.

All of these letters on Leonardo's behalf didn't have much effect, however, and the lawsuits continued until 1511. Ultimately, Leonardo didn't receive any inheritance from his father's estate, but he emerged from the years of conflict with rights to his Uncle Francesco's farm, land, and money.

Nephew of a Genius

Although none of Leonardo's siblings were particularly artistic, he did have a nephew, Pier Francesco da Vinci (1531–1554), called Pierino, who was a decent sculptor. The son of Leonardo's half brother Bartolomeo, Pierino was apparently a child prodigy and became known as a talented sculptor who produced works all over Italy.

Pierino didn't have the breadth of genius of Leonardo, though he also didn't have that much time to experiment before his death in Pisa at the age

of twenty-three. In spite of his short career, the sixteenth-century art historian Giorgio Vasari dedicated a biography to Pierino, and one of Pierino's sculptures is in the Louvre. Maybe if he'd lived a little longer, Pierino would have shown more of Leonardo's legacy, but unfortunately we'll never know.

"Current" Events of Fifteenth-Century Italy

Even before Leonardo, pre-Renaissance Italy was gearing up for a dramatic shift from the Middle Ages. While most of the heavy hitters were yet to come, Italy was rapidly becoming a hot spot for invention and innovation. Many of the world's best-known artists rose to fame in the years before Leonardo, and their efforts made Leonardo's own success possible.

Historically speaking, fifteenth-century Italy was a mishmash of city-states. At this time, Italy still had a long way to go before it would become a single, united country—this unification didn't occur until the mid-nineteenth century. Small political groups were constantly battling each other, leading to a fairly unstable atmosphere.

Feudalism, a two-tiered system of lords and peasants, provided yet another reason for discontent. Did such hostility make it impossible for artists to break out with their own new styles? Not at all—artists were actually responsible for helping to reshape Western European society. Dante, Giotto, Brunelleschi, Alberti, and later Leonardo were all artists who created a cultural connection between feudalism's two class extremes.

chapter 2

Leonardo the Young Artist

With the goal of becoming an artist, Leonardo started off life on the right foot. He had the opportunity to experiment with observation and technique from an early age, and showed remarkable talent as a child. His early apprenticeships served to further his ultimate goal, and he was lucky to be apprenticed to a master of great skill. Once he finished his apprenticeship and joined a painting guild, Leonardo began to develop his own style and methods which would lead to his astonishing career.

Youthful Adventures

Most people start showing signs of their adult personalities as children, and Leonardo was no different. With his childhood games he would flit from one project to the next, probably exasperating his teachers in his few attempts at formal education. Yet when projects interested him, Leonardo could spend hours, even days, working on fine details, seeming to lose track of time. These qualities remained with him throughout his life.

Early Models

Giorgio Vasari's biography of Leonardo records one particular example from Leonardo's childhood; it demonstrated the work habits Leonardo became known for as an adult. According to this report, Leonardo's father received a request from a local peasant to decorate a wooden shield, and he decided to give the project to his young son. Leonardo decorated the shield with the face of Medusa, the mythological serpent-headed creature.

FACT

During his youth, Leonardo probably spent hours on end observing nature first-hand, and his earliest sketches were studies of landscapes, plants, and animals. His ability to replicate nature in all its various forms definitely helped him out in his future artwork. He used these skills to create realistic-looking natural scenes, in both his scenes with human figures and landscape paintings.

Rather than painting a pleasant, romanticized version of Medusa (which a "normal" painter at the time would have done), Leonardo gathered various snakes, lizards, and other creatures from outdoors, positioning them in a studio to use as models. After a few days of work, Leonardo's father came to see what progress his son was making. He was in for quite a shock! When he walked into the studio, Ser Piero was not only confronted with the shield's grotesque realism, he got hit with the stench of decomposing reptiles! As the story goes, Leonardo had been oblivious to his models' offensive smell, and didn't seem to mind working amidst dead creatures. Now that's devotion

to your work! Whether or not this story is actually true, it shows Leonardo's penchant for drawing nature accurately began when he was a child.

Although his illegitimate birth barred Leonardo from most formal education, including university study, his relatives and family friends probably tutored him. Though he seems to have tried studying Latin on his own, Leonardo never learned it very well. And not knowing Latin came with a heavy price, because it effectively prevented Leonardo from studying many ancient Roman writings. Although the revival of classical knowledge was a key element of the Renaissance, Leonardo was forced to innovate largely on his own. It's possible that his poor Latin skills inadvertently helped him; he was forced to use his own innovations and thought processes, and he was almost entirely free of precedent.

Studying the World

Much of Leonardo's early work focused on the interplay of light and shadow, and again, his careful scrutiny of nature gave him the detail he needed. His grandfather's notes mention that Leonardo spent time drawing animals and plants, indicating a keen awareness of the world around him.

For Leonardo, nature truly was the best teacher. He was particularly interested in margins, such as the line between the beautiful and the grotesque. Rather than drawing or painting the most beautiful things he could find, he searched for the unusual: strange hills and rocks, odd animals, and rare plants. He also continued to study and observe humans; the details he added to his drawings of faces and expressions made him stand out.

Throughout his career, Leonardo spent a lot of time sketching and painting images of mothers with children. Hundreds of years later, Sigmund Freud theorized that these works, while religious in nature, were actually Leonardo's attempt to deal with being abandoned by his mother at a young age. Maybe this is a stretch, but then again, maybe you *can* see his lack of a true maternal bond in some of his works, like the painting *The Virgin and Child with St. Anne*. Here, the child is thought to be a self-portrait, while the Virgin and St. Anne might represent Leonardo's mother, Caterina, and his first stepmother, Albiera. Though such interpretations are only theories, they support the possibility that Leonardo's popular religious themes may have had personal underpinnings.

Leonardo's Early Training

Even before he became famous, Leonardo was heavily involved in the arts. Though he was in many ways a typical kid, he was already beginning to break away from the pack. Unfortunately, not many specifics are known about Leonardo's early education, but it's possible to make a few generalizations based on what we do know.

If you grew up in New York, you might have spent hours drawing skyscrapers. Leonardo grew up in the Tuscan countryside, a place of incomparable beauty, and so he learned to draw by studying the mountainous landscape. He used everything he had available—sketching, painting, and modeling—to record the natural environment.

Running the Gamut

Leonardo got a taste for a wide variety of arts at a young age. He studied music and singing during his formative years, learning to play the lyre and other Renaissance instruments. One of his favorite "academic" subjects was probably mathematics; the ability to apply mathematical principles to art would, of course, be one of his signature trademarks later on.

Leonardo was known for starting more tasks than he finished; his notebooks reveal many ideas that never actually took shape. Is it possible that Leonardo simply had too much exposure to too many different things as a child? Maybe he tried so many things that he never learned to focus on one at a time.

The Great Lefty

Perhaps not insignificantly, Leonardo was left-handed. Generally speaking, the right hemisphere of the human brain (more dominant in left-handed people) controls art, music, creativity, and emotions. In contrast, right-handed people are more oriented toward the left hemisphere of the brain, which is associated with math, science, language, and speech. It's

no surprise, then, that Leonardo was left-handed. Many other great artists throughout history have been left-handed, including M.C. Escher, Paul Klee, and Michelangelo Buonarroti. A number of famous musicians are also left-handed—Robert Schumann, Maurice Ravel, Sergei Rachmaninoff, and Ringo Starr, just to name a few. Da Vinci was in excellent company!

Leonardo's left-handedness likely has something to do with his unusual style of writing, which flowed from right to left. He also wrote individual letters backward, so they formed a mirror image. You might already know someone who writes this way—this style isn't uncommon among left-handed people, and Leonardo could have devised the technique as a child.

FACT

Some historians believe that Leonardo actually developed his "backward" writing as a sort of secret code to protect his notes and sketchbooks from being copied; others think it was the result of being both left-handed and dyslexic. Whatever the reason, Leonardo's writing method definitely added to his uniqueness.

Homemade Materials

Leonardo didn't learn to make formal brushes and pigments until his apprenticeship to Andrea Verrocchio. During the Renaissance, artists couldn't just run down to the corner art supply store for paints and brushes—they had to make them all themselves! As a child, Leonardo probably used materials he found on his own (or ones borrowed from his grandfather) to create his sketches.

His willingness to use what he could find served him well. Had Leonardo's skills not been sufficiently developed, he probably wouldn't have earned his apprentice position. Though only seventeen years old when he was apprenticed to master artist Verrocchio, Leonardo had already shown early promise. Few dated drawings survive from Leonardo's childhood and the first few years of his apprenticeship. Nevertheless, one of Leonardo's earliest known drawings, a pen-and-ink landscape of the Arno Valley, from 1473, is also one of the first drawings ever to detail landscape in a truly

realistic, convincing style. Even at the very beginning of his career, Leonardo was already innovating.

What Did They Do Before Bookstores?

Leonardo da Vinci's early educational resources were few and far between. He certainly didn't walk to the nearest Borders to pick up new books! Rather, most of his knowledge came from experience. As previously discussed, he spent plenty of time with his Uncle Francesco as a youngster. Being a farmer, Francesco taught Leonardo much about nature. Leonardo's early interest in sketching probably began at this time.

Leonardo was well aware of the middle-class discriminatory norm that prevented illegitimate children like him from attending a university. Because of these restrictions, he probably paid much more attention to his Uncle Francesco's teachings than he would have otherwise.

There were no expectations placed on young Leonardo, other than those he imposed on himself. Since many "professional" occupations were off-limits, Leonardo eased into the world of art gradually and completely. He was fortunate enough to be able to find his true self, rather than play a role that his family had chosen for him.

Remember That!

Even without the aid of modern mnemonic devices, Leonardo seemed to have a phenomenal memory. In his notebooks, he told a story he remembered from infancy. Apparently, a hawk-like bird called a kite landed on him, waving its tail feathers in his face. Though he couldn't have been more than a few months old when this event took place, Leonardo claimed to remember it clearly—he at least remembered it well enough to write about. This incident supposedly led to his later interest in flight.

While textbooks and teachers were scarce, Leonardo still loved to read. Though his formal schooling probably didn't go past a primary grade, he

took advantage of friends' and relatives' libraries. After moving in with his grandfather, he was probably home-schooled in math, science, reading, and writing. Amazingly, he learned physics and anatomy more or less on his own.

Early Readers

Leonardo's grandfather kept diaries and records, and fortunately for us, Leonardo adopted this habit as an adult. Historically, reading and research have always been important to artists; genius rarely appears out of thin air. Some of history's greatest figures spent years reading, thinking, and developing their ideas before coming up with their own creations. One of the best examples may be Jules Verne, the writer who produced *Around the World in 80 Days* and *20,000 Leagues Under the Sea*. An avid reader as a child, he favored (not surprisingly) writings about travel and adventure. Similarly, Leonardo attached himself to subjects in his particular areas of interest, including advanced physical sciences and mathematics.

Apprenticeship, or Learning From Your Elders

When Leonardo was sixteen years old (in 1468), his paternal grandfather died and his remaining family moved to Florence. This move would ultimately be of great importance to Leonardo's career; Florence was home to many of the best artists of the day, including Andrea Verrocchio (1435–1488). Art took many forms during the Renaissance, and Verrocchio was considered not only a master of painting, but also sculpture, goldsmithing, music, and other arts. No doubt, Leonardo's father made a smart move by securing his son an apprenticeship with such a great master.

Florence in the mid-fifteenth century was a haven for up-and-coming artists; imagine a loose parallel to Greenwich Village in New York City. Except in those days, patrons worked more closely with artisans. Artists held high social positions, were well respected, and often mingled with the most powerful Italian families. By the mid-1470s, Florence was home to more than fifty stoneworking shops and close to thirty master painting studios. For a

student like Leonardo, there was no better place to be. What a great place to live and work!

Learning the Basics

Leonardo wasn't the only star in the sky. Verrocchio had other students, including Sandro Botticelli. Still, apprenticeship did have its advantages for Leonardo. There was a fairly well-established program for the skills that interns had to learn, and Leonardo studied the technical aspects of painting, including how to grind and mix pigments into various colors of paint. He probably also studied color theory, learning which colors combine to form other colors, how saturation could contribute to different tones, and so on. You can't paint if you don't know the fundamentals, and Leonardo certainly learned them well.

This crucial internship covered the basics of painting on wood panels, and he became an expert in the preparation and maintenance of the necessary materials. Leonardo was probably exposed to canvas techniques, including how to stretch and prepare canvases for painting and how different materials would accept paint in different ways. The Renaissance was a transition period for painters; while most painted on wood, canvas became commonly used as well. Thus, while most of Leonardo's early masterpieces were oil on wood, his later works were transferred to paper and canvas. During his early internship period, he probably became familiar with a wide variety of media, and this exposure gave him a solid foundation for everything that was to come.

At this point, Leonardo also got his first introduction to casting in bronze, a skill he mastered later on down the road. Leonardo certainly learned bronze casting from one of the best—Verrocchio was responsible for some of the greatest bronzes the world had ever seen, such as his *David* and his equestrian statue with Bartolomeo Colleoni. He also created bronzes of many saints, including St. John and St. Peter. In addition to metalworking in 3-D, Verrocchio produced bronze relief sculptures, which were quite common at the time. In fact, Verrocchio was considered one of the best sculptors in Renaissance Florence.

The Tools of the Trade

Leonardo da Vinci probably got his first formal exposure to artists' technical tools during his apprenticeship to Andrea Verrocchio. As already mentioned, artists in the fifteenth century had to make their paints from scratch. Leonardo much preferred oil paint because it allowed subtle variations in the colors that just weren't possible with tempera. The Renaissance was a time of transition not only from wood panels to canvas, but also from tempera to oil paints. And, as usual, Leonardo was right in the thick of this transition, innovating away.

Making Paint

Can you imagine having to create all the tools of your trade before you could use them? It would be like having to go out and build your engine before you could drive the car! Though we can credit Leonardo with many things, developing the art of oil painting is not one of them. Ancient Greeks and Romans used oil-based pigments, and flax seed oil and poppy seed oil were available as far back as ancient Egypt. Olive oil was plentiful in Italy, and it may have been used both to blend with a pigment, and to aid in drying. The Flemish painter Jan van Eyck (1390–1441) is often credited with improving the art of oil painting by developing a solid varnish based on linseed oil; with paint that could dry faster and last longer, oil painting came into more popular use.

The science of mixing oil paints was pretty intense, and it certainly wasn't a simple skill. The paint had to be colored, and it also had to adhere properly to the painted surface. Paint is a type of emulsion (a liquid suspension where oil and water are mixed together, suspending the oil in the water). Look closely the next time you reach for a bottle of oil-and-vinegar salad dressing; you'll notice the seasonings floating to the top. That mixture is called a suspension. Milk contains lots of fat droplets, which spread out over a glass or bottle; they never fully mix and end up creating a type of suspension called an emulsion. Paint is a colloid, a particular sort of emulsion containing solids (pigment) suspended in a liquid (oil and binders). It's complicated stuff, and Leonardo had to learn it well.

Leo the Garzone

In Leonardo's first year at Andrea Verrocchio's shop, he likely worked as a *garzone* (a sort of servant). While he had cleaning and other menial tasks to perform, one of his most important jobs would have been making paint. At the time, pigments came from a variety of natural sources: Plants and minerals provided the greatest variety of colors. Leonardo would have spent hours washing and then hand grinding local Italian minerals. Doesn't sound like too much fun, but important work, nevertheless.

Iron was a commonly available mineral during this period, as was terra verte (found mostly near Verona, Italy). Renaissance painters didn't have dust masks or any way to keep from inhaling airborne particles; they would just measure an amount of pigment onto their grinding surface, add water into the middle of the pile, then start to grind. And they probably had to be careful not to sneeze!

QUESTION?

Is pigment all you need?
Color alone isn't enough to make paint; you need to mix it with a medium (like oil or water) that will both carry the color and dry along with it. A third substance makes the color adhere to the oil or water.

During the Renaissance, most artists used animal products, such as eggs, animal glue, or milk as binding agents to stick the paint to the wood, canvas, or wall surface. After grinding the pigments into a thick paste, Leonardo would have either added the color and the other requisite ingredients to the oil to make paint to use right away, or stored it carefully for later use.

Leonardo actually improved the technique of creating oil paintings by mixing ground pigments with linseed oil and adding beeswax and water to the paint while it was in a boiling stage; this additive kept the colors light and prevented over-saturation. As you'll see later, some of his painting innovations were far more successful than others. More important than the new techniques, though, was the fact that he used oil paint extensively, which

caused a ripple effect throughout the artistic community. Given how successful his paintings were, it's not surprising that people wanted to copy his techniques.

In addition to paints, Leonardo almost certainly learned how to make and draw with chalk while apprenticed to Verrocchio. In Renaissance Italy, mineral chalks were dug out of the ground and fashioned into drawing tools. Red and brown chalks (common earth tones) were the most popular, and those are the ones in most of Leonardo's later chalk drawings.

Getting Off to a Good Start

Leonardo's period with Verrocchio (1468–1472) was his first foray into the real world of professional art. While apprentices often worked with their masters on commissioned projects, most of these students didn't go on to outshine their teachers! Then again, most of the students weren't Leonardo da Vinci, either.

The Baptism of Christ

The first real tip-off to Leonardo's talents came when he worked on a painting called *The Baptism of Christ*, completed in 1472. Andrea Verrocchio was the official painter, but it was one of the first commissioned works in which Leonardo took part. The monks from the Florentine church of San Salvi requested the painting, and many members of Verrocchio's studio worked on it. Though apprentices like Leonardo had to do office duty and other routine tasks, they also got to help on the master's jobs.

In this painting, Verrocchio probably painted Christ and John the Baptist. Although written documentation is slim, it's thought that da Vinci's particular addition to the painting, along with some of the landscape, was a kneeling angel supporting the mantle. This figure appears more lifelike than the others; the angel's expression, hair, and clothing are particularly detailed. The angel in question was also painted in oil, Leonardo's paint of choice, whereas much of the remainder of the painting was done in tempera. And remember, Leonardo much preferred oil paint because it allowed subtle variations in the colors that just weren't possible with tempera.

Reactions of the Master

Using diagnostic technology to examine this painting, historians have essentially proved that Verrocchio did a master sketch before applying paint. From these tests, you can see that Leonardo strayed from this overall scheme and took liberties with his portion of the painting. You can also see that Leonardo's rendering of the landscape, full of shadows and bright sunlight, is different from the parts Verrocchio painted. Even at this early point in his career, Leonardo was using his own creativity and invention rather than simply following orders. That kind of attitude only worked, though, because he was so highly skilled to begin with. Still, we'll never know if Verrocchio was angry or pleased with Leonardo's changes to his initial design.

While Verrocchio's work didn't exactly pale in comparison to Leonardo's, it was clear even from his early work that Leonardo's painting abilities would eventually surpass those of his master. In fact, one story (that may or may not be true) has it that Verrocchio actually swore to give up painting when he saw Leonardo's work, since he knew he could never be that good! But even if that story were true, Verrocchio was an artist skilled in many areas, and he could just as easily have focused his talents on metalsmithing, sculpture, and bronzing. Fortunately for Verrocchio's ego, Leonardo didn't develop his skills in those areas until later.

Study it First!

Leonardo often made clay study-models of figures before committing them to canvas or wood. In the case of the angel in this painting, Leonardo probably first made a model of clay and then painted the model; this approach would have made the final drawing seem more accurate. This technique might explain the apparent stiffness in the folds of the cloth draping Leonardo's angel, but it speaks volumes about Leonardo's willingness to experiment. And of course Leonardo was right—the best way to learn to paint something is to study it in three dimensions!

Collaborative Effort

Besides Verrocchio and Leonardo, a number of other particularly well-known collaborators, including Sandro Botticelli and Lorenzo di Credi,

were involved with the creation of *The Baptism of Christ*. Many of these artists would eventually become famous in their own rights. This masterpiece remained at the monastery in San Salvi until 1530, and it currently resides in the Uffizi Gallery in Florence.

FACT

One of Leonardo's other early commissions was a tapestry for the King of Portugal, a work that would have combined gold, silk, and other materials to be woven into an elaborate scene depicting the fall season. The scene contained trees, landscaping, animals, and other natural elements that had an amazingly realistic appearance. Leonardo made detailed drawings and plans for this work; like many of Leonardo's projects, however, the actual tapestry never materialized.

Leonardo's apprenticeship in Verocchio's studio lasted until about 1472. At that time he was admitted to the Company of Painters, Florence's painting guild. Probably eager to test the waters on his own, Leonardo had the opportunity to branch out as an independent artist. But he didn't give up all ties to Verrocchio's workshop, probably because he wanted to further his education and continue his association with the master.

Collaboration on paintings was not uncommon at this time; a patron might provide the general direction for a piece of art, and sometimes entire studios (masters and apprentices) would work together on a single painting. In addition to Leonardo's assistance on *The Baptism of Christ* in 1472, he collaborated with Verrocchio on other works, including the *Madonna di Piazza* (1474). Though Leonardo must have gradually evolved from a student to an equal in Verrocchio's eyes, he didn't really come into his own until he finally started working alone.

In the Company of Painters

With the success of *The Baptism of Christ*, Leonardo's confidence probably hit a high point. His work was recognized far and wide, and this realization may have given him a push to leave Verrocchio's studio and strike out on his

own. Though most artists based their own styles on those of their masters, Leonardo was clearly branching out and discovering his own, individual talents.

Guilds

In 1472, Leonardo joined the Company of Painters. This group belonged to one of many guilds that existed in Italy during the Renaissance. The notion of the guild (an association, usually for either religious, craft, or business purposes) had been around since the first century, but guilds became much more popular during the Middle Ages. Guilds provided artists with opportunities to get together, share techniques, and provide mutual protection. They were a common resource for patrons, too.

The main types of guilds in the pre-Renaissance era were merchant and craft; merchant guilds were for businessmen, and craft guilds were for painters, architects, sculptors, and other artists. A cross between a club and a users' group, guilds provided a common interest base and promoted the development of specific trades. Generally speaking, each major city had a guild for each art. And these guilds weren't just social affairs. In some cities, guilds would design entire public-works projects.

Reasons to Join

The Company of Painters had many benefits for its members—for starters, there was the prestige and credibility. For another, guilds increased artists' visibility to potential patrons. And not just anyone could walk up and join; these artistic guilds were selective in their membership process, women being perhaps the most obvious exclusion; while this was usual practice for the Renaissance, you'd be a lot less likely to see this sort of discrimination in an art society today.

For Leonardo, joining the Company of Painters was a big deal. While he kept working out of his master's studio, enrollment in the guild gave him a higher status and enabled him to receive commissions both individually and as part of the guild. But the honor of belonging to a guild certainly didn't come free. The guild's record books show that Leonardo was behind on his dues at least once.

In typical fashion, Leonardo rebelled from within; he came out in favor of educating artists through schools, rather than apprenticeships and guilds. This method actually became more popular toward the end of the sixteenth century. Even when he had finally joined an exclusive club, Leonardo still wasn't satisfied with the status quo!

Leonardo was prolific in this early period, producing many sketches and paintings. As mentioned before, one of the first dated works attributed to da Vinci is a pen-and-ink landscape drawing of the Arno River Valley. This sketch, from 1473, was one of many that Leonardo created before he became famous. The Uffizi Gallery in Florence contains several of the paintings Leonardo created between 1472 and 1475; one such work is the *Annunciation*, a religious scene that combined oil and tempera on wood.

The National Gallery of Art in Washington houses other early Leonardo paintings, such as *Madonna and Child with Pomegranate* (1472–1476) and one of his early portraits, an oil painting on wood of Ginevra de'Benci (1474–1476). Even in these early works, you can begin to see Leonardo's innovations and genius. Not bad for a twenty-two-year-old!

Leonardo's *Portrait of Ginerva de'Benci* was one of his first surviving Renaissance portraitures. This oil-on-wood painting shows a woman with incredibly detailed curls in her hair and a facial expression that suggests she may have been used as practice for Leonardo's later work on the *Mona Lisa*.

Burn No Bridges

During his first years with the guild, Leonardo was still working with Verrocchio's studio on many projects. Records indicate that he either assumed more of a financial-management role with Verrocchio's jobs, or he actually had several of his own commissions within the studio. Never one to turn down work, Leonardo may have also worked with the neighboring studio of Antonio Pollaiuolo on projects. He probably got his first formal exposure to anatomical painting at this time, as well. At least the rivalry between

competing studios couldn't have been too intense, if Leonardo was able to work for both at once!

Striking Out on His Own

After five years with the Company of Painters, Leonardo broke free of the guild and opened his own art studio in Florence. While he still kept close ties to Verrocchio, he began establishing his own identity, splitting from Verrocchio on several major issues. For example, while Verrocchio was a master of tempera, Leonardo preferred working with oil paint. Leonardo thought that oil paints had a more natural glow, and they also increased his ability to mix colors.

His apprenticeship with Andrea Verrocchio gave Leonardo both the confidence and the reputation to join the Company of Painters; the experience he gained with the guild likely spurred him to branch out even further by going to work for himself. In modern-day terms, Leonardo's striking out would be equivalent to working for a large corporation, and then taking out loans to begin a start-up company. Leonardo's company was, of course, just himself!

Leonardo's work during this period includes sketches he made around 1478 of an angel, which could be based on his angel from Verrocchio's *Baptism of Christ*, done several years earlier. Many paintings of the Virgin Mary done during this period have been attributed to Leonardo as well. Of particular interest is a vibrant *Madonna and Child* from 1478 that shows incredible attention to detail and human facial expression.

Benois Madonna

The *Madonna with the Carnation*, also called the *Benois Madonna* (1478–1480), is another of Leonardo's works done during this early independent period. This oil painting again demonstrated extremely realistic human features with a rich depth of expression, apparent especially in the Madonna's facial and hand gestures. And like many of Leonardo's other paintings and artistic endeavors, this work also appears to be partially incomplete. Further, in this painting, lighting appears to be coming from both behind and in front of the window, indicating that Leonardo was experimenting with

the advanced painting techniques he would refine in later years. The innovations in Leonardo's early works are often copied throughout his career—when he found something that worked, he refined it and then used it over and over again.

FACT

In between commissions, Leonardo sketched out ideas he would later develop more fully. Some of the most interesting drawings from these years are remnant sketches of machines, including mechanical pieces and military components. His latent pacifism definitely took a back seat in some cases. You'll read more about this later in the book.

From Independence to Patronage

Leonardo's period of self-employment was short-lived, however—at least at this point in his career. Devoted as he may have been to his art, Leonardo still had to eat and pay the bills. He didn't yet have a full-time patron, and no one would pay him to just sit around and draw for himself.

Then there was also the issue of handing projects in on time—something that plagued Leonardo throughout his career. Although he had a good reputation from the start, he was also known for starting more projects than he finished, and most patrons preferred a completed work to an idea or sketch—especially when they were paying for it.

As it turns out, the artist-in-residence option fit Leonardo better than individual commissions. When just one patron employed him, Leonardo had much more leeway in his work. Leonardo went on to work for many important people over the course of his life, and his art developed and grew with each change in patronage.

chapter 3
The Renaissance

The Italian Renaissance is a truly unique part of history—it impacted society in just about every way possible, from the culture and art of the day to the religious and intellectual atmosphere. As society opened and changed in a new period of prosperity following the Middle Ages, there was room for intellectual pursuits such as art, music, and science to blossom. Leonardo was right in the middle of this exciting period, and was influenced by the changing world around him.

Way Back When

The basis of the Renaissance was actually hundreds of years before Leonardo's time. The Renaissance was a brave new world that, in a way, bridged two recent pasts. The Christian medieval tradition, which was well established, crossed paths with a new age of science, mathematics, and religious discovery. As Renaissance philosophers and scientists challenged their existing notions of faith, they came to study ancient examples from classical Greece and Rome in the hopes of finding more universal truths.

Classical beliefs, rules, and structures were seen in a new light: ancient Greek and Roman texts took on an entirely new and important meaning as Renaissance man struggled to make sense of the world around him. This spawned a new philosophical movement called humanism, which was based in classical studies.

Don't Forget the Golden Oldies

Renaissance humanism has been determined by historians to be one of the dominant movements of the European Renaissance. Humanism encompasses the idea that as Renaissance artists, philosophers, scientists, and scholars were devoted to invention as society emerged from the Middle Ages, they were also strongly pulled toward embracing the past. Renaissance artists celebrated individual abilities, to be sure, but it was also an era that prompted the rebirth of classical Greek and Roman antiquity. People believed that the ancient Greeks and Romans had gotten things right: Their art had rules—and good rules at that. The certainty of the classics provided a calming effect that Leonardo and his contemporaries were desperate to incorporate during such tumultuous times.

One of the most attractive elements of this classical revival was a sense of beauty and proportion. Classical architecture used balance and harmony for its aesthetic appeal and symbolically religious nature. Inner and outer beauty were equivalent in classical sculptures. Greek statues

were notoriously well proportioned, a balance that was created in order to please the gods and, by association, the surrounding world.

The idea of balance extended to architecture as well. Classical temples with ordered plans and symmetrical columns produced a sense of order that Renaissance architects tried to recapture. Three major Greek orders, or architectural styles, emerged, providing a clean way to organize form and structure. The three orders, Doric, Ionic, and Corinthian, are best known for the columns with those names. These columns were composed of distinct pieces, and each had a clear structural and sculptural role. Renaissance architects reused these systems while trying to create their own more modern sense of harmony. Because classical temples were completely devoted to the gods for whom they were named, their proportions had to be symbolic of the gods' perfection. The idea was that an ordered space should project that order onto its inhabitants, sort of like a clean desk inspiring you to work more efficiently.

FACT

One of Leonardo's major works, *The Last Supper*, uses a careful sense of proportion and symmetry to reflect a divine influence—certainly appropriate for the subject matter. This idea was actually derived directly from Greek and Roman design and construction methods. Later Baroque architects used Leonardo's architectural experiments as fuel for their work.

There was a bit of nostalgia at work here, too. When it came to looking back to the antiquities, Renaissance artists adopted the familiar "grass is always greener on the other side" philosophy. In their view, Greek and Roman culture provided strong role models, little apparent corruption (at least compared to what Renaissance artists faced), and some vague notion of a glorious past. These were strong ideals, and Leonardo and his contemporaries embraced them eagerly. The Renaissance Church was, of course, still a powerful influence in the lives of fifteenth- and sixteenth-century Italians, and maybe its strong presence stood in stark contrast to the perceived serenity and order of their Greek and Roman predecessors.

Classical Importance

Reading and writing in classical languages such as Latin was popular during the Renaissance. Although Leonardo probably wasn't able to study original Latin texts, many of his works do show a careful study of classicism. For instance, his *Adoration of the Magi* has architectural elements in the background that show a distinctly classical influence. Similarly, *Annunciation* uses Greek-like cornerstones, as well as other architectural elements, which likely came from Leonardo's interest in the classics. He did, though, add a Renaissance twist by giving the stones rough surfaces and pronounced joints instead of a smooth, classical-era finish. How typical of Leonardo to take an established style and make it his own.

Renaissance Humanism

As much as Renaissance scientists and artists forged ahead with discovery and invention, there was a strong pull to both know and honor the classics. Only through an understanding of the Greek and Roman beliefs could one gain the insight that was needed to move forward. And these new thoughts were not simply replicas of the old; Renaissance humanists took strides that are essentially unparalleled in modern evolution.

ESSENTIAL

Perhaps the most amazing aspect of Renaissance humanism is how far-reaching it became. As socio-political thought engaged philosophers and scientists, it also reached out to authors, musicians, doctors, and artists. Few were unaffected by these new interests in both ancient tradition and the modern individual.

So where did humanism begin? There wasn't a single point at which historians can say, "Now *that* was the start of humanism!" Rather, a series of key players changed their way of thinking and acting; those cumulative events have allowed researchers to look at the Renaissance as a whole, and see how the trend of humanism began developing.

Poetry

One of the first signs of humanism was in poetry. Dante (1265–1321) and Petrarch (1304–1374) were two authors from this period who started to study ancient Greek and Roman writings (which was, in and of itself, quite an innovation). In imitating both the style and epic feel of ancient works, Dante started a whole new tradition for the Renaissance, one that deviated from the pious Christian ethic. But, it was a tradition that became immediately popular among those who could afford his writings! His works were compared to ancient masters such as Virgil, whose *Aeneid* was one of the best-known classics of the day.

Dante and Petrarch, though, added a new quality to their work: one of beauty and attraction. Their works were, for the first time, lilting and fun to read. This was quite a new concept, and one that attracted many people to the art of writing. As these masters were read and imitated, more and more budding authors tried their hand at writing books that people would enjoy reading. This was one of the most basic tenets of Renaissance humanism: a rebirth of interest in the arts, including those with non-religious subjects.

Hail the Thinkers

As this newfound interest in the individual affected writers, the spirit of humanism moved into philosophy as well. Renaissance philosophers moved beyond Aristotle, who had been held up as "The Philosopher" for generations, and began exploring other past trends in the struggle for a new understanding of themselves and their world. Ancient pagan philosophers had essentially been forgotten for hundreds of years; now, they were suddenly brought into the light, studied and, in some cases, revived. The Stoics and the Epicureans were now the subject of new interest. Plato, whose particular philosophies had long been squashed by more modern Christian beliefs, was suddenly of great interest to Renaissance philosophers.

The High Renaissance: Leonardo's Backdrop

All of these Renaissance revivals of the classics were important for artists such as Leonardo da Vinci. He was exposed to a far wider range of

precedent than his predecessors, but it was more than that. The time during which Leonardo was working was positively rife with history, a history that had been locked away in previous generations. Leonardo had the benefit of being surrounded by this revival of past legends.

These hallmark characteristics of the Renaissance peaked between about 1490 and 1527, when German and Spanish imperial troops sacked Rome. This period, when Leonardo da Vinci did much of his work, is usually called the High Renaissance because it represents a culmination of all the ideas that had been floating around Florence in the previous years.

The main idea of the High Renaissance was that beauty could be achieved by combining classical forms with landscapes, cityscapes, and other "natural" elements. Unlike the Early Renaissance (which centered mostly around Florence), other parts of Italy, including Rome and Milan, felt the High Renaissance's influence.

FACT

In addition to Leonardo da Vinci, other famous artists of the High Renaissance include Michelangelo Buonarroti (1475–1564) and Raphael (1483–1520). Like Leonardo, Michelangelo and Raphael both studied in Florence and worked in painting, architecture, and other arts.

Moving On

By around 1520, the heyday of the High Renaissance had passed. History likes to record itself in discrete elements, and the Renaissance is no exception. The period after the Renaissance was also characterized into a somewhat less well-known era called mannerism. The artists of this period took their main inspiration from Michelangelo and Raphael. Mannerist art is characterized by an overdoing, or a hyper-stylization, of Renaissance art. Compositions are typically busier and more confusing, and humans are placed in increasingly complex poses. Leonardo's work, which is often seen today as more classic in its poise and beauty, was less of an inspiration for mannerists than some of Leonardo's contemporaries.

And what came next? As mannerism swept the world, so to speak, a large movement rose up against its newfound complexities. This artis-

tic counter-revolution urged a focus on a more naturalistic art, one that showed the emotional and transcendental quality of human life. This movement evolved into the baroque style, which dominated most seventeenth-century artwork. Its masters included Caravaggio, Velasquez, and Rembrandt, among many others.

The Growth of Culture

Aside from battles, attacks, and other less-than-kind acts, the Renaissance is known for its immense cultural strides. The movement that started it all, humanism, played an extremely important role in the development of art, music, religion, and just about every other aspect of society. As one of the Renaissance's most important conceptual innovations, humanism helped spur the growth of philosophy, literature, and creative intellectual thought.

The Rebirth of Italy

So where did the Renaissance begin? It had its origins in Italy, which, at the time, was made up of a number of disparate city-states. As a bit of background, Italian city-states of the fourteenth century were very different from each other: They were ruled separately, and this often created situations where one city would have enormous influence over the surrounding areas. At the beginning of the Renaissance, the main centers of power were Florence, Milan, Venice, Naples, and the region around Rome ruled by the pope. As the Renaissance spread and produced more interaction and communication between city-states, it also provided the means to create a more united Italy, and a more unified Europe.

Pre-Renaissance city-states were economically mixed. Generally speaking, rich people lived in the cities and poorer ones lived in the country. Gradually the wealth spread out. As bankers and other merchants became wealthy, classes other than nobility were coming into money for the first time.

Florentine Origins

The Early Renaissance really began in Florence. There, some of the wealthiest members of society started supporting humanities and the arts.

Writing, painting, sculpture, architecture, and science were all fields that were suddenly in the public eye. The Medicis were one of the most influential families during the Renaissance and would turn out to be one of Leonardo's many patrons.

Lorenzo de Medici (1449–1492), son of Cosimo de Medici (one of the period's wealthiest Italians), gained popular acknowledgement and support by funding art and architecture. He was Leonardo's first patron, and helped launch his career as an established artist.

In spite of newfound money and culture, life was not entirely peaceful during the Renaissance. In 1454, Milan, Florence, and Naples were united under the Treaty of Lodi, through which each city attempted to ally itself with the others. But thanks to Pope Alexander VI's scheming goals, France's King Charles VIII headed up an Italian invasion and several areas were conquered as a result.

In 1495, King Ferdinand of Spain got involved and helped to create the League of Venice, which also included Spain and other Italian city-states. France invaded Italy on several other occasions during this period, contributing to the political unrest so characteristic of the Renaissance. The popes of this era (Alexander VI, Julius II, and Leo X) served mainly to enforce a Christian system of beliefs throughout the country, in part by preventing an Ottoman invasion. By 1527, the Holy Roman Empire had taken over what was left of the city- and papal-states.

Renaissance Religion

It's important to understand how the Renaissance truly reached all facets of society. The movement had the biggest impact on the humanities, arts, and sciences. As with everything in Europe at that time, however, there were also religious implications. Papal states (regions run by the pope, who served as the bishop of Rome) were as important politically as the city-states, which included Florence and Milan.

The Reign of Julius II

At the beginning of the High Renaissance, Pope Julius II (reigning 1503–1513) was in power. Though a religious figure, religion wasn't the only thing he influenced. Julius II's goals were also politically and geographically motivated. He strove to remove the French from Italian territory before they could completely take over the Italian papacy. By 1512 Italy had joined Spain in the Holy League and the countries united to defeat the French, thus scoring a victory for both Christianity and Italy.

During this period, popes were often expelled for bribery or other treacheries, but their power was usually restored. To this extent, religious leadership was consistent but not absolute. Popes also often handed their office over to close friends and family members, and this culture of nepotism contributed to the unrest. Further, popes led privileged lives and had access to luxuries that much of the population would never experience.

ALERT!

Some in-laws are definitely better than others! High-level politicians would often marry off their daughters to popes or papal families. Lorenzo de Medici, for example, had his daughter Magdalena marry a pope's son. Not a bad way to ensure a solid connection between religion and government.

Religious Uproar

A fragile stability was reached during the early sixteenth century. Rivalries and power struggles continued between the Italian regions, however. In 1527, Charles V and the Holy Roman Empire crushed the Italian popes through their cataclysmic sacking of Rome. The Holy Roman Empire was a powerful political entity, dominated by highly powerful emperors, that was in existence from 843 until 1806. The first official Emperor was Otto I, (crowned in 962), and the last was Francis II, (who stepped down in 1806).

By the middle of the sixteenth century, virtually all of Italy was at least nominally Roman Catholic. The Roman Catholic Church's corruptions were apparent, however. The close union of religion with politics and wealth

dismantled the very nature of the Church as an institution of holiness. People were also dissatisfied with the emphasis the Church placed on ritual, rather than personal prayer.

Then, in 1517, Martin Luther (1483–1546) unknowingly sparked the Protestant Reformation when he nailed his Ninety-five Theses to the door of the Castle Church in Wittenberg, Germany. The Protestant Reformation attempted to transform the Church by calling for a return to the Bible's teachings. Since religious revolution was a popular idea at the time, people from all over Europe joined in support. Because of the Reformation, the Church was ultimately forced to revise its close dependency on outside groups. But the Reformation also caused a split in the Catholic Church, as new Protestant groups such as Lutherans and Anabaptists were created.

Religion and Art

Religion was one of the most significant reasons for art's popularity during this time. Sponsoring a religious work of art made you appear more pious, putting you in good stead with the Church and conferring greater prestige on your family. Wealthy families lived in the public eye; to be perceived as wealthy, people had to surround themselves with beauty—particularly beauty created expressly for them. The ability to afford commissioned artwork was a sign of power, and Renaissance politicians and other leading figures were not shy about flaunting their wealth.

Leonardo appeared, for a time, to be happy to oblige the wealthy in this endeavor. And who can blame him? If nothing else, it probably paid well. Even though the Church was still entrenched in its strongholds from the Middle Ages, the Renaissance helped artists to break from tradition and, in many ways, address their art in a more personal fashion.

Renaissance Economics

The start of the Italian Renaissance also meant the restoration of trade, which had almost completely dried up during the Middle Ages. Financial and economic growth were major factors in the prosperity which allowed support of the arts and cultural growth, and economic policies were key in allowing the growth of the Renaissance.

The Origins of Trade

The bartering system is nearly as old as time itself. Before currency was invented and popularized, people (and entire cultural groups) would trade goods for goods, or goods for services. The eventual switch to currency came about as a practicality; it was simply easier to pocket a couple of coins than it was to haul around twelve barrels of apples. Currency also gave the ancient rulers a chance to further promote themselves. They could have their image stamped onto a piece of metal that almost every citizen would see every day. The Roman Empire, for example, was one of the first civilizations to be built with the power of the coin.

QUESTION?

Why did early cultures use trading?
Trade was not only a means of transferring barter-able products from one place to another, but also a means for kings to exchange gifts. Different cultures with no easy form of communication could still create meaningful relationships through bartering.

Trade by Water

Sea trade traveled up major water thoroughfares, landing in major port cities such as Massalia (today known as Marseilles). Etruscans (ancient Romans) also had their own methods of trading through various mountain passes. Trading over long distances was one of the first ways in which ancient cultures shared both consumable products and ideas; it also led to the growth of certain industries in places that were formally unable to achieve such new diversity. Salt, for example, was produced in areas near salt mines. Once salt could be transported to more inland sites, those cities were able to start preserving food using salt, and entirely new types of sustenance were developed.

As populations grew and prosperous city-states expanded in Italy, England, and France, trade increased as well. The first order of business was shipping luxury goods from the Mediterranean to Italian port cities such as Pisa, Genoa, and Venice. Even the Crusades helped to strengthen trade,

since travel caused increased contact with other cultures and helped open new markets. Situated between Western Europe and the Mediterranean, Italy was in a great location to become a major trade center. These port cities got bigger and wealthier as trade increased, which, in turn, caused changes in many aspects of society, including art and finance.

As trade increased the flow of money through Italy's port cities, those with secondary industries such as banking started to flourish. Florence, Leonardo da Vinci's home region, became Italy's central banking city in the early fourteenth century, which included the bank of the influential Medici family. Although based in Florence, the Medici's bank had branches in other cities across Italy and the rest of Europe. The bank financed a variety of projects, and its substantial profits were invested in the political and cultural life of Florence and other Italian cities.

The Rise of Commerce

As commerce grew, people in the trading and banking industries came to towns to interact and profit. Trade opened up the world beyond the confines of traditional town walls, and openness to new ideas and innovations spread to other parts of society. Towns and cities grew, and peasants migrating to towns from the countryside helped to create a new class structure. These former country folks became the working class, whereas the noble people and wealthy merchants became the ruling class. These urban elite led the Renaissance's political and cultural changes, while the rural poor participated very little.

The closing of trade routes to China during the Italian Renaissance also had a big economic influence. Beginning with thirteenth-century Venetian explorer Marco Polo and his famous trip to China, Italy established complicated routes to China and the Far East to trade luxuries such as spices and silk. However, when the Ming Dynasty came to power in the fourteenth century, China closed its borders to trade with outsiders. Suddenly, the wealth and resources that would have previously gone into foreign trade were instead available for projects within Italy. The rich ruling merchant class began to invest in Italian society, commissioning myriad works of art and architecture that enriched the culture. Individual artists who received these commissions, like Leonardo, also benefited from this process.

The Daily News

Another innovation, the printing press, had a large effect on the spread of knowledge during the Renaissance. In 1452, the printing of Johannes Gutenberg's famous Gutenberg Bible served as an early example of movable type's possibilities. While Germany took the early lead in printing efforts, Italy soon took up the challenge, establishing presses that printed affordable copies of classical texts and other works. Suddenly, knowledge was easier to spread—libraries could serve as repositories for information, and people could afford to buy printed books instead of expensive hand-copied volumes.

FACT

The printing press also allowed the presentation of a standardized form of ideas, without the changes or errors induced by copying. Leonardo da Vinci, among many others, gleaned much knowledge in his early years from the volumes of books available in his family and friends' libraries. And he definitely put this knowledge to good use!

The Importance of Being Sponsored

Everyone knows about the stereotype of the starving artist. Even during the Renaissance, when artists were important members of society, patronage was one of the only ways an artist could earn a living while devoting himself to—you guessed it—making art. While some Renaissance artists had to find other work to pay the bills, many searched high and low for a patron—someone to sponsor their artistic development.

The idea of having the Church or other groups sponsor artists and particular artworks began well before the Renaissance. In medieval times the Church sponsored many religious works of art, and during the Middle Ages there were groups of secular politicians (kings, noblemen, and princes) who would come together in sponsoring artists to create both religious and secular works.

The Inner Workings of Patronage

The Renaissance took patronage to a new level. In some cases, a wealthy individual would bring an artist into his home, providing food and shelter in exchange for art. Alternatively, a person or group would commission a particular work of art, and the artist would be employed until the work's completion. Depending on the size and scope, these commissioned works could take years to finish. In that respect, these two types of patronage were sometimes nearly equivalent, although commissioned artwork gave the artist more independence than the artist-in-residence option.

In addition to societal and religious approval, patronage was also a matter of simple aesthetics. In a world before television, movies, and popular culture, appreciating fine sculpture or painting was a pleasure for many people. Those who could afford art created by the masters chose to support it, and in return, they were able to surround themselves with the most incredible and skilled art of the period.

Some patrons would actually specify the quantity of gold, silver, and other precious metals they wanted artists to include in their paintings. These measurements assured the patrons of bragging rights for having the most expensive sculpture or the most precious painting.

Did Women Have Patrons?

As a side note, virtually all of the Renaissance's patronized artists were male. Women were not encouraged in the arts during this period, in part because of humanism. Drawing and studying nudes was a part of every artist's training, and it was considered socially inappropriate for women to partake in this part of the world of professional art.

While uncommon, there were still a few female artists in the Renaissance. Despite the lack of encouragement, some women did manage to make a name for themselves. One example is Caterina van Hemessen (1527–1566). She was a Flemish painter who was the daughter of a well-known Renaissance artist, Jan Sanders van Hemessen. She had the good fortune of being able to learn and study in her father's art studio, and she actually earned her own patronage from Hungary's Queen Mary. Once she married in 1554, though, her painting career essentially came to an end; there are no records of her works from that point on.

There was more than one exception to the Men Only rule! Case in point: Marietta Tintoretto (1560–1590), daughter of the famous Venetian painter Jacopo Tintoretto. Her father assured her of a solid artistic education, and her works were so impressive that she was actually solicited to be the court painter for Spain under Phillip II. Her father urged her to stay home, though, and she did; "La Tintoretto," as she was called, died in childbirth at age 30, so her contribution to the art world was unfortunately quite short.

A Group of Patrons

In addition to wealthy individuals (including kings and political figures), collective patronage was also popular during the Renaissance. For example, the wool guild patronized artwork in the Florence Cathedral and sponsored a competition for the design of the baptistery doors. Not too different from corporate sponsorships of cultural events today.

The relationship between patron and artist was usually quite formal. Most of the time a contract was involved, requiring the artist to create a specified number of pieces. Some patrons, particularly ones with a lot of cash to throw around, sponsored artists to work more or less at their whim. If this arrangement worked, then everyone was happy; if the obligations of the contract weren't met, however, patronage could be terminated and the artist would be dismissed. Many different patrons sponsored Leonardo over the course of his life. While in most cases he was likely terminated for reasons beyond his control, it's also possible that Leonardo ended some of the relationships on his own.

No Starving Artists Here!

Generally, when artist and patron argued, it was over money—as in the artist wanted a raise but the patron didn't want to shell out. In Leonardo da Vinci's case, there were lots of arguments over his inability to complete projects. You can't blame the patrons for wanting what they paid for. In some cases, the style or content of a particular work sparked disagreements. Early in the Renaissance, patrons more or less had complete control over their artists. As the Renaissance progressed and art became more highly valued, however, artists demanded more freedom when it came to their work.

Leonardo's Many Patrons

Today's politicians might donate to one or two worthy causes, but it was different during the Renaissance. Back then, sponsoring an artist was all the rage. Florence's political leaders earned respect through their reputations, and providing patronage for a successful artist was a great public relations move. Leonardo's career can be tracked by looking at his successive patrons, from his early days in Florence to the last years of his life at the court of François I in France.

4

Lorenzo the Magnificent

In Renaissance Florence, the Medicis were the most important political family. The richest family in Italy (and perhaps in Europe), the Medicis spent a great deal of money building churches, supporting art, giving to charity, and constructing family monuments to ensure their continued political and social control of the city. They were like Renaissance Vanderbilts or Rockefellers.

During Leonardo's time, Lorenzo de Medici (also known as Lorenzo the Magnificent) ruled Florence. Thanks to Lorenzo's avid support of the arts, Florence rose to a central position in the Renaissance artistic world. Lorenzo's many cultural commissions elevated Florence to the status of the other capital cities of Europe, and Florence's cultural influence became far-reaching. As the cultural center of Europe, Florence also became the founding location of the new humanist movement. Florence was certainly the place to be!

FACT

Under the Medici family, patronage grew to include more than just single works of art. The Medicis commissioned not only gardens, fountains, and public sculptures, but also residences, government centers, fortified compounds, artistic institutions, and even intricately staged public events.

By 1480, Leonardo had established his own studio in Florence and became well known enough to acquire a patron. He became a member of the garden of San Marcos, which was under the patronage of Lorenzo de Medici. In fact, Lorenzo was Michelangelo's patron as well.

Adoration of the Magi

During this time, Leonardo was commissioned to paint *Adoration of the Magi* for the monastery altar of San Donato Scopeto. The scene shows the Three Kings along with Mary and her infant son. Although Leonardo was given more than two years to work on this piece, even that wasn't enough

time. He managed to finish enough of it to show that he was well on his way to breaking away of Verrocchio's influence. The style is different from his previous works, with a triangular grouping of people in the foreground and an elaborate background that combines natural and architectural elements. While many works of the day were composed linearly, a straight line was just too boring for Leonardo. *Adoration* has a balanced, symmetrical structure, again showcasing Leonardo's rapidly developing independence.

While under Lorenzo de Medici's patronage, Leonardo worked on other paintings such as *San Gerolamo*. Unfortunately, this patron-artist arrangement did not last for long. Leonardo was a strong-spirited artist with a reputation for not finishing everything he started, and Lorenzo the Magnificent expected his sponsored works to be completed. With a name like Magnificent, you expect things to be done your way! After a few years, it was time for Leonardo to move on.

The Duke of Milan

In 1482, Leonardo applied for patronage with the soon-to-be Duke of Milan, Ludovico Sforza. Like the Medici family in Florence, the Sforzas basically controlled Milan at this time. However, unlike the banking Medicis, the Sforzas were warriors. Some members of the Sforza family were actually *condottierei*, mercenary soldiers who fought in wars for the highest bidder. The Sforzas rose through the military classes over time, eventually gaining control over the city of Milan from about 1450 to 1535.

The Sforza Years

Ludovico became duke in 1494. Although he initially aligned himself with France's King Charles, he later fought against France in an attempt to protect Milan. Anything to protect his city! Leonardo likely learned about military equipment and machinery during his tenure under the duke. He became Ludovico's court painter, a relationship that lasted until 1499.

In that year, Sforza's land was invaded and he was forcibly driven out of Milan. France's King Louis XII invoked a claim on Sforza's property, and Ludovico ultimately died in a French prison. While Sforza spent a lot of time embroiled in political turmoil, he made a point of investing in the arts and

especially in Leonardo da Vinci. Interestingly enough, this warrior gave equal time to peaceful artistic expression as well as violence.

Under Sforza's patronage, Leonardo created some of the work for which he would become most famous. When applying for the job with Sforza, Leonardo wrote a detailed list of his engineering and military credentials, with his artistic skills listed almost as an afterthought. Fortunately, Sforza took advantage of all of Leonardo's talents.

Creating a Name

Leonardo came into his own while under the patronage of the Duke of Milan. He got the chance to experiment with painting, sculpture, weapons design, architecture, and machinery. Leonardo was an artist, but he was also a realist; he understood the necessity of defense, even though he didn't agree with the concept of war. Of course, he also didn't want to alienate his sponsor.

As the Duke's chief military engineer, Leonardo invented several different war machines and weapons during this period. He began the habit of saving all his designs and notes in various notebooks; these books provide the basis for most of our information about Leonardo's un-built designs and innovations. Imagine how limited our knowledge of Leonardo would be without these books!

Virgin of the Rocks

Beyond his military inventions, Leonardo created two of his most famous paintings while in Milan. He started *The Virgin of the Rocks* in 1483, a painting intended for the altar at the Chapel of the Immacolata, located in the church of San Francesco Grande. The contract was extremely specific: the monks wanted the painting to be composed in a certain way, and it had to be done using certain materials. The notoriously individualistic Leonardo quickly ran into problems—see Chapter 6 for more on the ensuing lawsuit.

The Last Supper Began

Also during this period, Leonardo began to work on another of his most famous paintings, *The Last Supper*. Commissioned by the Duke of Milan himself, this work was to be painted on the refectory wall of the family chapel, the church of Santa Maria delle Grazie in Milan. The giant mural was almost thirty feet long—pretty amazing that it was actually completed. However, it began to deteriorate almost immediately, most likely due to the type of paints Leonardo used and the extreme humidity of the refectory's walls. Many attempts were made to restore it over time, culminating with a painstaking effort finished in 1999 (see Chapter 6 for more information).

During his time in Milan, Leonardo's workshop had many apprentices and students. A generation of young Italian artists trained under Leonardo, and you can easily see his influence in the work of his successors. During this period Leonardo also spent a great deal of time studying nature and the environment constructed around him. These observations would play a large role in his later work.

Look Out, It's Cesare Borgia!

One of the Renaissance's more notorious political figures, Cesare Borgia (the Duke of Valencia) lived from 1476 to 1507. Born out of wedlock, he was actually the son of Pope Alexander VI. Initially, Borgia set out on the path to become a cleric, but he wound up as the Archbishop of Valencia (modern-day Spain) while his father was traveling down the road to papacy. Supposedly one of his father's favorites, Borgia probably used his family connections to obtain several of his official positions. He spent much of his life fighting for different city-states.

FACT

Cesare Borgia is infamous for supposedly having killed his own brother, Giovanni, in 1497. There isn't much proof, although Cesare was said to have been jealous of his brother's high social position, and may have also fought with him over a woman. He had a violent reputation and may have been responsible for other murders over the course of his lifetime.

In 1498, Borgia did an about-face, changing his unruly ways after taking on the role of general of the Church. Because he was the illegitimate son of a priest, he had a hard time finding a suitable royal bride, so he spent much of the following year traveling, promoting his career, and dealing with various responsibilities. He also led the efforts to unite the fighting Italian city-states.

Hard Times for the Warlord

By the early 1500s, Borgia owned land all over Italy, at least part of which he had taken by force. He was quite a character—in between the murdering and the stealing, somehow he found time to be crowned Duke of Romagna for a period. As his power grew, so did his enemies. When his father died of illness in 1503, Cesare tried to obtain a religious position in Italy, but it all went downhill from there. His power slowly waned, his lands were overtaken, and his castles fell into his enemies' hands. Borgia was imprisoned on several different occasions and, in a fitting end to a life of crime, he was killed while attempting to take over a castle in 1507.

Needless to say, Cesare Borgia's infamy guaranteed him a place in history. Renaissance writer and philosopher Niccolo Machiavelli (1469–1527) may even have based *The Prince*, his political examination of the monarchy of the day, on the life of Borgia. It is also possible that Machiavelli's work was more parody than praise; in any event, Borgia's contemporary influence was enormous and undeniable.

Leonardo's Role

So how did this ruthless character relate to Renaissance master painter Leonardo da Vinci? For starters, Leonardo traveled with Cesare Borgia in the early 1500s. As a military engineer and architect, Leonardo was put to work designing war machines. By this time, Leonardo had worked for the Duke of Milan for many years, but when his former patron, Duke Sforza, was driven out of Rome, Leonardo had to look for work, and the military experience Leonardo gained while working under the duke helped him to secure the position with Borgia's army.

Even bad guys like art! Like so many religious and political figures of the day, Borgia was a patron of the arts, and having Leonardo da Vinci in his

company was another feather in his cap. Leonardo ended up staying with Cesare Borgia until his return to Milan in 1506.

ALERT!

During his time with Borgia, Leonardo designed many machines, including collapsible bridges, wall-mounted ladders, and rotating scythe blades attached to moving chariots. He also designed weapons, such as catapults, crossbows, machine guns, and cannons. Leonardo's genius turned lethal, when required!

The King of France, in Italy

King Louis XII of France (1462–1515), affectionately dubbed "Father of the People," was a popular king who had a major influence during the Renaissance. In a typically nepotistic fashion, he inherited a ducal position from his father, the Duke of Orleans. Like Leonardo, he too stood up for what he believed in as part of the rebellion against the French King Charles (who was his cousin). This little incident landed him in prison from 1487 to 1490, but later, he worked his way back into Charles' circle of friends. How forgiving!

But how did he end up in Italy? At that time, many powerful French leaders of the day were asserting their claims to dominance in Italy. Louis was a part of this movement, and he made a name for himself by participating in the Italian invasions. He went on to become king upon Charles' death in 1498, and decided to invade Milan shortly thereafter.

More Political Turmoil

After gaining power over Milan in 1500, Louis had the unenviable task of reformulating the Naples heads of state, as well as engaging in constant battles for power with Spain. He also had to suppress the Italian city-states' various rebellions, including those in Genoa and Venice. Around 1511, however, Pope Julius II formed the Holy Roman League. One of the main purposes of this alliance was to eradicate French leadership in Italy.

Louis remained in power in Milan until 1513, when the French presence was driven out. In 1514, King Louis' second wife died, and he was remarried

to Mary Tudor, King Henry VIII's eighteen-year-old sister. When Louis XII died in 1515, the French monarchy went to François I.

FACT

As king, Louis was popular among the people because he lowered taxes and made other general improvements. He was also a patron of the arts, and Leonardo da Vinci served as his court painter in Milan for several years.

Leonardo and the King

After his stint as Cesare Borgia's military engineer, Leonardo returned to Milan. He was becoming increasingly famous, and King Louis' governor, Charles D'Amboise, requested him specifically for the position of court painter. Leonardo's reputation was well established by this time, and King Louis' court wanted to get in on the national treasure that Leonardo was becoming.

It's easy to see that Leonardo was in high demand from a letter that was sent from King Louis' court to the city of Florence, asking for Leonardo's services. Hard to imagine the Queen of England writing to the entire City of New York to ask for a painter, isn't it? King Louis wanted Leonardo to remain in Milan until his highness could set up court there, and of course Leonardo obliged.

Services to the King

In addition to painting, Leonardo provided architectural, military, and other engineering services to King Louis. He was also responsible for other general duties as directed by the court. When Louis traveled to other cities, for example, Leonardo may have been in charge of decorations and whatever traveling road show was required by the king. All in all, it was a very sweet deal for our master painter.

Leonardo painted several masterpieces during this period. In 1506, he worked on a version of *The Virgin of the Rocks*. He also painted *Leda and*

the Swan (now lost) and *The Virgin and Child with St. Anne* in 1509, as well as *St. John in the Wilderness* from around 1510 to 1515.

Learning and Personal Growth

Leonardo also took this opportunity to do some independent study. He was fascinated with botany, hydraulics, mechanics, and other sciences. He took his study of anatomy to a higher level, and in working with Marcantonio della Torre, he learned much, storing his newfound knowledge away for future use in his paintings, writings, and other designs.

But Leonardo did more than just study. In 1512, he produced one of his first self-portraits. Then, of course, there were the legal distractions related to his settling his father's and uncle's estates—Leonardo had to make several trips back to Florence, which distracted him considerably.

Leonardo remained Louis XII's court painter until the king was forced out of Milan in 1513. At this time, Leonardo left Milan briefly and found work in Florence and Rome over the next several years.

Don't Mess with the Pope

One of the most important political, social, and religious units in Florence, the Medici family controlled the republic more than the government possibly could have. While the family was historically composed of doctors and artists, they later became bankers and basically ran the region financially.

Famous Families

Giovanni de Medici, son of Lorenzo the Magnificent, rose to be a cardinal in the Roman Catholic Church in the early sixteenth century. But the Medicis certainly weren't the only powerful family in Italy. Other families challenged their financial and cultural control, but Giovanni used his connections with the pope to reassert the Medicis as a primary ruling family. Ultimately, Giovanni became Pope Leo X.

Giovanni's brother, Giuliano de Medici, was also a great success as head of the pope's army. Art historians in particular like to study Giuliano because he served as Leonardo da Vinci's patron from 1513–1516. After King Louis XII

of France was forced out of power in Milan in 1513, Leonardo was freed from his role as court painter and quickly got back on good terms with the Medici family.

The Move to Rome

Leonardo da Vinci's lifestyle underwent some major changes during these years. He moved to Rome and lived in the Vatican, where he earned respect from both religious authorities and other artists. Respect equaled more commissions, so he was definitely making friends in the right places. He had his own workshop in Rome and took on many projects under the direction of both Giuliano de Medici and the pope.

Having such a high position gave Leonardo luxuries that other artists didn't have; he had plenty of free time to study, and he focused his efforts on learning more about anatomy and physiology. During the course of his studies, Leonardo became convinced of the scientific importance of dissecting human cadavers. This approach certainly made sense, given what Renaissance doctors and scientists were beginning to understand about the human body. However, much to Leonardo's dismay, the pope issued orders expressly forbidding the dissection of human bodies. Faced with no other choice, Leonardo reluctantly obeyed.

Knowing the Competition

While in Rome, Leonardo had the chance to work more closely with some of his primary rivals. Both Michelangelo and Raphael were becoming major players in the art world, and Leonardo just had to accept that other artists were getting jobs, performing well, and earning as much respect as he did. While Leonardo didn't have much direct contact with these artists, their obvious abilities certainly prodded him to keep up, if not surpass them.

Da Vinci created several masterpieces while under Giuliano de Medici's patronage. One of his crowning achievements was *St. John the Baptist* (1513–1516), which may be the last painting Leonardo ever worked on. This painting is particularly significant because it clearly demonstrates *sfumato*, Leonardo's technique to make people and objects appear to dissolve into one another and the accompanying background. You can see another excellent example of *sfumato* in Leonardo's *Mona Lisa* (1503–1506). Given

his advancing years and increasing health problems, it is likely that others in his workshop also contributed to *St. John the Baptist.*

Among Leonardo's later technical achievements during his period in Rome was a mechanical lion he developed for the coronation of France's successor to the crown, King François I. Following the coronation in 1516, Leonardo again joined the royal courts, serving under François until his death in 1519.

When Illness Falls

At least one major illness struck Leonardo in 1513, when he was working for Giuliano de Medici in Rome. Between 1513 and 1516, Leonardo was quite sick and did not produce much new work. It was said to have been a very trying period for the great master.

In addition to battling medical problems, his work does not appear to have been going well during these years. Leonardo worked on creating new types of paint and developed a few ideas for puzzles, but did not produce many pieces of art. His notebooks reveal this frustration, as he comments that he very much wanted to keep producing art despite his failing health.

A letter to Giuliano de Medici from 1513 indicates that both Leonardo and his patron were suffering from illness at this time, and that while Leonardo was pleased that de Medici's health was improving, he wished he could have hastened his own recovery. Perhaps it was this precarious physical situation that encouraged Leonardo to accept what was basically retirement at the French court of King François I.

François I, King of France and Friend of Leonardo

From 1516 to until his death in 1519, Leonardo worked for the court of François I (1494–1547), the King of France. François was crowned in 1515 after

he inherited the monarchy from Louis XII. Often considered to be the first true king of the Renaissance, François was enchanted with the artwork of the day. His mother and early tutors steered the young François toward the arts and humanities, and he reportedly invited Leonardo to visit the French court and ultimately convinced him to stay. Once there, Leonardo was honored and respected. Rather than being simply a court painter, he was given the title of Premier Architect, Engineer, and Painter.

Living Near the King

While some of his earlier accommodations were little more than stable rooms, da Vinci's final home was a luxurious house near the royal palace in France. He lived at the Clos Luce Manor, located in the Loire Valley. And the free room and board wasn't all—Leonardo was well paid for his work during these final years and was reputed to have been closer to François than any of his previous patrons. Apparently, the king did not ask Leonardo to produce much toward the end of his life. His primary role was to serve as the king's friend. There may have even been an underground passage between the Manor and royal castle, which would have given the king easy access to his aging friend.

Final Tasks

Toward the end of his life, Leonardo spent much of his time sketching. He continued with trends from his earlier years, including drawing animals, plant life, and water in various states. During this period, he developed some of the first sketches of water flowing freely and circulating in a whirlpool. Later, scientists researching turbulence would actually study his drawings. Leonardo also developed preliminary designs for scuba gear, diving suits, movable bridges, underwater craft, and many other devices that foretell designs to come.

François, by all accounts, had a special place in his heart for Leonardo, and the feeling appears to have been mutual. Leonardo's favorite work was the *Mona Lisa*, which he kept with him at all times until, as evidence suggests, he may have either given or sold his treasure to King François near the end of his life.

chapter 5

Innovations
in Painting

Though Leonardo's interests were all over the map, today we primarily know him for his paintings, and for good reason. They demonstrate Leonardo's various technical innovations, including the blending techniques of *sfumato* and *chiaroscuro*. Leonardo pioneered the use of realistic perspectives in his paintings, and he brought his scenes to life with fantastical backgrounds and real and imagined architectural details.

Putting Things in Perspective

Renaissance art paid homage to its Greek and Roman ancestors, but at the same time forged its own path. It wasn't enough to copy the classics; Renaissance artists went one better. Different methods of artistic representation were developed during the fifteenth and sixteenth centuries, and Leonardo popularized several of them, establishing gold medal standards that future artists would emulate.

Linear Perspective

One of the most enduring innovations in Renaissance drawing was the notion of linear perspective. The concept of perspective involves the idea that it's possible to represent a three-dimensional shape (such as an apple or building) on a two-dimensional piece of paper or canvas. Sounds simple, but that's because we take it for granted today. Perspective can be called a "factual art," rather than an "interpretive art" or one which doesn't aim to represent the world as it is actually seen.

Perspective is a method of drawing that shows objects as they really are, with relative distances between them. Things that are closer to the eye look bigger than things that are further away. Perspective maintains the proportions of objects with respect to each other.

Leon Battista Alberti (1404–1472) devised a mathematical model for drawing in perspective, where the artist pretended to draw as if through a window. This method made use of a "horizon line," which represented eye-level, and used "vanishing points" that served as connection points for all lines of sight. These points helped to designate locations for all objects in the scene. Artists drew "visual rays" from vanishing points, and through these rays, they could create objects composed of right angles (such as walls, bricks, or anything else with a sharp edge). Early Renaissance architects such as Brunelleschi

and Alberti worked with linear-perspective techniques, and Leonardo was a major proponent of this new drawing method.

One-Point Perspective

One-point perspective is a particular type of perspective drawing, and one that's still taught to today's art students. This flavor of perspective is called "one-point" because, as the name suggests, it contains only one vanishing point. It is also sometimes called single-point perspective.

FACT

In one-point perspective, all lines which would be parallel in the real world are drawn converging onto a single point on the horizon line. This technique is one of the easier ones to learn, since there is only one point in space to worry about.

Single-point perspective is very useful for scenes that look down a narrow corridor or alley. Leonardo's *The Last Supper* is an excellent example of an interior scene that used this type of linear perspective. The vanishing point for this scene is right behind the face of Jesus; all lines (people, tables, wall niches) point in to Jesus, emphasizing his focus as the center of both the painting and the religious nature of the scene. As the eyes follow the slanting lines of the walls, they cannot help but fall upon the face of Jesus—and that is the purpose of using one-point perspective.

Two-Point Perspective

Two-point perspective is another method of drawing perspective. Rather than a single point, it uses two vanishing points along the horizon line. Since the vanishing points lie on the horizon line, it's possible to create perspective scenes that show the undersides of high objects, as well as the topsides of low objects. For this reason, artists tend to incorporate two-point perspective into landscapes and other scenes that contain wide angles of view. Two-point perspective is also used whenever the artist wants to highlight the corner of a building, hence its application in outdoor scenes.

Multi-Point Perspective

Other, less-common types of perspective were developed in later years. Three-point perspective utilizes three sets of parallel lines where the third "dimension" points down, so that all objects appear to be spiraling into a downward vortex. Four-point perspective forces objects to appear fatter around the middle, and stretched out tall as they curve upward. Five-point perspective uses five vanishing points to basically create a circular image; this type of projection was used in church paintings, as well as other situations where it's desirable to show a full 180 degrees of content in a single image.

In learning how to construct precise, accurate perspective drawings, Leonardo may have worked with a device called a perspectograph. The idea behind it was similar to a mechanic's workbench, only it was for drawing. This system involved a table with a stand that had a cutout, through which the artist could trace perspective lines of objects beyond the stand. While Leonardo didn't invent the idea of drawing in perspective, he used it to such an extent that other artists soon came to admire, and then imitate, his style.

Light and Shadow and Tonal Transitions

Leonardo was actually increasing his workload by painting more realistically (and more three-dimensionally) than his predecessors. With this new way of drawing, he had to develop new techniques to make the entire painting appear more convincing. In addition to perspective, Leonardo realized that simple, flat colors would no longer suffice. Figures seen in the round had to be properly distinguished, both as their own forms and as objects distinct from the scene's background.

Chiaroscuro

Historians largely credit Leonardo with developing a critical artistic innovation known as *chiaroscuro*, which, translated from Italian, means "clear/light and dark." Leonardo used light and dark colors to portray both shade and shadow more convincingly, as they were actually experienced in real life. This use of the *chiaroscuro* technique represented the first time a

Renaissance painter had contrasted lights and darks to help create a truly three-dimensional image.

FACT

Chiaroscuro is evident in many of Leonardo's paintings, including the early *Benois Madonna* of 1478. Leonardo's *chiaroscuro* technique has become so integral to artistic training that some historians have even called it one of Leonardo's most important artistic contributions.

Could just any artist have come along and become famous by using *chiaroscuro*? Not likely, since the technique relied on a solid understanding of perspective, light, and color. It also required the painter to be able to visualize the way light fell onto his subject and other surfaces. Leonardo's myriad talents allowed him to create and develop *chiaroscuro*, but this effect alone could not have made his work as powerful as it was; the effects were only as good as the artist creating them.

While initially developed by Leonardo, the technique of *chiaroscuro* was more fully utilized and developed in later periods. During the later sixteenth century, mannerist and baroque artworks took full advantage of this fledgling technique. Art in this style tended to be very dramatic, with dark figures and highly dramatized lighting. As religion worked its way back into artwork more fully, focused lighting was used to give a painting a particularly deific feel. *Chiaroscuro* was the key technique for these developments.

Sfumato

In addition to representing lights and shadows accurately, realistic paintings need to convey subtle transitions from one tone to another. *Sfumato*, an Italian word meaning "vanished," is used to describe a technique Leonardo developed to do exactly that: graduate color values between parts of an object to make it accurately reflect the object's full roundness. Layers of paint were combined, often along with miniscule differences in tone, with the goal of creating a three-dimensional image that looked as real as the subject. Leonardo used this effect to make his paintings not just mimic reality, but to actually become real—or as real as a painting can be.

FACT

The Italian word *fumo* means "smoke", and that was exactly the effect that Leonardo was after. Smoke has a translucent effect so that it often appears ephemeral, yet still visible when concentrated. It doesn't contrast sharply with its environment, and doesn't have sharply-defined edges or borders.

The *Mona Lisa* is an excellent example of *sfumato*. While the woman's face is enveloped by shade and shadow, it is also completely smooth. Leonardo used brushes and his fingers to blend the tones and create perfect transitions to represent light as it swept around the woman's head. Then, the light in the scene simply subsides into darkness. The transitions between light and dark here are imperceptible; the superb blending allows viewers to focus on the painted subject, rather than the technique of painting. This is the ultimate sign of success for a humanist painter; Leonardo's work could be evaluated and enjoyed without having to see it through the veil of the paintbrush.

The Scene Behind the Scene

The great thing about Leonardo's paintings is that you can appreciate them on so many different levels. His studies of facial expressions were incredibly detailed, and he showed people in a variety of natural poses—doesn't sound like much, but it was new at the time. In addition, the backgrounds of Leonardo's paintings add another particularly intriguing layer to his works. His work was inspired by, but moved beyond, the classical art of ancient Greece and Rome.

Greece 101

In the classical period of ancient Greece and Rome, art focused on celebrating the gods. The Greeks were polytheistic, meaning they believed in the existence of many different gods. There were twelve gods and goddesses who, as legend told it, lived on Mount Olympus. Led by Zeus, the lord of the

sky, these gods and goddesses controlled certain aspects of humans' lives. Everything from health to hunting to love was made possible through the actions of the gods. To honor their gods, the Greeks created artwork, temples, and even entire cities.

The Parthenon, Erechtheion, and other Greek buildings atop the Acropolis, for example, are some of history's most quintessential gestures of devotional art and architecture. In this case, they were played out on a super-human scale. Built atop the Sacred Hill, these Classical tributes included monumental structures designed to honor Athena Parthenaos, Athena Polias, and Athena-Apteros Nike.

Classical celebration of the gods delved into nearly all types of art. Those same buildings on the Acropolis are filled with friezes commemorating the lives of the gods. One example is the famous Parthenon Frieze, which represents the annual Athenian Procession. These scenes wrapped around the Parthenon and had panels with both mortals and deities, showing the immense influence of the gods on the daily lives of Greek citizens. The Greeks and their gods were intertwined to the point where any complete separation would have been artificial.

Natural Religion

The Renaissance, on the other hand, presented a new way of expressing both religious devotion and artistic license. Renaissance painters created a new tradition of naturalistic art, one that placed religious scenes or even portraits in natural surroundings. Subtly woven into many of these works was the idea that it was possible to represent the presence of a supreme being, while simultaneously paying attention to the individual. Many of Leonardo's paintings were religious in nature, and the Renaissance's focus on humanism gave Leonardo the opportunity to incorporate his fondness for the natural world into the pre-existing influence of Christianity.

Leonardo took this developing Renaissance methodology to a new level. Many of his works include fantastic landscapes as backgrounds, and these

backgrounds sometimes involve complex architectural creations (think Escher) or landscapes with natural elements such as rolling hills, valleys, streams, and mountains. Yet even these more natural elements take on an air of the ethereal thanks to Leonardo's innovative techniques.

QUESTION?

How did Leonardo achieve such ethereal effects?
Leonardo's conceptual method involved rendering scenes as if they appeared through a fine veil of mist. This technique, *sfumato*, is actually visible in his earliest remaining landscape drawing, created in 1473 when Leonardo was only twenty-one. Details of this landscape seem to recede into the distance thanks to atmospheric perspective.

Backdrop for the Mona Lisa

Perhaps the most famous of Leonardo's background landscapes is in the *Mona Lisa*. Rather than placing her indoors, as was typical for most portraits, Leonardo positioned Lisa, the woman with the enigmatic smile, in front of a dreamlike landscape full of craggy mountains and sinuous streams. The background's movement captures Leonardo's view of the natural world, one that is ever-changing and constantly in motion.

The only man-made element in this background is a small bridge crossing one of the rivers. If you were to inspect the background closely, you'd also see that the two sides do not match up—the horizon on the right side of the figure is significantly higher than that on the left side. Most likely, this was a deliberate trick on Leonardo's part to lend an increased sense of activity and realism to the central figure by making her place in the painting appear to change depending on whether you look at her from the left side or from the right.

St. John in the Wilderness

A late painting, *St. John in the Wilderness* (attributed to Leonardo, although not confirmed as his), goes one better. It combines a realistic natural setting (trees, roots, cliffs, and animals) with one of Leonardo's traditional misty backgrounds. Toward the top left of the painting, the landscape

recedes into mists and lakes—very surreal. An earlier painting, *The Virgin of the Rocks*, creates a fantastic setting for a typical religious theme, placing the subjects in a cave, or grotto. The scene is complete with a reflective pool of water, plants, and a background of rocks that erupt from the floor and hang dangerously from the ceiling. Rather than receding into darkness, the rocks extend into a bright misty region typical of Leonardo's other backgrounds.

Madonna Litta

Even in an indoor painting like the *Madonna Litta*, it's easy to see Leonardo's love of fantastic backgrounds. He positioned two windows over the shoulders of the woman, and each bears a typical scene of faraway mountains, clouds, mist, and sky. The windows lend a depth to the picture that would otherwise be lacking in a typical, flat portrait. While no one's certain who actually did this painting (Leonardo's assistants may have executed it), it is clear from sketches now in the Louvre that at the very least, Leonardo did design the picture, even if he didn't actually paint the final version.

Leonardo and the Fine Art of Completion

While no one would ever question Leonardo's overall genius, doesn't it seem strange that we celebrate him so much as an artist, while so few of his paintings remain today? As mentioned previously, one reason for this conspicuous lack of finished products was Leonardo's tendency to start many paintings, but actually finish very few. Even in his earliest days, he flitted from subject to subject, learning and experimenting with writing, drawing, painting, sculpting, music, science, engineering, and math.

So why didn't he just focus on one art form? It's possible that as stunning as his works were, they did not match the perfection of the images in his head, and he gave up rather than fail in the expression of his imagined perfection. Another possibility is that, especially later in life, Leonardo saw himself more as an inventor and scientist than as an artist, and thus devoted more time to such works. The inevitable consequence was that he ended up neglecting his art.

The Battle of Anghiari

The Battle of Anghiari is one example of the failure of Leonardo's new innovations. The project was supposed to have presented an entire battle scene on a wall opposite a new work by Michelangelo. When Leonardo actually painted the work, using a new experimental technique, the paint adhered to the walls without problem. Unfortunately, when Leonardo applied heat to dry and fix the paint, his luck ran out. Some of the paint ran off the walls and the rest scaled off in pieces. The project was almost a complete failure, and other artists actually wound up painting over top of Leonardo's original work.

Leonardo was an innovator, and as such, he wanted to rush out and test newly discovered techniques—which, of course, went against the tried-and-true methods of his time. Granted, his innovative approach sometimes had disastrous results. Take, for instance, his fresco *The Last Supper*. Leonardo painted this masterpiece using a new technique he'd developed, but the paint began to peel from the wall almost immediately.

Bad Habits

Beyond his penchant for experimentation (which sometimes backfired), perhaps Leonardo simply got bored. Maybe he worked first and most intensely on the aspects of a painting that he found most interesting: the design and rendering of faces, hands, hair, and background landscapes. Once he was finished with those portions, he may have simply left other parts of his paintings incomplete or had his students fill in certain elements, which seems to be the case with his *Portrait of a Musician*. Leonardo rendered the face and hands exquisitely, but he barely sketched the drapery of the young man's tunic into place.

Other paintings, like *St. Jerome Praying in the Wilderness*, were left in almost draft form. This work reveals the sketches and designs Leonardo would have painted over if progress had continued on the painting. Even in its barely begun form, however, this painting has a haunting quality, and the anatomical detail of Jerome's face and body is stunning.

Not finishing what he started got Leonardo into trouble on more than one occasion. In some cases, patrons never paid him for his unfinished work; in other cases, he had to return the initial advance money he received when he didn't complete a painting on time. For example, despite having a contract, Leonardo never completed *Adoration of the Magi*, meant for the monks at Scopeto in 1481. Apparently, Leonardo only finished a sketch and never even started the main painting. A lawsuit over another work, *The Virgin of the Rocks*, dragged on for about ten years. As a result, Leonardo eventually completed two versions of the painting to fulfill the contract.

Larger than Life

The equestrian *Statue of Francesco Sforza* is yet another work that, although ambitious in creative scope, perhaps overreached the realm of feasibility. If Leonardo had been willing to settle for a smaller sculpture—life-sized for instance—the statue might have been built and probably would have survived the battles in Renaissance Italy. However, settling doesn't seem to have been in Leonardo's nature.

Instead, he designed this sculpture to stand more than twenty-five feet tall and, as a result, he ran into problems. For starters, there was no foundry big enough to create such a large sculpture. Then, as he was gathering bronze to cast the sculpture, Milan became embroiled in war and Leonardo had to surrender his precious supplies for military usage. Leonardo had only a clay model of the horse statue to show for all of his efforts, and that was eventually destroyed when the French used it for target practice.

Building the Scene-Scape

The advent of humanism brought plenty of changes to Renaissance artists and patrons. Artists like Leonardo had to develop new techniques and skills to paint increasingly convincing scenes—people expected more, and artists had to live up to those expectations. Fortunately, Leonardo excelled at incorporating nature and landscapes into his paintings. He spent much time studying anatomy, biology, and geology, and his observations gave him a keen sense of proportion and movement.

Three-on-Two Dimensions

Along with this interest in humanism, architectural landscapes also became increasingly popular during the Renaissance. As this idea was a relatively new addition to Leonardo's artistic bag of tricks, some of his early examples seem awkward or forced. The *Dreyfus Madonna* of 1469 demonstrates this problem quite well. The Madonna is seated in front of a window, which is too close to the viewer to be properly discernable. Its rendering is too dark in contrast to the brightness of the Madonna in the foreground, and it appears out of place. The landscape seen through the window seems equally disjointed. Despite questions about its execution, this painting is important because it represents one of Leonardo's early attempts to create coherence amongst natural, built, and human forms.

FACT

Madonna with the Carnation is another interior scene that deals with the background in a more three-dimensional way. This painting dates to 1478, and you can easily see Leonardo's increasing expertise with perspective. The arched colonnade clearly shows one-point perspective, though the angle of view is somewhat inconsistent with the perspective of the foreground figures.

From 1472 to 1475, Leonardo contributed to at least one version of an annunciation scene. This painting features many architectural elements, including a marble sarcophagus representing a Medici family tomb. The composition appears awkward, and not all of the figures are drawn in the same perspective (the Virgin Mary is posed in a three-quarter view, whereas an angel is depicted almost sideways). Nevertheless, this painting has much more pronounced architectural definition than Leonardo's previous works. There is a partially revealed doorway, and the wall behind it is defined with enormous quoins.

This sort of precise architectural detailing was without classical precedent, and even artist-architects such as Brunelleschi and Alberti did not present built elements to such an extent. The landscape in the background appears nearly

flat, however, indicating that Leonardo still had some refining to do when it came to working out the coordination of nature and architecture fully.

Collaboration

In Leonardo's defense, many paintings from the Renaissance were collaborative efforts. While Leonardo surely had a hand in the works attributed to him, other lesser painters may have actually done some of the detailing. The *Madonna di Piazza,* for example, was originally commissioned to Verrocchio, but Leonardo da Vinci and Lorenzo di Credi worked on it. This particular scene shows a strong understanding of single-point perspective, but the colors and tonal work do not seem reflective of Leonardo's other paintings.

The Last Supper, completed in 1498, combines the best of both worlds: humanlike figures with real architectural interiors. Leonardo used single-point perspective to create a space that was geometrically precise. Most of the painting is also symmetrical, showing off the latent influence of classical notions of balance and proportion. The upper part of the image (before restoration) actually shows imperfect symmetry and slightly off-center perspective. Leonardo found a way to sneak in his own special touch through these small sorts of details.

Architecture of the Imagination

As if creating some of the first Renaissance architectural paintings wasn't enough, Leonardo also painted scenes that demonstrated a sort of "faux architecture." This term might sound odd, but bear with us. These works contained architectural elements that had more in common with flights of fancy than with anything rooted in concrete reality. The *Adoration of the Magi* of 1481 is one of the best examples. Commissioned for the monastery at San Donato Scopeto, Leonardo worked on this scene during his years under Lorenzo de Medici, and it was the first work that he created largely on his own. While the painting focuses on Mary, the baby Jesus, and the three Magi, the scene also contained about sixty other people, a variety of animals, and other natural elements.

Where Does Reality End?

Although Leonardo never finished this painting, it is clear that the scene contains architectural elements that were, at least partially, more imaginary than real. Take, for example, the staircase depicted in the background. It could be part of a medieval castle, or maybe it belongs to the ruins of a Roman imperial palace. Either way, these structures would have been completely out of place for this religious scene set in a lush countryside—not the best place to build a castle, which surely would have required at least basic defenses.

The scene is a fanciful composition, to be sure. Its early sketches were even wilder, showing animals in different perspectives and poses. Some sketches had parts of the stairs dating from a different period and age; some were even composed of different materials. It was a motley collection of painting elements, and Leonardo probably loved painting every minute of it. There are multiple points of perspective, and the scene almost looks more like a collage than one coherent painting. Although the perspective in this scene is varied, it is, at any rate, more geometrically correct than Leonardo's work in *Madonna with a Carnation*.

A Humanist Slant

The details in *Adoration of the Magi* mark an important milestone in Leonardo's career. As a true Renaissance painter, Leonardo was fully involved in humanism, which was the idea that human beings were inherently worthy of individual study and representation. Leonardo's developments in painting, including *chiaroscuro* and *sfumato*, discussed earlier in this chapter, were a means toward that end. He focused on finding ways to represent humans, animals, and nature more accurately through the medium of painting.

Faux-architecture, on the other hand, takes a step away from reality. Perhaps Leonardo's playful side came to the fore through these sorts of details, or maybe they afforded Leonardo the opportunity to contrast his new skills against a more whimsical background. Whatever the reason, the fanciful architecture incorporated within Leonardo's paintings increases the depth of his work and speaks to both his inherent creativity and his willingness to take risks.

chapter 6
Famous Paintings

While Leonardo is well-known for his consummate body of work, many would argue that his paintings are perhaps the most impressive component of his resume. From early works such as *Lady with an Ermine*, to *The Last Supper* and the *Mona Lisa*, the hand of the artist is evident in all aspects of his paintings—right down to the last details. As he was wont to do, Leonardo included cryptic details or messages into most of his paintings; solving these puzzles adds to the multiple levels of enjoyment when viewing the works of Leonardo.

It's All in the Details

Leonardo had a knack for capturing facial expressions, and you can see that even in his early works. *Lady with an Ermine*, painted around 1490 (or perhaps earlier), is a portrait of Cecilia Gallerani, the young mistress of Duke Ludovico Sforza. An ermine (a small mammal also known as a short-tailed weasel or a stoat) was a symbol of purity and moderation in Leonardo's time. But the ermine was symbolic on other levels as well. It was a symbol of the Duke, who had received the Order of the Ermine in 1488. This Order was one of the Orders of Chivalry, an association throughout Europe prevalent among warriors and nobility; it was similar to the British Knighthood. The Duke used the ermine as a heraldic figure, and it was present in his coat of arms.

New Positioning

Often called the first modern portrait, this work is very different from established methods of portrait painting in the fifteenth century. Leonardo posed Cecilia in three-quarter view, rather than in the strict profile view favored at the time.

There's also an added sense of motion inherent in this scene, as she twists her head and upper body, fixing her gaze on something outside the field of view. The warm lighting in the image provides a three-dimensional look that has an almost sculptural effect. The painting also renders the detailed embroidery and ribbons on Cecilia's gown with painstaking precision. Leonardo's knowledge of anatomy and nature allows him to capture both the beauty and the intelligence of the young lady, and create a realistic portrayal of the ermine. The beauty of Cecilia's face, and her enigmatic half-smile, evoke a later (and much more famous) portrait—the *Mona Lisa*. Leonardo started a trend with *Lady with an Ermine*, which set the stage for further exploration and development.

Stylistic Markings

Lady with an Ermine had other differences compared to the rest of Leonardo's paintings. For example, one of da Vinci's other famous faces is found in his *Portrait of Ginevra de'Benci*. This painting could date to as early as 1474, when Leonardo was still working with Verrocchio. It includes

some elements typical of Leonardo's style, such as a mystical backdrop and detailed background rendering, and it also shows botanical elements such as the juniper bush. The portrait itself is much flatter and has none of the three-dimensionality of *Lady with an Ermine* or some of Leonardo's other later works. The subject has a brooding, almost sulky expression, and her face doesn't have that familiar mysterious smile. However, her face and skin do have the marble appearance found in Leonardo's later works, and the emphasis on the ringlets of her hair is also typical of Leonardo.

Leonardo's students may have worked on (in part or in full) some of the other early works attributed to the master. One example is the *Litta Madonna*, completed between 1480 and 1490, which shows an infant Christ child nursing from his mother. Leonardo did some initial sketches for this work, and the tilt of the Madonna's head is similar to the head positioning found in many of Leonardo's other paintings. However, the image's composition is awkward, and the child doesn't look like other children in Leonardo's work. Historians think that Leonardo designed the layout of the painting, and painted the Madonna's head and some other small details, but left the completion of the painting to a student such as Giovanni Boltraffio.

Another early work, *Portrait of a Musician*, dates from around the same period as *Lady with an Ermine* (1482–1483). However, attributing this painting to Leonardo is problematic—there are no records mentioning the painting, nor is there any documentation for its commission.

FACT

Portrait of a Musician has some elements of Leonardo's style, but one of his students could also have been the artist—the likeliest suspects include Bernardino Luini, Giovanni Boltraffio, and Ambrogio de Predis. The sitter for the portrait is also unknown, although the sheet music indicates that he is a musician.

Only By Leo

So what's the proof of Leonardo's influence on *Portrait of a Musician*? Consider the shadowed background, the length of the figure, and the three-quarters view of the subject. These were all his trademark elements, and it

shows that he had at least something to do with the painting. But that's not all—other details also suggest Leonardo was the artist. For instance, the delicate bone structure required detailed knowledge of anatomy, and Leonardo was one of only a handful of painters who had that skill. Then there's the subject's casual, unforced pose, delicate fingers, and curling hair. All of these details point to Leonardo. This painting also remained unfinished, and various elements are only sketched in—and Leonardo was unfortunately known for leaving many paintings only partially finished.

Monks and Lawyers and Artists, Oh My!

Who would've thought that Leonardo had a legal run-in with Catholic monks? But that's exactly what happened with *The Virgin of the Rocks*. In fact, this project was actually done twice because of the lawsuit that ensued.

The chapel of the Immaculata at the church of San Francesco Grande, in Milan, originally commissioned *The Virgin of the Rocks* in 1483 as an altarpiece. One of Leonardo's first commissions in Milan, the painting relates to the Immaculate Conception, the Catholic Church's teaching that Mary was conceived without original sin. In the painting, Mary is shown childless and surrounded by prophets. The Immaculate Conception is a particularly important Church doctrine, and so the Italian papacy charged Leonardo with the task of portraying the Virgin in a pure, holy, and innocent manner.

Follow the Rules

The original contract for the work was very specific, spelling out the exact subject of the picture. The premise seems straightforward enough: the monks of San Francesco wanted the Virgin to be the painting's central focus, with prototypical Greek angels flanking her. Leonardo designed his work to fit into a panel, which would have been framed by painted or gilded shutters. Evangelista and Ambrogio de Predis were to complete the surrounding work. Details of the background (mountains and rocks) were also laid out before Leonardo began work on the project. The monks were picky and knew just what they wanted. The original contract even called for specifics on the Virgin and angels' robe colors.

This painting is easily identified as Leonardo's by its realistic-looking figures painted using *chiaroscuro* to alter light and shadow. *Sfumato* also enhances this piece; the tonal gradations are so smooth, they are virtually unnoticeable. The landscape appears mysterious, with the Virgin emerging from the darkness.

Despite all of the specifics of his contract for *The Virgin of the Rocks*, Leonardo did take some measure of artistic license. For instance, he exchanged one of the angels for St. John. It seems that the one consistent element in Leonardo's career was that he always had to assert his personal style in each of his projects.

Leonardo's attention to the natural appearance of the scene is evident in the change in color from background to foreground, as well as the increased rocky detail in closer objects. So what sets Leonardo's landscapes apart? Mostly, it's their specificity. Many Renaissance painters, including Leonardo, studied botanical books; while others would simply copy the plants they saw in their texts, Leonardo drew directly from nature.

A Timely Deadline

The Virgin of the Rocks wasn't exactly a rush job, but the contract length was very short—Leonardo had only eight months to complete the entire painting. It was supposed to be completed prior to the Feast of the Immaculate Conception, held annually on December 8. Predictably, Leonardo ran into some trouble finishing the painting on schedule, and the work became the subject of a lengthy lawsuit. The eventual result was that two versions of the work were created—one is presently part of the Louvre's collection, while the other resides in London's National Gallery.

In addition to the missed deadline, Leonardo and de Predis apparently had a dispute with the monks about their commission. Leonardo complained to the monks that not only had they not received their full payment, but that the initial amount negotiated for the entire work had in fact barely

covered the cost of the frame. Disputes and lawsuits over time and money continued for many years.

Eventually, the monks deemed the first version of the work incomplete, thus forfeiting the rest of the money and giving Leonardo ownership of the painting. Leonardo probably gave this version as a gift to King Louis XII of France, who helped resolve the lawsuit, and it now hangs in the Louvre. Leonardo renegotiated the contract with the monks, who agreed to pay for a second version of the work in 1506.

The monks gave Leonardo and de Predis two years to complete this second painting, paying them half the amount originally negotiated. This version was actually finished on time and finally hung in place in the chapel on August 18, 1508. It remained in the chapel until 1781, when it passed through the hands of a number of collectors, eventually ending up in the National Gallery of London.

The newer painting contains a few significant changes from the older version of the masterpiece. The colors are brighter and bluer, the angel on the right is no longer pointing at St. John (who is now holding a cross), and halos have been added above the Virgin Mary and one of the angels.

While Leonardo is likely the sole artist behind the Louvre version, this may not be the case with the second. Leonardo probably supervised the creation of this second painting, but it is likely that other artists in his studio did the actual painting.

The Life and Times of The Last Supper

One of Leonardo's signature paintings, *The Last Supper* is also one of the most accident-prone and least well preserved. Leonardo completed this giant wall painting in 1498. It depicts the moment at which Jesus announces that one of his disciples is going to betray him (ultimately, it is Judas).

A Speedy Finish

Duke Ludovico Sforza, Leonardo's patron at the time, commissioned the painting. Sforza had selected the Church of Santa Maria delle Grazie as his family chapel, and Leonardo was hired to paint a large mural of the Last Supper on one wall of the refectory (a room where meals are served).

Although the work was to be done on a grand scale—thirty feet long and fourteen feet high—Leonardo was not one to turn down a challenge.

Leonardo completed *The Last Supper,* certainly one of his great masterpieces, in only three years. This time scale seems especially miraculous when compared to many of Leonardo's other projects, which either were never completed or dragged on for many years; this speedy execution points to the depth of concentration that Leonardo put into this project.

Telling a Story

The work's design is one of Leonardo's most innovative. The perspective makes the painting appear to be a logical extension of the room, with the eye invariably drawn to the head of Christ at the center. The Apostles are crowded around the table in natural poses, in contrast to the stiff appearance of most versions of this scene during Leonardo's time.

Each Apostle has a distinctive appearance and character. Apparently, Leonardo modeled each of their faces on a particular individual. The two main figures, Judas and Christ, gave Leonardo the greatest difficulty. Christ's expression, a model of serenity, is a dramatic contrast to the Apostles' stunned and conflicted faces.

One legend tells of Leonardo's difficulty with modeling Judas, Jesus' betrayer. Supposedly, when the chapel's prior complained about how long it was taking for the painting to be completed, Leonardo retorted that it was because he was lacking a model for Judas, but the prior seemed to him a good candidate! Leonardo got away with this slight, but luckily doesn't seem to have made a habit of it.

Stop-and-Go Painting

Leonardo worked on *The Last Supper* in his characteristic style. Days of frantic work, during which Leonardo worked all day without stopping, were followed by days during which Leonardo was not seen at all. After being absent for several days, he would sometimes appear, gaze silently at the painting for several hours, excitedly add a few brush strokes and then disappear again. Leonardo did eventually finish the work, however, and the public immediately recognized it as the masterpiece that it is.

So all was well—Leonardo finished this sacred artwork and everyone was happy. Right? Unfortunately, *The Last Supper* began to deteriorate almost as soon as it was finished, once again due to Leonardo's love of innovations. Instead of using the usual method of fresco painting, in which paint was applied to a wall of fresh, wet plaster, Leonardo designed a new method where he applied paint directly to dry plaster.

This new method let him work much more slowly and methodically than the wet plaster required and allowed a wider range of colors and tones in the paint. Unfortunately, that's where the good news stopped. This method proved unstable, and the paint began flaking off the wall during Leonardo's lifetime. The deterioration was exacerbated by the room's humidity and the moisture in the wall upon which *The Last Supper* was painted.

By 1586, the masterpiece had degraded to such an extent that it was hardly visible. Over the years, a number of attempts were made to restore the painting. Unfortunately, these methods often caused more harm than good, or they involved so much over-painting that little of Leonardo's masterpiece remained visible. The work also suffered out of more practical concerns in the church. For instance, at one point, workers cut a door opening through the bottom of the image—at the expense of Christ's feet, which were removed because of it.

ALERT!

In 1796, Napoleon's troops used the room containing the painting as a stable, of all things! After that, *The Last Supper* still had more than its share of disasters to endure. A flood in 1800 left it covered in a layer of green mold, and Allied bombing in 1943 blew the ceiling off the church rectory. Given this tumultuous history, it is surprising that anything is left of *The Last Supper* at all.

An initial restoration was completed in 1954, and finally a twenty-two-year-long project was completed in 1999. The restoration attempted to remove centuries' worth of preservation and repainting, in order to reveal Leonardo's original intent. The process was truly painstaking, requiring restorers to reattach tiny flakes of the original paint in their original

locations. Unfortunately, parts of the work are beyond repair, including the facial expressions of the Apostles. However, a number of copies exist, some dating from before the deterioration had become problematic. If you compare these views to the currently restored version, you can imagine how spectacular the original of *The Last Supper* must have been right after it was painted.

There's Something About Lisa

Just about everyone knows the *Mona Lisa*—it's the painting for which Leonardo da Vinci is, perhaps, most famous. Completed in 1506, this work of art went through a number of iterations before the design and execution were finally finished. What is it about this particular piece that has created such a lasting impact on the artistic world?

The subject of the *Mona Lisa* was most likely the wife of Francesco del Giocondo. A silk merchant in the late fifteenth century, Giocondo was also involved with the government in Florence, and he and his wife Lisa were probably married around 1495.

Details

The portrait poses Lisa as a pyramidal foreground to a distant, somewhat foggy landscape in the background. The glow on her chest radiates to include her face and hands, creating a softness not previously seen in Renaissance painting. This painting was much smaller than many of Leonardo's other works. It measures approximately 30" × 40" and consists of oil paint on a wooden panel.

With the *Mona Lisa*, Leonardo made profound use of the techniques he had developed throughout the Renaissance. The soft transitions between colors (*sfumato*) create a fully realistic three-dimensional figure with amazing modeling of the skin. Leonardo used the same techniques in the background—the sky and water complement each other perfectly. Similarly, the use of contrasting light for shade and shadow (*chiaroscuro*) creates a connection between the curves of Lisa's face and hair, and the mountains behind her.

That Famous Smile

The expression on this Florentine woman's face is one of the painting's most exceptional features, with her simple, dark clothing making her face the real focus. Her smile appears to be at once both innocent and enticing. One account describes how Leonardo had to hire musicians and mimes to amuse Lisa during the sitting—after all, three years is a long time to pose! The entertainment could provide one explanation for Lisa's slight smile. Also significant about Lisa's expression is that one eye is slightly higher than the other, increasing the sense of movement in the painting.

If you've ever seen the *Mona Lisa* in person, you probably know that her eyes seem to follow you around the room. Leonardo probably created this effect on purpose. The corners of the mouth and eyes are the most expressive parts of the human face, and Leonardo did not over-define these parts of the *Mona Lisa*. Instead, they are highly shadowed and almost vague, causing her expression to appear to change depending on the viewer's perspective.

FACT

While it appears that the figure of Lisa is floating in front of the landscape, in the original painting she was actually standing in between two columns, probably on a porch or balcony. Because these elements were removed from the final version, viewers today cannot experience the painting as it was initially intended.

Although women of the day usually had portraits painted while they were dressed in their finest, Lisa is dressed quite simply. She's not wearing any elaborate jewelry or a fancy dress. One theory behind Mona Lisa's everyday outfit is that Leonardo didn't want to detract from the pure lines he was creating. Her simple, dark clothing makes her face the real focus of the painting.

Mona Lisa on the Road

Like Leonardo himself, the *Mona Lisa* did plenty of traveling. Leonardo carried it with him to France during his tenure under King François I. At the end of his life he either gave or sold it to the King, and it ended up in the

Louvre. Napoleon borrowed the painting for a period, and it was hidden during the Franco-Prussian War to ensure it wasn't damaged. In 1911, a Louvre employee named Vincenzo Peruggia stole the painting and then tried to sell it, but he was captured and the artwork was returned to the Louvre in 1913.

The *Mona Lisa* was hidden again during World Wars I and II. Then, it toured various countries (including the United States) during the 1960s and 1970s. Unfortunately, due to security concerns, it's unlikely that it will leave the Louvre again any time soon. At present, it resides in the museum behind bulletproof glass in a climate-controlled enclosure.

Ultimately, everything about this work of art is subject to interpretation. Try as historians might, no one will ever know exactly how Leonardo intended for his work to be viewed; it remains a mystery. And that is precisely why it is so famous: Ten people can study this painting and come away with ten different experiences every time.

Oldies But Goodies

While his early work is probably his most famous, Leonardo made many paintings later in life that would become popular in their own right. One of Leonardo's last works, *The Virgin and Child with St. Anne,* is one of his most celebrated. Leonardo first explored this obscure religious theme in a sketch done in 1498. The layout of the scene contained the Virgin Mary with her mother, St. Anne, and the infant Christ. Although that early sketch has been lost, a later one, dubbed the "Burlington House Cartoon" (named after a former British owner's collection), shows a discarded concept for this work. In fact, this sketch is sometimes preferred over the finished painting.

QUESTION?

Did Renaissance artists really draw cartoons?
Not exactly. A "cartoon" referred to a full-sized sketch that showed the planned layout of a painting which the artist then transferred to the canvas or panel to be painted. The Burlington House Cartoon, for example, shows the infant Christ blessing a young St. John, accompanied by Mary and Anne. Leonardo abandoned this concept for unknown reasons, but the sketch received major acclaim.

Creation of *The Virgin and Child with St. Anne*

The monks of the Florentine Santissima Annunziata commissioned the version of *The Virgin and Child with St. Anne* that Leonardo actually did paint as an altarpiece for their high altar. Leonardo completed the work, which dates from 1507–1513, in his typical fashion: not on time. The monks, eager for their new work, had to commission another piece. In fact, they had given the original commission to Filippino Lippi, but he rejected the project, suggesting that the monks give the commission to Leonardo (whom he considered a superior artist). When Leonardo failed to complete the work on time, Lippi took on the project, but he died before finishing his work. The monks finally got their painting when Perugino completed Lippi's work.

Leonardo's painting of *The Virgin and Child with St. Anne*, completed well past the monks' deadline, shows Mary seated on her mother Anne's lap. Mary is leaning over to her infant son, who is holding a lamb. (The lamb represents a symbol of what Jesus would become: a sacrifice.) Anne's face is peaceful and serene, while Mary's suggests resignation, as if she realizes the fate for which her infant son is destined. She almost restrains Christ from embracing the lamb, and therefore his destiny, yet she also seems to have accepted his role.

The painting's composition is balanced and fluid, although some critics have remarked that the poses seem awkward. Leonardo positioned Mary and Jesus' arms like links on a chain, links that span multiple generations. The background of the painting includes a typically Leonardo-esque wilderness, complete with hazy, impassible mountain peaks, and meandering rivers. The tree in the near background is more earthly than the misty background, but rendered with Leonardo's signature botanical precision.

More Unfinished Masterpieces

Like so many of Leonardo's paintings, Leonardo left *The Virgin and Child with St. Anne* unfinished. Leonardo was distracted by many other projects during that time, and it's possible that he simply lost interest in the painting once he had painted the most interesting parts. Careful examination of the painting has suggested that Leonardo himself painted the background and the three figures, although the heads lack the detail and expressiveness of the *Mona Lisa*. However, it's likely that one of Leonardo's students

completed the rest of the painting, including the lamb and the drapery covering the Virgin's legs. Unlike many of Leonardo's paintings, which he worked and reworked, the paint on this one is of variable thickness, and the sketch lines beneath the paint are visible in places.

Leonardo painted his final work, *St. John the Baptist*, during his last years in Rome, between approximately 1509 and 1516. When Leonardo died in France in 1519, he had three of his favorite paintings with him: the *Mona Lisa, The Virgin and Child with St.Anne,* and *St. John the Baptist.* This final work is quite an unusual treatment of the subject. Scripture portrays St. John the Baptist as a gaunt creature living in the wilderness. The way Leonardo painted him, however, St. John looks almost womanly. He has Leonardo's signature long, flowing, curly locks, a demurely bent arm, and an enigmatic smile quite similar to Mona Lisa's. Leonardo used the finger pointing toward heaven, which signifies the coming of Christ, in some of his other works as well. *St. John the Baptist* was widely copied by Leonardo's students, and a number of these copies exist with questionable attributions.

FACT

Unlike most of Leonardo's paintings, there is no mystical background behind St. John. Rather, the painting shows a mysterious darkness from which a glowing figure emerges. A different artist likely painted the cross that St. John holds and the animal skin he wears, and it's possible that the same unknown artist darkened the background as well.

More Than Meets the Eye

Wit plus intellect: What better combination to create an artistic web of mystery? Add that to Leonardo's passion for humor and secrecy, and you've got the makings of code-riddled art full of hidden meanings. And what are the answers to Leonardo's puzzles, you ask? The riddles buried in his works range from object placement, to more outlandish claims of secret coded messages. The question is, how many of these codes are really there, and how many are the fictionalized inventions of overzealous art critics? You be the judge.

Puns in Painting

Leonardo seems to have loved puns, and many of his paintings include backgrounds or other elements that are puns on the name of the person who was being painted. One of his earliest known paintings, *Ginevra de'Benci*, is a portrait of a young woman that was probably painted to celebrate her marriage. The woman is posed in front of a large juniper plant, which was a symbol of chastity and therefore appropriate fare for a marriage portrait. Yet Leonardo has sneakily included another reference here: the word for juniper in Italian is *ginevra*, so the placing of a juniper plant in the painting is also a pun on the young lady's name.

Another of Leonardo's early paintings, *Lady with the Ermine*, contains a similar pun. The woman in the painting is thought to be Cecilia Gallerani, a mistress of Leonardo's patron at the time, Duke Sforza of Milan. The ermine that the young lady holds was a symbol of Sforza's court and appeared on his coat of arms. Thus it was a logical choice to appear in the painting. In addition, the Greek name for ermine is *galee*, which makes the animal's inclusion another clever pun on the young lady's name.

The addition of an ermine into Leonardo's famous painting has some subtle underpinnings that reveal Leonardo's sense of humor. An ermine, with its pure white coat, was considered a symbol of chastity, making the ermine an ironic choice to place with the duke's mistress.

In another one of these instances, Leonardo designed a huge forest scene on the walls and ceiling of a room in Sforza's castle. This room, dubbed the *Salla delle Asse* (Tower Room), is thought to have been painted mostly by his students, based on Leonardo's design. In addition to the various symbols of Sforza's family, including intertwining branches to symbolize his marriage, the inclusion of numerous willow trees is actually an allusion to Leonardo's hometown of Vinci, which has "willow" as one of its meanings.

Religious Symbols

As you can probably tell, symbolism was common in Leonardo's works. Some objects, such as a carnation or a lamb, may seem a bit random until you know the underlying religious significance.

For instance, Leonardo's early work *Madonna with the Carnation* shows Mary holding a carnation out for the infant Jesus. The inclusion of a flower might seem odd, but since the carnation was actually a symbol of the Passion, its inclusion makes perfect sense. Another similar Madonna and child painting, *Madonna with the Cat*, shows the mother and child holding a cat. The inclusion of the cat comes from a story that a cat gave birth at the same moment that Mary gave birth to Jesus.

Another painting, *Madonna of the Yarnwinder*, has the infant Jesus holding a yarnwinder or spindle. The winder is shaped like a cross, however, symbolizing the Passion of Christ and his upcoming crucifixion. Perhaps most obviously, the infant in *The Virgin and Child with St. Anne* is embracing a lamb, a symbol of himself as the "Lamb of God."

A later painting that is thought to be Leonardo's work is *Salvator Mundi*, a painting of Christ ("savior of the world"). The painting includes an eight-pointed star that symbolizes his upcoming resurrection, and a ruby to signify his martyrdom and passion. Other Christian symbolism in the painting includes the globe itself, which was likely originally an orb; it could have been designed to bring to mind Christ's famous declaration, "I am the light of the world."

Secret Messages?

Leonardo's most famous work, the *Mona Lisa*, is full of symbolism. The veil that the woman wears could symbolize widowhood. It could also symbolize chastity, which would have been appropriate for a married woman. The winding path shown in the background behind her could be the so-called path of virtue (from a myth about Hercules), and if so would indicate that Lisa was most likely a wife, not a mistress. It has also been suggested that the *Mona Lisa* is actually a self-portrait of Leonardo as a woman.

Leonardo's interest in codes and hidden messages has caused people to scrutinize his works, especially the *Mona Lisa*, for any sign of hidden meaning. For instance, Lisa's dress has a neckline with numerous small detailed loops, which have been searched for any signs of hidden meaning, to no avail.

Historians have also searched the sheet music held in *Portrait of a Musician* for hidden puzzles, but without success. Did da Vinci deliberately design secret meanings into his paintings, or are modern historians (and popular novelists!) chasing a question that has no answer?

chapter 7

Leonardo's Sculptures

During his apprenticeship to Andrea Verrocchio (1468–1472), Leonardo learned how to paint—but his education didn't stop there! He was exposed to many different aspects of arts and craftsmanship, including three-dimensional techniques such as castings and sculptures. Leonardo was a bit biased in that he considered painting to be the true sign of genius in an artist, but sculpture was also a required part of his training. He viewed sculpture as being more mechanical, whereas he saw painting as more expressive and creative.

A Bit of Background

Sculpture is as old as dirt—literally! The world's first known sculptures come from prehistoric times, long before it was formally codified into an art. Some of the world's first cultures, including those during the Stone Age, made freestanding statues from materials such as ivory and clay.

Most of Leonardo's sculptural work centered around animals and humans, but he was certainly far from the first to create such sculptures. Early sculptures were primarily of animals or religious figurines, but statues of people date back thousands of years. One of the earliest examples of a human statue is known as the Venus of Willendorf; she dates to 30,000–25,000 B.C.

Early Sculpture

Ancient Sumerian and Babylonian cultures furthered the production of sculptures. They primarily used materials that were locally available; these included clay and terra cotta. The carved marble sculptures which were common during the Renaissance and the baroque period were not popular during the Sumerian heyday of around 3000 B.C. These sorts of hard stones were simply not found in the region.

Later, Egyptian sculpture was focused on representations of the deities, both those on earth (the Pharaoh was typically seen as a god) and those in the heavens. One of the most well-known Egyptian sculptures is that of the Great Sphinx (2500 B.C.), which resides near the Giza pyramids. Made of soft sandstone, it was colossal in nature, about 240 feet long by 60 feet high.

Stone statues became more ubiquitous during the period when Aegean cultures, such as the Minoan and Mycenaean, became more developed. There are many known sculptural artifacts dating to this period, about 2500–1500 B.C. Some are of musicians and other humans going about their daily tasks, and others are of religious figures.

Sculptural Revival

The Renaissance brought about a new interest in all things pertaining to ancient Greece and Rome; a revived interest in ancient sculpture was a part of this trend. Roman sculpture took on many different forms: free-standing sculptures, three-dimensional portraitures, and sculptural reliefs that adorned everything from temples, to monumental arches, to funeral sarcophagi. Roman sculptors were known for producing very detailed work, indicating the high level of skill that Roman artists attained.

Greek sculpture provided yet another set of amazing examples for Renaissance sculptors such as Leonardo. Sculptures produced during this period, including *Kritios Boy* and *Diskobolus*, focused on ways to accurately show the body in motion. These two statues in particular showed the human form in the throes of physical activity—leaning, bending, and curving. The attention to correct musculature and anatomy was a breakthrough in sculptural depiction, and certainly served as an inspiration to Leonardo's own later studies.

Portraits or Bust!

Portrait busts were probably first created in early Egyptian civilizations. Somewhat morbidly, this incredible type of sculpture started out as a funerary tribute; sculptural portraits were created to honor those who had passed away. Unfortunately, since many of these busts were buried with the deceased, they weren't around for people to enjoy. Up through the Roman period, portrait sculpture was still created largely for funerals; busts would be placed alongside urns, and they would be placed together into the communal tombs of the day.

Sculpture to Celebrate

In the later Roman period, the notion of "public sculpture" started to become more popular. Military leaders, kings, and other political leaders were commemorated via sculpture, and these were often placed in public forums. Generally, the purpose behind these sculptures was political; great leaders were celebrated, and they were used mostly as propaganda for the current

regime. Of course, these were usually commissioned by the royal family, so they were self-serving to a large extent. But that doesn't take anything away from their artistic value, or the role they played in sculptural history.

Facial Expressions

Leonardo's early experiments with sculpture focused on the human emotions. During his early sculptural period, the early 1470s, Leonardo created several busts of women demonstrating various expressions, including smiles and laughter. His interest in mathematics probably enhanced his ability to create geometrically precise sculptures and busts.

The Tools of His Trade

What tools would Leonardo have been using in his sculptural endeavors? First off, since most Renaissance sculpture was made of stones such as marble, the stone had to be acquired. Stone had to be quarried and transported to an artist's studio, and this was no easy task; imagine having to haul a life-size hunk of solid rock across the city in the days before trucks!

Hammer and Point

Stone sculptors had to be trained in a variety of tools and techniques. The main method, called "hammer and point," had been around since the ancient Greek days and was fairly well-established during the Renaissance. Sculptors used chisels, mallets, and other specialized tools as they worked with the stone and shaped it into their desired form.

FACT

Experienced Renaissance sculptors would get into a rhythm of swinging the mallets and hammers on a regular beat; some have equated the art of sculpture to playing a musical instrument. Care and awareness are certainly required for both!

Bronze Technique

Bronze sculptures were somewhat easier in that they didn't require removing large chunks of the earth, but they involved their own difficulties. To sculpt in bronze, the artists typically made a wax model, in full scale, of their design. They would cover the model in clay, remove the wax and then fill the shell of the design with hot liquefied brass. Sculptors would then reshape pieces as necessary, and add the finishing touches by hand.

Another material used in some sculptures was plaster. Plaster is a compound made from mixing gypsum or lime with sand and water; when hard, it forms a smooth surface that can be painted or otherwise colored.

QUESTION?

Did Renaissance artists invent plaster?
Not even close, although they did use it in some imitations of Roman friezes. Egyptians used a form of plaster as a surface to be painted upon, but the Romans are widely attributed with popularizing plaster. Roman art and architecture made heavy use of plaster; they covered both wall and ceiling surfaces with painted plaster relief.

It's apparent that learning the art of sculpture was no easy task. It required years of study just to master the techniques. Leonardo was so good at so many other areas, it's possible that mastering sculpture would have simply been an overload; his focus on painting necessitated less time for other arts.

Leonardo's Theory of Design

Many Renaissance sculptors took inspiration from the classics. Michelangelo and Raphael, for example, studied classical proportions, styles, and technique. You can see classical motifs in much of their work. Leonardo, on the other hand, was much more of an individualist. Since he didn't have much schooling, maybe he just never learned to imitate from precedent. Whatever the reasons, you can see his personal style in all of his work, particularly in his approach to three-dimensional art.

Models as Tools

Sculpture, for Leonardo, wasn't just about the final result. He also used sculptures to enhance his paintings. That may sound a bit odd but, for Leonardo, it was an amazingly successful technique. Leonardo made clay studies of things like draperies, which he then used as models for his paintings. He most likely used this technique primarily in his early works, such as the draperies on the angel he painted as part of Verrocchio's *Baptism of Christ.*

Studying the Model

This idea of using a physical model to help with another version of the work is one that has had a great influence on today's artists and architects. In architectural school programs, for example, students learn very early on that they need to build "study models" for their designs; they use cardboard, foam, and other building tools to create a scale model of their actual project. This model allows students to present their ideas to peers and teachers alike, and brings an entirely new dimension to their paper drawings.

Architectural firms routinely build finely crafted scale models of buildings; it helps them to study their ideas, and to present the finished design to their clients. There is something tangible about a physical model, and models portray space in a way that's difficult to convey through drawing alone.

Leonardo's methodologies have crept into nearly every facet of modern art and design. He certainly wasn't the first artist to use a study model, but because he was so careful and skilled, his use of models came to be imitated by future generations of artists. And what's good for the goose is good for the gander! Architects, interior designers, and artisans of all sorts study their projects in a variety of ways before their final execution—and much of this method can be attributed to the workflows of Leonardo.

An Early Marble Bust

Bust of a Woman with Flowers, created in the 1470s, was probably Leonardo's first professional foray into sculpture. He was something of a perfectionist and made numerous studies. The final version of this particular sculpture appears to be the first one modeled for a specific commission.

Bust of a Woman with Flowers is supposedly one of Leonardo's first marble sculptures. But did Leonardo really create it? Historians know that this sculpture was made sometime between 1470 and 1480, placing it squarely within the years that Leonardo worked with Verrocchio. Stylistically, it resembles Leonardo's work more than it does his master's; while this sculpture was originally credited to Verrocchio, experts now think that Leonardo was its primary sculptor.

Ginevra de'Benci

The bust in question was probably created from a live model, Ginevra de'Benci, who was also a model for one of Leonardo's early paintings in 1474. De'Benci, who came from an educated family of bankers, was one of the most famous female intellectuals and poets of her day. Leonardo probably painted the portrait for her marriage in 1474, as marriage portraits were fairly common in the early Renaissance. This sculpture may have been part of the same package.

This work is particularly significant because, unlike classical busts that typically only show the figure's head and shoulders, this one displays the figure's hands and arms as well. Just as Renaissance portrait paintings were starting to show people in three-quarter (rather than frontal) view, sculptures were also beginning to show more and more of the whole person. This transition relates back to the Renaissance focus on humanism. As society began to place more emphasis on the individual and his or her personal dignity, artists such as Leonardo embraced this new social movement by allowing more individual expression in artwork.

A Horse is a Horse, Of Course, Of Course

Whether it's yard gnomes, porcelain Santas, or pink flamingos, most of us appreciate some form of small outdoor sculpture. In 1483, Leonardo set about creating the largest statue the world had ever seen. His personal colossus was a design for an oversized equestrian *Statue of Francesco Sforza*. This truly grand project was begun in honor of Francesco Sforza, the father of Ludovico Sforza (Duke of Milan), one of Leonardo's patrons. At more than

twenty-five feet high, the statue would have been enormous, and was supposed to feature Francesco mounted upon a steed.

Leonardo Digs In

As we now know, sculpture was never Leonardo's favorite art. There are only a few existing sculptures known for certain to have come from his own hands. But this particular project probably interested Leonardo because of his fascination with nature and animals, especially horses. While this design was a Leonardo original, he probably took cues from the Roman statue of *Marcus Aurelius*; the notion of capturing a battle scene in sculpture definitely had precedents in Roman and medieval artwork.

Leonardo was a busy artist during the 1480s, and he had many projects underway. No surprise, then, that the Sforza equestrian statue was far from his only commission. Since his track record for completing projects was far from perfect, the Sforza family prodded him along, to keep the work moving.

ALERT!

As anyone working under a contract knows, it's dangerous to over-extend yourself when it comes to making commitments. It seems that Leonardo bit off more than he could chew sometimes, taking on several commissions that would often go uncompleted. In Leonardo's case, though, his work was of such a high quality that his reputation basically went untarnished. Too bad we can't all be like Leonardo!

The Evolution of Design

Leonardo's design process went through several iterations. One notable design featured the horse rearing. It would have contributed a highly dramatic effect to the scene, in addition to creating an unusually tall statue to honor the Sforza family. As it turned out, though, this idea was technically unfeasible. Leonardo would have had to design an entire structural system for the statue, and a complex one at that; it would have required structural support from a variety of sources. Historians who have studied Leonardo's

designs in present times have concluded that, even with the use of modern techniques, it still might not be possible to cast something so large supported only at two points.

While Leonardo had created many sketches and variations of the design by the early 1490s, he still hadn't built an actual statue. At this point, his patrons were getting impatient, so Leonardo had to hurry and create a full-scale clay model. It was quite a hit and was set up in the garden of the Palazzo Vecchio. People traveled from all over to see this enormous masterpiece, affectionately dubbed *Il Colosso*.

A Wondrous Study

The clay model itself did wonders for Leonardo's reputation. People all over Italy knew him as that crazy artist who'd made the fantastic tribute to the Sforza family. The final bronze statue should have been one of Leonardo da Vinci's crowning achievements. He even had to design special furnaces for the bronze casting, since none of the existing furnaces was even close to being large enough.

Despite the immense popularity of the design, it is not certain that this statue ever really could have been built, as there was no precedent at the time for casting a hollow-shell statue (close to two inches thick) on such a large scale. Leonardo and his workshop were in the middle of obtaining bronze (no small task for a statue that would have weighed more than sixty tons) when warfare demands intervened. France was invading Milan, and the bronze Leonardo would have used for the statue was cast into military equipment, such as cannons.

Adding insult to injury, Leonardo's treasured clay model for the Sforza statue didn't even survive the war. As the French encroached on Milan in 1499, French soldiers set up outposts near the Palazzo Vecchio. The clay horse statue was destroyed when the French used it for target practice! The bits that remained degraded slowly over time, and nothing of the original is left today.

Modern Realization of Leonardo's Dream

One of Leonardo's greatest disappointments could have been that his massive *Statue of Francesco Sforza* was never built. Leonardo's larger-than-life masterpiece from 1483 would have been the biggest equestrian statue on the continent. Imagine a twenty-six-foot-tall bronze horse and rider. If it would be spectacular today, imagine how amazing such a sculpture would have seemed 500 years ago!

Charles Dent

Now, fast-forward 500 years to an American airplane pilot named Charles Dent reading about the destruction of the clay model of Leonardo's masterpiece in a 1977 *National Geographic* article. Creating this horse sculpture quickly became Dent's obsession; he felt it would honor both Leonardo da Vinci and all of Milan. He wanted to donate the sculpture to the people of Italy in celebration of Leonardo's achievements. Dent, who was an amateur sculptor, set to work creating his own scale model of the horse.

In order to fund his project, Dent created Leonardo da Vinci's Horse, Inc., a nonprofit group dedicated to raising funds to cast the enormous equestrian work. When he died in 1994, Dent bequeathed a large amount of money to this foundation. From that point on, the project took off at a rapid pace. The group gathered funds in later years by selling smaller-scaled reproductions of Leonardo's horse.

Tallix Makes It

Eventually, a smaller model of the horse was sent to the Tallix Art Foundry for casting. They had planned to simply use Charles Dent's model and cast the new sculpture from it. Numerous problems surfaced, though, so the foundry decided to start over. The master sculptor was a woman named Nina Akamu. She had been trained in Renaissance art and sculpture, and was keenly interested in seeing the project completed. She spent at least a year researching the project, then another year creating a new scale model. This model was then upsized at the foundry to create the final bronze sculpture.

Akamu and her team at the Tallix Art Foundry proceeded to build a fifteen-ton, twenty-six-foot bronze of Leonardo's design. The similarity to the original work was retained, and observers later commented that the strength, poise, and force of Leonardo's original red-chalk drawings were preserved in the foundry's replica.

In deference to Dent's wishes, the magnificent sculpture was sent off to Milan. The giant horse had to be split into seven pieces for safe travel and welded back together in Italy. It was unveiled there in September 1999, where a grand ceremony accompanied its unveiling to the public. Many of the people who had worked on the sculpture accompanied it over to Italy; hundreds of artists and others associated with the project were in Milan for its presentation. Their skills were also needed in Milan, since the weld joints had to be sanded and smoothed after the horse was fused into its final form.

Akamu's horse was actually cast twice, and a second copy was created with all the quality of the original. This second version was bought by the Frederik Meijer Botanical Gardens and Sculpture Park; it currently resides there in Grand Rapids, Michigan. This version is known as the "American Horse."

FACT

The Frederik Meijer Botanical Gardens and Sculpture Park is owned by the same Frederik Meijer who created the national grocery store chain. These stores are based in the American Midwest, and the garden itself is in Michigan. Check out ✎www.meijergardens.org for details.

These sculptures represented a tribute to Leonardo's legendary skill and ability, and the first casting became a source of pride for the Milanese people. Italy suffered greatly with the original clay model's demise, and Leonardo's own ego was probably tarnished by failing to complete this enormous project. Supposedly, even Michelangelo teased him about his unfinished horse. This 1999 sculpture from the Tallix Art Foundry righted previous wrongs to help bring a sense of completion to Leonardo's legacy.

Other Equestrian Works

Few of Leonardo's sculptures were ever completed, and of those that survived, it's often difficult to know which works are actually Leonardo's. Collaboration was common in the Renaissance, and Leonardo belonged to Verrocchio's workshop for years, and then had his own students afterwards. One of the few pieces about which there is no doubt, though, is a bronze statue called *Horse and Rider*. It dates with relative certainty to Leonardo's late years, 1516–1519. During this period, he made several models of horses for the King of France, François I.

This particular statue, featuring a horse rearing up on its hind legs, looks remarkably like other horse-and-rider sculptures Leonardo made earlier in his career, such as the *Statue of Francesco Sforza*.

The Trivulzio Statue

Leonardo was also involved with a horse-and-rider sculpture created for the funeral monument of Gian Giacomo Trivulzio (1441–1518). Trivulzio hailed from Milan, and was a military leader during the tumultuous Italian Wars. Like many of Leonardo's clients, Trivulzio was a high-powered noble in the Milanese elite, and initially served under Ludovico Sforza. Trivulzio later switched sides, though, to join the French. His allegiances were somewhat varied, but it appears that he came from a family of mixed patriotism; several other family members aligned themselves with both Italy and France. Gian Giacomo became the governor of Milan under the reign of Louis XII, and fought in several important military battles.

During the Renaissance warring years, it was fairly popular for wealthy families to switch sides mid-war. Trivulzio's family was just one example; they were loyal Italians, but only up to a point. Joining ranks with the French, when the French were winning, was accepted because so many noblemen chose to defect rather than lose. Loyalty to country was not as important during the Renaissance as it was during other historical periods.

Another Incomplete Act?

From the sketches, we can tell that this sculpture would have been quite a spectacle, having a marble base and eight other figures. The horse would have followed the same basic design as the aforementioned Sforza monument, only with a more dynamic posture. There is no evidence, however, that the work itself was ever completed. There is documentation to show that Gian Giacomo Trivulzio commissioned this statue himself, probably in 1511, but there aren't any actual sculptures or models of a finished product. It's possible that the work was completed but destroyed. It's also possible that Trivulzio changed his mind at some point and decided against this honorary statue; the more likely explanation, however, is that it was simply an unfinished project.

If, at this point, it's beginning to seem as if Leonardo rarely completed *any* of the sculptures he concocted, this isn't the case. Fortunately, it's nearly certain that Leonardo sculpted other pieces that were indeed finished, such as *The Young Christ*. Leonardo worked on this terra cotta statue between 1470 and 1480, roughly the same period during which historians believe he created *Bust of a Woman with Flowers*.

Team Efforts

In addition to these accomplishments, Leonardo worked on sculptures executed mainly by others in his workshop, such as *St. John the Baptist Teaching*, a bronze completed in 1511. Giovanni Francesco Rustici, a student who was originally in the Medici Garden, sculpted this statue in large part. Lorenzo de Medici took a particular liking to Rustici, and as a result, he was apprenticed to Andrea Verrocchio.

Leonardo and Rustici met in Verrocchio's workshop, and Rustici worked alongside Leonardo for many years afterwards. Rustici could have been famous by way of patronage to popes and kings but, unlike Leonardo, he didn't seem to have much ambition and preferred to be alone. Fortunately, since he came from a wealthy family, he had the luxury of more or less doing as he wished.

In the early 1500s, Rustici was working with a local merchants' guild commissioned to create bronze statues for the church of San Giovanni. The

star attraction was to be a sculpture of St. John the Baptist. As the story goes, Rustici refused to work with anyone except Leonardo, and the two artists probably designed and executed the statues together. At the very least, Leonardo provided design guidance for the younger Rustici's models. Collaboration was common in Renaissance artwork, and greater and lesser artists often worked together on projects. Rustici and da Vinci appear to have been close friends, driven by both a love of their craft and mutual respect.

Leonardo's contributions to the sculpture are evident in several areas, especially in the hand and finger positions of St. John. Similar positioning can be seen in other da Vinci works, such as his painting *St. John the Baptist*, created between 1513 and 1516. The finger pointing is nearly identical to that seen in the San Giovanni sculpture. It is also quite similar, in this respect, to another one of Leonardo's probable paintings, *St. John in the Wilderness*, which dates from 1510 to 1515.

chapter 8
Architecture

Leonardo da Vinci was not a practicing architect, though he spent years studying mathematics, urban design, and civil engineering. He designed a large number of military structures, buildings, and other architectural objects. Even though none of his designs was constructed during his lifetime, he was amazingly prolific. Leonardo's voluminous drawings, sketches, writings, paintings, and other artwork reveal his architectural achievements.

Building the Renaissance

Even masters such as Leonardo had to build their experience (and reputation) on the success of others. Leonardo's main sources of architectural inspiration were probably Brunelleschi, Alberti, Bramante, and Raphael.

Filippo Brunelleschi (1377–1446) provided an early architectural model, one that Leonardo continued into the Renaissance. Brunelleschi was one of the first architects to seize upon classical foundations in the creation of a modern architecture that could rival that of its ancestors. He designed churches such as San Lorenzo and San Spirito, which were based on Roman ideals of balance, harmony, and proportion. Leonardo took those ideas under advisement in many of his own architectural designs.

Leon Batista Alberti (1406–1472) was an architect, artist, and author who was also responsible for writing the Renaissance's first treatise on architecture. He based his designs on classical architecture, and it is likely that Leonardo studied Alberti's designs during his apprenticeship to Verrocchio.

Donato Bramante (1444–1514) was another primary Renaissance architect. As an official architect for Pope Julius II, he created masterpieces in the style of Greek and Roman classics, interpreting them in light of Renaissance Christian teachings.

Raphael (1483–1520), followed in Bramante's footsteps by becoming the next papal architect. He was known for adhering to a fairly strict system of classical spatial organization, and was the main architect for St. Peter's Basilica in the Vatican.

FACT

Raphael was also a distinguished artist. He painted a number of frescos in the Vatican palace, and other religious works such as his paintings of the Madonna and holy family. Pope Julius II specifically requested that Raphael decorate the Vatican.

Palladio

Although he came into the architectural picture later than Leonardo, Andrea Palladio (1508–1580) is also integral to understanding the path of

Renaissance architecture. Palladio was arguably one of the most influential architects of all time. Starting with aristocratic villas and palaces in his early career, Palladio spent much of his time researching and writing about the basic tenets of architectural form. His 1570 work, *I Quattro Libri dell 'Architettura* (*The Four Books of Architecture*) became an instant staple of any architectural education. He celebrated the ancient Roman methods, and also helped to create a distinct style of Renaissance architecture based on these classical tenets.

Architectural Techniques

Though not trained in architecture, Leonardo was familiar with architectural drawings. He presented his ideas in the formal drawings of architecture: plan, section, and elevation. These documents represent different views of a building, and architects use them worldwide. They are, in fact, the main way that architects and builders from different countries communicate with each other. Plan views take a horizontal cut about four feet off the ground and look down; sections take cuts vertically through a building; and elevations represent a building's "side view" from the outside.

In addition to learning the language of architects, Leonardo used the perspective techniques he developed in painting to represent his designs for palaces, churches, cityscapes, and other projects. Particularly with landscapes, Leonardo was fond of drawing "bird's-eye perspectives." While typical eye-level perspectives were drawn as someone on the ground would see them, aerial views showed a project from up in the sky.

With the bird's-eye perspective, Leonardo could show a project in its entirety, including the surrounding areas. Along with Michelangelo and Raphael, Leonardo was one of the first Renaissance architects to make use of this technique. In the days before airplanes, the ability to visualize a scene from overhead was a rare and useful talent.

While synthesis of form and structure can be a goal for many architects, it is not a given. As both an artist and a student of mathematics, however, Leonardo had the distinct advantage of being able to conceptualize a project in its entirety. He was interested in appearance, as well as structure and construction. Leonardo's talent for encompassing both areas in his studies set him apart from many of his predecessors and paved the way for more modern ways of thinking about architectural design.

The Milan Dome

During his major period in Milan (1482–1499), Leonardo was busy with assignments from his patron Ludovico Sforza, the Duke of Milan. His artistic accomplishments during this time include *The Virgin of the Rocks* and *The Last Supper*, paintings that earned an esteemed place in history for their beauty, innovation, and highly skilled production. This was a time of major experimentation for Leonardo—he produced paintings, sketches of military equipment, sculptures, machinery prototypes, and architectural designs.

Early Designs

One of Leonardo's most significant ventures in architecture occurred in 1488, when he created a preliminary design for the dome and tambour of the Milan Gothic Cathedral. This massive cathedral was a huge undertaking, not just for Milan but for much of Italy. Built over a 500-year period, the cathedral brought the High Gothic style to Milan. It is the central focus of town, with most streets ending at its doors.

Work on the cathedral, which is located on the same site as the original St. Maria Maggiore, began in 1387. As political and religious power continued to change hands over the years, new designers and master masons were invited to work on the cathedral, which would be a living tribute to the creativity of Italian artists. Political and financial messes slowed down the project, though, and the great spire wasn't constructed until the mid-eighteenth century; additional spires and stair towers were built during the nineteenth century. By this point, some of the original work was already crumbling. Restoration was necessary, and that task occupied much of the early twentieth century.

A Feat of Engineering

The original chief engineer, Simone da Orsegnigo, came up with a vision for the cathedral that he was able to maintain across a disparate body of architects, masons, and other craftsmen. Another engineer, Nicola di Bonaventura, took over in 1389, and a stream of French and Italian master designers followed. During the end of the fifteenth century, the Sforza and Solari families exerted strong Tuscan influence over the cathedral's design during their powerful fifteenth-century tenures in Milan. The Solari family, based in Milan, consisted of artists and architects whose designs were prominent all over Italy. Giovanni Amadeo was slated to design the drum of the Milan cathedral, and despite the burgeoning presence of Renaissance architecture, he was determined to keep a strong tie to the site's Gothic roots.

Around this time, Leonardo da Vinci was consulted regarding several aspects of the cathedral. As usual, he wanted to involve himself in as many projects as possible, so he submitted drawings for the dome. At least one of Leonardo's contemporaries, Donato Bramante, also put in his two cents on the project.

ALERT!

Even though it was never built, Leonardo's design for the dome was an important marker in his career since, at this point, he was starting to incorporate studies of mathematics (particularly geometry) into his designs. The fact that he was tapped to design part of such an important national landmark is proof that he was well-respected, even relatively early in his career.

Multiple Skills

This project also brings to light Leonardo's famed multitasking. He studied many areas simultaneously and, in this case, they all applied to the same project. For example, Leonardo produced designs for several types of construction equipment, and his ideas for cranes were particularly useful for this dome project. He understood the construction difficulties inherent to

church domes, and he included sketches of lifting devices with his drawings for the dome.

Leonardo's interest in city planning came into play here as well. Plagues devastated Italy, particularly Milan, around 1484–1485. In some cases, entire buildings had to be permanently evacuated. As a result, many architects (including Leonardo) paid increasing attention to "healthy" town planning and urban design. Leonardo's domed design, then, was a response to society's clamoring for a healthy "town square" that also had strong religious underpinnings.

Order in the Church

The history of church design is a long and rich one. Religious structures are typically more permanent (and more respected) than any other type of building. Despite political and social turmoil, ecclesiastical architecture tends to survive. Ancient Athenians devoted their entire lives to constructing the Acropolis; the Parthenon, the Erechtheion, and other Greek temples were models of religious fervor coupled with civic pride. It's hard to think of a comparison today, since we now have so many different religions and beliefs within a single culture. The Romans built arches and monuments for their emperors who, many Romans believed, had ties to the gods themselves. Medieval French architecture, as demonstrated by Chartres Cathedral and others, celebrated Catholicism with amazing feats of Gothic engineering.

Rules of the Road

Across time, culture, and geography, churches and other religious edifices have provided opportunity for social consciousness and pride; they've also fascinated designers. Church designs were of particularly high importance because of their enduring influence. During the Renaissance, the principles of architecture were crystallized into treatises. Leonardo most likely read and studied these works, and the strict series of rules they presented probably influenced his rigorous church designs.

Through his drawing, painting, and architecture, Leonardo was devoted to showing the order and articulation beyond what was visible. In the 1480s, Leonardo made pages and pages worth of sketches for various

church designs. His notebooks include designs for multilevel structures and churches with domes, but he seems to have experimented most intensely with the central-plan church. (Brunelleschi's churches made use of the central-plan design, and his designs probably influenced Leonardo.)

Leon Battista Alberti's *On the Art of Building in Ten Books* (first published in 1485) is a particularly significant text. This manifesto defined both symbols and usage, and was central to changing the perception of architecture from a craft into a true profession. Leonardo must have studied this work, because his sketches of religious architecture embody many of its principles.

Leonardo's Take on the Greek Cross

The basic idea for the central-plan design involved a focal point for the church—a square, circle, or some other variant—from which other rooms radiated outward. Leonardo made many sketches of the Greek cross, a three-dimensional cross shape where all legs were of equal size. His drawings are filled with complex geometrical interactions based on the idea of a modular unit that was repeated and combined with other identical units. Proportions, directly derived from formal mathematical relationships, were also key in his designs.

The bilaterally symmetrical Greek cross, which Leonardo used in his studies, represented a shift from the medieval period; at that time, Latin cross plans were popular for their symbolic representation of the biblical cross which had one long and one short axis. While Leonardo's various church designs were never actually constructed, they are especially significant because they provided inspiration for later Renaissance architects. Bramante in particular probably studied da Vinci's church sketches, and several of his churches show evidence of Leonardo's classical sense of proportion and form.

In 1500, the building committee for San Francesco al Monte appointed Leonardo, and he made design recommendations regarding the structure and underlying foundation. Though he was best known during that time as

a painter, his engineering research earned him respect in many other areas of art and architecture. Later, while he was under the patronage of Louis XII (1506–1513), Leonardo was at the beck and call of the governor, Charles d'Amboise. One of these jobs involved another religious design; Leonardo produced sketches for Santa Maria della Fontana, a church that d'Amboise would have funded. Unfortunately, as with most of Leonardo's architecture, there's no record that this project was ever built.

FACT

While Leonardo da Vinci's own church designs remained un-built, he had many other associations with the design and layout of churches. For example, he designed many of his paintings for churches, so he knew where to place artworks and how to fit them into the surrounding architecture.

San Giovanni Church: Closer to Heaven

Leonardo became involved with the design of the church of San Giovanni. This church has enormous cultural significance for Florentines. In addition to housing a number of sculptural masterpieces, it's rumored that several famous Italian artists and authors were baptized here, including Dante.

Renaissance Florence was historically a family-run town. Powerful families dominated each region, and the Florentine system of government was more or less an oligarchy. By 1343, the city was divided into sections, or quarters: Santa Croce, Santa Maria Novella, Santo Spirito, and San Giovanni. Each quarter had its say in nominating officials and would eventually have a major church supporting its saint.

Baptistery of San Giovanni

The Baptistery of San Giovanni, located in what is known today as the Piazza San Giovanni, was a crowning achievement. It was created and named for the patron saint of Florence, St. John the Baptist (San Giovanni in Italian). Workers began construction on this building in the eleventh and twelfth centuries, and hundreds of years later it was still going strong. The basic design is

an octagonal structure faced with white and green marble. The most famous parts of the Baptistery are the bronze doors on the eastern side. These doors would eventually contain a number of sculptural scenes from the Bible. Their first designer, Andrea da Pontedera, worked on this project in the 1330s. This was the first time artists had attempted to cast sculptural bronze at this scale. At twenty-eight panels total, it was also a very large job.

Sculptural Doors

A competition was held in the early fifteenth century for sculptural panels on a new set of baptistery doors. Lorenzo Ghiberti beat out Brunelleschi for this honor, and saw his panels hung in 1424. Ghiberti received the honor of creating the remainder of the work, and this project kept his shop busy well into the 1450s.

Although he wasn't involved in the design, Leonardo probably played an advisory role during the creation of the sculptural doors. In the winter of 1507, he was called to Florence to aid a sculptor, Giovanni Francesco Rustici (1474–1554), with a project for the Baptistery. The three bronze statues of St. John, a Pharisee, and a Levite are located on pedestals above the north doors. Judging from the sculptures' anatomical precision, Leonardo either worked on them himself, or at least developed detailed sketches for them. See Chapter 7 for more information on this project.

Moving On

But Leonardo's work on the Baptistery didn't end there. He later got involved in a second round of work that was more monumental than the first: Leonardo developed a scheme for transporting the building! Believe it or not, he actually proposed a plan to lift *and* move the entire Baptistery of San Giovanni. He had the idea that elevating the structure so that it would sit upon a marble base would make the church more authoritative and divine. Needless to say, this project would have required an enormous engineering effort. Leonardo's notebooks describe models and preliminary designs, as he often made models to work out the principles behind his ideas.

It's not clear whether or not Florence's church or city officials ever solicited this radical undertaking. One thing is for sure, however: During the time Leonardo was in Florence, his notes suggest that he was pressuring the

council with increasingly elaborate designs meant to improve the church. He probably brought this idea to powerful citizens and those on the church board. He was so persuasive that they may have actually considered Leonardo's suggestions. Once Leonardo left Florence, though, people quickly realized that his plans weren't feasible. Although modern technology certainly allows engineers to entertain these sorts of possibilities, Leonardo's ambitious scheme was well beyond the capabilities of the day.

Designs for Other Public Structures

Most of Leonardo's architectural designs were for cathedrals or entire cities, but he also worked on a variety of smaller-scale public projects. Unfortunately, like his church designs, most of these public designs were never built. Leonardo employed his creative talents to design many public buildings with the goal of improving functionality and enhancing city dwellers' lives. He also included elements based on ideas of symmetry and balance, just like those he used in his designs for religious buildings.

A Wide Range of Projects

Leonardo designed to extremes. Some of his projects were on a grand scale and full of elaborate detail, while others were more pedestrian in nature. One of his more mundane designs included a sketch of a horse stable with arches and columns supporting a vaulted ceiling—quite a well-designed horse habitat! Designed between 1487 and 1490, the layout for this early project included three lower-level arcades and a number of air-circulating openings outside the building. The stable's design was important for ensuring a positive environment for the horses, which were essential for both the military and for the city's general public.

In one of his more elite forays, Leonardo designed a palace with a series of multileveled porticoes. He designated the light and airy top levels of the palace for the upper classes, leaving the roads and paths that extended through the lower levels for the merchant classes. He reserved the roads through the base of the structure for transporting animals. The height of the palace was equivalent to the width of the streets below it, and he added porticoes and windows to improve airflow through the structure. In spite of

its intricacies, Leonardo's design also had more pragmatic intentions; it was an attempt to ameliorate the narrow, crowded conditions on Milan's existing streets, which many designers and scientists of the day believed had actually contributed to the plague that killed almost a third of Milan's population between 1484 and 1486.

FACT

Along with his stable design, Leonardo also included notes on how to run a fresh, orderly stable. Was Leonardo an overbearing "mother hen," or just keenly interested in all aspects of the design process? It's clear that Leonardo had respect for all living creatures, and thought that even horses deserved a clean and elegant living space.

Chambord

During his time in France with King François I, it's thought that Leonardo helped design the king's chateau, Chambord. Construction took place between 1519 and 1547, and Leonardo probably worked on initial plans for features such as a double spiral staircase. This special stair was similar to the four-ramp staircase that Leonardo had designed for a military fort. Reportedly, the two paths of the spiral staircase allowed the king's wife to take one route, and his mistress to take another, which meant there wouldn't be any unpleasant chance encounters.

Leonardo also sketched houses and places he visited. One such drawing was the layout of a house in Vaprio d'Adda called Villa Melzi. The family of his student and later companion, Francesco Melzi, actually owned this residence; Leonardo stayed at their home for a period in 1513. One of the sketches is annotated as a room in the tower in Vaprio, and the sketches also include the layout of the nearby fortress of Trezzo.

Other Public Works

Leonardo's public projects include work he did in 1492, with Ambrogio da Cortis and Bramante, to rebuild the public marketplace in Vigevano. While today the city of Vigevano boasts that Leonardo designed their public square,

in truth, other individuals designed all of the surrounding buildings and ornaments. While Leonardo probably worked on the general design, it's possible that only his plans for the plaza's overall proportions were fully realized.

In 1518, Leonardo began one of his last architectural projects, studying the topography of the Loire River Valley, in France, for a royal fountain he was designing. Like so many of his other projects, however, this fountain was never built.

He Built This City

Urban design was of major interest during the Renaissance. Cities were becoming more rigidly controlled. It was important that towns had a place for people to gather for both political and social events, which gave rise to the formation of the town center. The public space, or *piazza* (plaza), was one of the most common architectural elements during the Renaissance. Piazzas presented a contrast to private structures, which did not promote social gathering or draw the town together in any way. Also added to the mixture were defense towers and palaces, which were also common during the fifteenth and sixteenth centuries as key symbols of a family's wealth and influence.

Protective Design

Medieval city-states were constantly vulnerable to barbarian invasions; they went through several periods of growth, destruction, and rebirth. Following the invasions, family groups such as the Medicis and Sforzas exerted their financial influence over just about everything: local politics, religion, and culture. Urban design stood out as a new and important field, and Leonardo had a major role to play.

Renaissance design influenced the set-up for Milan's city center, as was the case for so many other European cities. Its major structures are the Castello Sforezsco and the Duomo cathedral. Although the architects of that

time were working on Renaissance-style designs, they also focused much of their energy on continued construction of projects that had begun in the medieval period, such as the Church of San Giovanni in Florence. Just like the artists of the time, Renaissance architects looked to classical Rome for inspiration, and a mandatory part of the architectural apprenticeship usually included a trip to Rome to study the ancient orders.

City Planning

Somewhere along the way, Leonardo developed a taste for urban design. His notebooks are filled with sketches of not only buildings, but also bridges, tunnels, streets, and entire cityscapes. As Milan's population grew, Leonardo sketched out a proposal for separated "satellite" cities that would surround a central core. Sounds like suburbia, doesn't it? Leonardo based this particular idea on a concern for the health of Milan's citizens.

QUESTION?

Why was Leonardo so concerned about health?
Milan was hit particularly hard by a series of plagues between 1484 and 1485. As a result, Leonardo started to think about a "healthy design" for an ideal city that emphasized cleanliness and hygiene. Some of Leonardo's suggestions included wider streets, more space in between buildings, and an anatomically based "circulatory system" of roads that would allow for better air passage.

Applying his humanist, classical training to urban design, Leonardo came up with a system of proportion whereby city streets had to be at least as wide as the houses were tall. While Leonardo's goals of cleaning up Italy were certainly admirable, it's evident today that his schemes were inadequately engineered. Still, his sketches of separate transportation passageways for horse-drawn wagons and foot travelers prefigured developments of modern city planners.

Upper and Lower Italy

Leonardo also proposed the idea for a multilevel city where workers and craftsmen would literally function beneath the wealthy, the clergy, and others with more noble stature. How would *you* like to live under your boss' feet? For these studies, he likely drew on his knowledge of other architects, including Alberti and Brunelleschi, who had produced similar ideas. In suggesting this population division based on social status, Leonardo prioritized the city over its occupants—perhaps not a bad idea in theory, but it probably didn't go over very well with the people who would have lived there!

Imola

Leonardo was also a pioneer in the field of cartography, particularly in the production of accurate city maps. His map for the town of Imola, produced during his time in Florence around 1502, is thought to be one of the first geometrically precise town plans. This plan may have had strategic importance, as notes included along with the drawing contain distances and directions to various locations in Imola.

Romarantin

As one of his last architectural designs, in 1515, Leonardo outdid himself when he submitted a plan for a combined city and palace complex to François I in Romarantin, France. This design, contained in the *Codex Arundel*, would have created a scenario similar to his ideal city. The sketches show bridges, canals, and a multilevel city center with underground traffic tunnels. Leonardo's design, yet again, was never built.

General and Life Sciences

In addition to working on many projects related to painting and architectural design, Leonardo devoted much of his time to studying the sciences. He based his theories on observations of the natural world and then attempted to explain and understand his observations. In this regard, Leonardo was the first of the modern scientists, since his methods were a sharp contrast to the medieval world. Leonardo's observation-based techniques were much closer to modern science and the scientific method. In addition, his anatomical studies revolutionized the study of medicine.

Observe and Understand

Leonardo's interest in flight led him into the world of engineering, where he invented a number of flying machines. Can you imagine Leonardo flying a helicopter over the streets of Milan? He also spent time as a military engineer, inventing a number of new weapons and defensive mechanisms. His other inventions ranged from improvements in the printing press to a diving apparatus that would allow swimmers to breathe under water. Many of his inventions were never built and were, in fact, beyond the technological capabilities of his time. However, some of his designs—his parachute, for instance—have been built in modern times, and they work quite well. Clearly, Leonardo's scientific thoughts were far ahead of his time.

ESSENTIAL

Leonardo spent his childhood immersed in nature, both observing and sketching what he saw. As an adult, he asked questions and sought answers to the mysteries of the world around him. His investigations led him to study anatomy and zoology. He performed detailed dissections on both animals and humans. He was also interested in botany and geology and the behavior of water as a fluid.

Leonardo the Scientist

Leonardo's scientific pursuits have earned him a firm place as the first of the true modern scientists. In fact, if he hadn't also been such a talented artist, he might be remembered as a scientist who "sketched a little" on the side. Leonardo was uniquely placed historically, bridging the gap between the hocus-pocus of the medieval period, and inquiries of "modern" science. At the end of the Dark Ages in the fifteenth century, the scientific discoveries of classical Rome and Greece had been largely abandoned in favor of biblical teachings, which were taken as literal truth by most of the population.

Leonardo broke with this tradition by actually asking questions, and from his earliest days, he made detailed observations of the natural world

around him. This work soon led to a desire to understand and predict, rather than just describe. Leonardo's tenacity and his varied interests allowed him to make important observations and discoveries in a wide range of scientific fields, from anatomy to zoology.

FACT

Leonardo's scientific studies were far-ranging. His studies of the motion and the behavior of fluids (such as water) were impressive. He investigated plants, animals, and geology. In addition, Leonardo made notes on astronomical topics, such as the nature of the moon, sun, and stars, and the formation of fossils.

Science Over History

Now for a contrast: While one of the hallmarks of the Renaissance was the rediscovery of writings from ancient Greece and Rome, Leonardo based very little of his work on classical discoveries. Perhaps because of Leonardo's preference for doing things his own way, or perhaps because he lacked knowledge of Latin (the language in which the ancient Roman works were written), he wasn't constrained by classical methods and insights. Instead, Leonardo built up his own views and methods of scientific inquiry and organization. Fortunately for us, he was usually right.

Although Leonardo's observation-based method seems simple to us today, keep in mind that his technique was revolutionary in his day. He would ask a seemingly simple question, such as "How do birds fly?" and then spend weeks or months making painstaking observations. These observations would include watching birds in flight, sketching birds in various poses, observing live birds close-up, and dissecting birds to understand their musculature and anatomy. He then translated his notes into a more general theoretical understanding of aerodynamics and flight. Leonardo, being the hands-on type that he was, then designed flying machines that would give humans the same experience as birds. He certainly was not one to back away from a challenge.

Drawings Plus Text

Leonardo also pioneered the technique of scientific illustration, which in turn led to the modern-day concept of illustrated textbooks. He filled many of his notebooks with meticulous sketches, accompanied by detailed notes, of various anatomical or mechanical principles. Unlike his predecessors, who relied on long-winded explanations, Leonardo felt that his sketches and drawings were the primary tool in illustrating his various points; his written notes were actually secondary. Sometimes a picture really is worth a thousand words!

Leonardo's Role

For these reasons, Leonardo was a major player in the scientific revolution and was crucial to the creation of science's new descriptive process. Leonardo's main technique was to frame a scientific question or idea, and then make repeated, careful observations to try to shed light on the answer. His approach actually formed the basis of the modern scientific method.

Leonardo was interested in more than the common good—specifically, his own good. He collected various observations in his notebooks in the hope of eventually publishing them into an encyclopedia of his knowledge. Unfortunately, as with so much of Leonardo's work, this dream never came to fruition and such a work was never published

FACT

Since so little of Leonardo's work was published during his lifetime, many of his scientific achievements were unknown to the scientific world until centuries after his death. Their rediscovery made it possible to see just how prescient Leonardo was in so many different fields of science.

The Human Body

Leonardo da Vinci was a man who could appreciate a great body. During his lifetime, the field of medicine was becoming more important, and artists such as Leonardo were increasingly fascinated with drawing the human

body accurately. In Leonardo's case, he went a step further to figure out how the bodily systems beneath the surface worked.

Leonardo's early paintings were studies in a new humanistic style of art, and he was far ahead of his contemporaries in this regard. The best example is his *Vitruvian Man* drawing of 1490. It broke barriers because it was one of the first accurate expressions of the relationship between the human form and geometrical proportions. He developed and refined the techniques of sfumato and chiaroscuro specifically to deal with the new approach to realism. Leonardo gradually stood further and further apart from the field; after all, how many artists invent their own techniques to solve a problem?

FACT

Many of Leonardo's other sketches define human anatomy with an unprecedented degree of detail. His drawings of the human ribcage, spine, and coccyx are highly accurate. He also rendered sketches of nudes in various positions, indicating a significant understanding of how the human form worked in motion.

Leonardo never stopped trying to learn more about the human body. You might even call him art's first forensic scientist. Not content just to draw the body as he saw it from the outside, he strove to understand the human form from the inside. How far would he go to increase this understanding? Farther than was acceptable or even legal at that time. He cut up cadavers, and studied organs as well as skeletal substructures—all in an effort to draw and paint more accurately. Circulation and musculature systems intrigued him for the same reason. But what mattered most to Leonardo was the quality of his work, and he was willing to get his hands dirty—literally— to ensure that quality.

Studying the Human Form

Leonardo's interest in anatomy ran deep, both literally and figuratively. He spent years researching the intricacies of how our bodies function. He could have written the first version of *Gray's Anatomy*. In 1489, he started work on a notebook focused specifically on anatomy. He studied all parts of

the body, especially the brain and eyes. He sketched skulls in cross-section, showing both an amazing understanding of the visible and an interpretive ability to figure out the unknown. His drawings demonstrate a clear relationship between eyes, nose, teeth, jaw, and vertebrae. To make things even more clear, Leonardo detailed most of his anatomical sketches with notes and measurements—almost like an architect doing construction documents.

Leonardo also paid particular attention to musculature, as we can see in several of his sketches. Some of his earlier anatomical drawings show extremely muscular men (perhaps indicating his own preferences!), while later sketches focus more on anatomical detail. A series of shoulder drawings from 1511 show tremendous schematic detail on the layering of bodies, depicting skin, bone, muscle, and surrounding tissue as a complex web. Leonardo's paintings from twenty years earlier show this same fascination with the muscle groups, which create sculpted definition.

His interest in the head likely resulted from his studies of perspective drawing. He understood that people see things in different ways depending on their relative positions; his study of the human eye was a natural extension of his work in perspective drawing. One of Leonardo's sketches from 1489 compares the human head to an onion, perhaps referring to the layers of complexity.

FACT

The comparison of a head to an onion may seem wild to us today. However, during the Renaissance, medics often used "natural" remedies for various ailments. For instance, placing a roasted onion in the exterior ear was a common medieval treatment for an ear infection. Leonardo's comparison between a head and an onion wasn't so outlandish in his day.

Examining Life Through Death

Disease ran rampant during the fifteenth and sixteenth centuries. Plagues were common, including community bouts of typhoid, diphtheria, and smallpox. Vaccines for these diseases wouldn't begin to be

developed for hundreds of years. Although medical care was available during the medieval and Renaissance years, people with more money probably received better treatment. Death was just a fact of life in the Renaissance, and Leonardo was one of the pioneers who realized that to figure out how the body worked in life, he could examine it in death.

QUESTION?

Did Leonardo invent the autopsy?
No, but he was one of the pioneers of corpse dissection. As the doctors of the day were only starting to realize, the best way to truly learn about the inner workings of the human body was, simply, to take a look inside.

In order to study musculature and bone structures in the arms, legs, and other body parts, Leonardo dissected many corpses in the early 1500s. His subjects seem to have included a homeless woman who had been about nine months pregnant at the time of her death. One of his sketches shows a human fetus, complete inside a woman's body with placenta and uterus. Leonardo's drawings describe a curled fetus and umbilical cord as they lie inside the womb. However, in his drawings the unborn baby is a highly muscular infant. From this error, we can see that his factual knowledge was probably minimal.

Despite some mistakes, Leonardo was one of the first to draw the female reproductive system accurately, and his drawings are certainly the most detailed to come from the Renaissance period. He also drew detailed sketches of other systems and organs, including the human heart. He even made three-dimensional models of human body parts based on his studies of cadavers.

Studies of Human Systems

Leonardo approached the study of the human body in the same way that he looked at architecture: He saw the totality of the whole as being more than just a series of parts. His sketches and proposals in urban design, for example, presented an entirely new way of seeing a city. More than just buildings,

a true urban scheme also had to recognize traffic flow patterns, health concerns, transportation, and the occupations of the city's residents.

A viable city plan needed more than structural integrity but also correct form, proportion, and harmony. For Leonardo, cities were like the human body: a whirlwind of movement, energy, and life all wrapped up in a perfect container. In other words, cities could be a perfect symbiosis of built and natural form. His work on the systems of the human body took a similar path.

Brave New World

Leonardo's work, detailing the nature of organs that had been previously undefined, was quite daring for the time. Renaissance clergy and others were of the mindset that the heart was some sort of spiritual element, not just a muscle like any other in the body. Although Leonardo explored science in rational, realistic terms, he did not dismiss spiritual notions. He always acknowledged the divine in his scientific studies, marveling at the complex beauty God had created.

It wasn't just the body itself that interested Leonardo; he plunged deeper inside to study blood circulation and the heart, first in the 1490s, and again about twenty years later when he produced many drawings that detailed human circulation. Leonardo never figured out the exact connection between blood flow and the heart muscle, though. He used his studies of animals (and later, humans) to map out the basics: the heart was a four-chambered muscle that was somehow connected to the pulse that you could feel in your wrist. Pretty amazing, isn't it, that a Renaissance artist was also an amateur physician? Leonardo also figured out that arteries could become overfilled and that this situation could lead to sickness or even death. And so he actually predicted the concept of clogged arteries—an ailment that would become a major medical focus in later centuries.

Reproduction (The Human Sort)

And now on to the nitty-gritty details of Leonardo's art: sex! Leonardo was very interested in human reproduction. He initially thought the male reproductive organs had a direct channel that went straight to the heart and lungs and, therefore, the brain.

As mentioned earlier in reference to the heart, the popular view during the Renaissance was that bodily organs represented divine, spiritual entities; this idea was considered a truism for centuries. In keeping with this tradition, Leonardo considered the main outputs of the male sex organs as, essentially, sperm and "spirit." He also believed that the human heart was a spirit.

Nice idea, but he quickly realized that this approach was wrong because it could not be proven. The idea of a "spiritual channel" could simply not be borne out by the cold, hard evidence that Leonardo personally witnessed. His anatomical explorations showed the true connections between body parts, and revealed no evidence of such a spiritual channel.

FACT

This idea originated with Hippocrates, a Greek physician from the fifth century B.C. and one of the founders of modern medicine. Hippocrates also believed in approaching the body as a whole organism and thought that both the cause and effect on the rest of the body should be considered when treating medical ailments. He actually wasn't far from modern holistic theories.

Fawning Over Flora

Leonardo began his long history of drawing animals by studying them in nature. From his earliest years, before his apprenticeship to Andrea Verrocchio, Leonardo spent hours studying the landscape and watching how animals moved. This was, it turned out, time well spent!

Many of his paintings show different animals, some moving and some standing still. The *Adoration of the Magi*, for example, includes horses, a camel, and a mysterious third creature that Leonardo never finished. He also sketched an iconographically significant lamb in *The Virgin and Child with St. Anne*, though he himself may not have painted that particular portion of the work. The lamb's folded legs and craning neck give the painting a very realistic look—which wasn't common in Renaissance painting.

The horse was one of Leonardo's favorite animals. We know about his obsession with them because they're the animal he sketched the most. He

drew them standing, sleeping, and in various states of motion. He also modeled them in three dimensions, including the never-completed *Statue of Francesco Sforza*, as well as many smaller bronze horse models that he gave to his final patron, King François I.

Animal Details

Leonardo's notebooks also prominently feature cats. He wrote stories about cats and sketched them in precise detail. He drew felines in a variety of positions, both asleep and in motion. Leonardo gave a cat the central focus in at least one of his paintings, the *Madonna with the Cat*. While there are both preliminary sketches and an actual painting, no one's sure that Leonardo worked on both. The sketch, which likely came from Leonardo's own hand, is based on a Christian nativity theme.

FACT

Leonardo also painted other animals at different points throughout his career, including pigs, bears, goats, birds, and dragons. There are also drawings of several animals that looked like either crossbreeds or completely fictional beasts. When you're a famous artist, you can get away with just about anything!

A little bit of knowledge can be a dangerous thing, but the *lack* of knowledge is definitely worse. Luckily, Leonardo had the insight to realize what he needed to work on. What is unique about Leonardo's drawings of animals is that he applied the same principles of geometry and proportion to them as he did to his architectural drawings. He made notes, for example, about how a horse's ear should be one-fourth as long as its face. He also studied the movement of birds in flocks and tried to rationalize their tendency to fly in circles.

When he wanted to paint animals as accurately as possible, Leonardo knew that he would have to learn more about how their bodies functioned. His notebooks tell us that he made several visits to slaughterhouses. His sketches contain studies of dissected animals, including some highly

detailed drawings of pig hearts. It seems that he spent time observing pigs' actual slaughter. Once he revealed the animal's innards, Leonardo was able to see the still-beating heart and observe how blood was moving out of the heart and through the arteries.

Studies of Plant Life

Leonardo's interest in the natural world spread to flora as well as fauna. Unfortunately, Leonardo's plant sketches are some of the worst preserved of any of his drawings. We do know, though, that he drew lots of plants because his first biographer, Giorgio Vasari (1511–1574), tells us so.

One existing sketch is the *Star of Bethlehem*, which was created between 1505 and 1507. This sketch is significant because, in addition to being one of his few surviving plant drawings, it shows a highly stylized, abstract flower. In contrast, most of his earlier plant drawings were more scientifically accurate. While a single flower may not seem like such a big deal, it's important to understand that Leonardo didn't just paint what he saw—he was also very creative.

Other surviving drawings include mountainous landscapes and rivers. Leonardo made these artworks in media such as metalpoint, chalk, and pen and ink. He is also known for the detailed botanical renderings of various plants and trees that exist in some of his paintings. While many Renaissance artists focused exclusively on the painting's central figure, Leonardo paid attention to every detail, and his work is richer because of it.

The Perfect Man

One of the most famous drawings of all time is Leonardo da Vinci's *Vitruvian Man* of 1490. In the original sketch, which currently resides in Venice, Leonardo used both ink and watercolor. It wasn't as small as it appears in reproductions—it is actually about 10" × 13". Leonardo's image has become an icon for art, science, and the Renaissance. Today it's such a widely recognized symbol that you can see it everywhere—in high-school textbooks and museum galleries, even on T-shirts. What is it about this particular drawing that has generated such attention? What is this drawing even about?

A Debt to Vitruvius

The source of inspiration for the *Vitruvian Man* was, not surprisingly, Vitruvius. But who was he? He was actually a Roman engineer from the first century B.C. who codified some of the first basic principles of architecture. Serving as chief architect under Julius Caesar, Vitruvius was ancient Rome's resident expert in urban planning and structural design. He wrote the first definitive treatise on architecture, *The Ten Books of Architecture* (around 27 B.C.), in which he specified guidelines for city planning, building materials, hydraulics, and other major civic projects. This influential book also established differences for religious, private, and public designs—the first time that such distinctions had been laid out so clearly. Some of the areas it covered were exceptionally precise, even down to specifying exact proportions and dimensions. In addition to providing rules and principles for architects to follow, Vitruvius expressed the important relationship between architecture and social-cultural values.

ALERT!

The master strikes again. Leonardo successfully combined art, humanism, and proportion into a drawing that represented both nature and science. It was an artistic melting pot, and truly revolutionized figural drawing. No wonder it's become such an icon of the relationship between art and science.

It is likely that Leonardo's first exposure to Vitruvius, and his ideas on form and proportion, came during his apprenticeship to Verrocchio. He was also probably influenced by Alberti's interpretations of the same subject. But Leonardo, as usual, went far beyond the original ideas to come up with his own radical uses and interpretations.

In fact, Leonardo's *Vitruvian Man* could have been a poster child for Renaissance ideals of humanism and proportion. The drawing consists of a square that is partially inscribed in a circle, with a human male form inscribed into the combination of these two basic geometric shapes. The reason this drawing has become so celebrated is because it represents the first example of a human form that wasn't forced into an unnatural

distortion simply to accommodate the geometry. Instead, the form is true to the actual proportions of an idealized human.

Pythagoras

The symbolism of the square and circle dates back to Pythagoras, a Greek mathematician from the sixth century B.C., who determined the mathematical relationships between forms. Once Vitruvius came along, he started with the mathematical theorems of Pythagoras and took them to a whole new level, extracting social and structural meaning from them. That meaning, in turn, paved the path for Leonardo, who expanded on the concepts that Vitruvius first made available.

Unit by Unit

Architecture, for Leonardo and most Renaissance architects, was a matter of harmonious modularity. As Leonardo proved with this drawing, it was possible to view the human body the same way: A composition of anatomical building blocks that were comparable to those of the built world. This idea of creating a human figure inside of geometrical shapes would be imitated in later years.

Several other architects attempted the same type of drawing, following Leonardo's lead. In 1511, an Italian architect named Fra Giovanni Giocondo published an illustrated edition of Vitruvius' masterwork. Giocondo included a diagram that was his attempt to explain Vitruvius' views of the relationship between man, divinity, and the built environment. But in Giocondo's version, his relationship between the circle and square forced the human inside not to be proportionally (or aesthetically) correct.

Then there's Cesare Cesariano, who did another translation of Vitruvius' *The Ten Books of Architecture* and also included new illustrations. As part of this work, in 1521 he created a drawing similar to Giocondo's, where the circle and square touched at four different points. In spite of its technical precision, this rendering still forced the human limbs into proportions and lengths that were impossible. Naturally, this invalidated the diagram's logic. Francesco di Giorgio (1439–1502) created yet another, more stylized version of this idea, but even his version wasn't as pleasing as Leonardo's.

Despite these subsequent attempts, Leonardo's version is the most proportionally accurate, showing his keen interest in the interlocking relationship between nature and science. Interestingly, it's been said that in a not-so-rare moment of artistic hubris, Leonardo may have borrowed his own self-portrait to use for the head of Vitruvius in this influential work. Doesn't it seem appropriate, though, that Leonardo himself might be both model and artist for this symbol of the Renaissance?

Physical Sciences

Leonardo studied anatomy, but his interest in science didn't end there. He was also a student of the physical and natural sciences. In particular, he used his methods of observation and inquiry to look at a number of problems in physics, geology, astronomy, and other fields. In these inquiries, he basically invented the scientific method of observation, theory, and experiment. This method of experimenting to see whether reality matched one's particular ideas was at the forefront of the scientific revolution of the seventeenth century, which was still more than a hundred years off.

Getting Physical with Science

While the majesty of Leonardo's artistic talents was realized during his lifetime, and he was celebrated for his works of art, Leonardo's scientific discoveries were largely underappreciated during his lifetime and for hundreds of years following it. This may be in large part because society as a whole lacked any context with which to understand the extent of his genius—without any understanding of the place and coming progress of science, it was difficult to see just how far ahead of his time Leonardo really was. Leonardo, however, seemed to appreciate and enjoy his scientific work. While his biographer, Vasari, rued the fact that Leonardo spent too much time dallying with his scientific pursuits, Leonardo himself sometimes felt that his works of art distracted him from his science.

Geology

In geology, Leonardo's contribution is particularly striking. While working as part of Duke Sforza's court, Leonardo devoted time to surveying various mountains and valleys, and this work served as background for military engineering projects, such as making roads and tunnels. During this period, Leonardo most likely had ample time to study the area's various rocks, and he also observed the fossils (mostly shelled sea creatures called mollusks) present within the rocks.

From his writings, we know that Leonardo understood the process of sedimentary rock formation, which occurs through sequential deposition of small layers in a watery environment. He also understood erosion, the idea that wind, rain, and rivers progressively wear away rocks. In fact, he realized that, as a result of erosion, sand and rock particles are eventually carried to the ocean to repeat the cycle.

Sedentary Sedimentation

Leonardo also understood that sedimentary rocks are organized in a way that allows an observer to determine relative ages. Since they are built up in an orderly pattern over long periods of time, Leonardo realized that the oldest rocks are at the bottom of any particular undisturbed series of layers, and that younger rocks are layered on top. This is called

superposition. Leonardo also realized that such individual layers can extend for many miles in all directions if conditions are right, allowing one to follow distinct layers to different places where they are exposed.

These principles were not rediscovered for almost 300 years, until the Danish scientist Nicolaus Steno explained stratigraphy and superposition. These techniques are used today by all geologists to construct detailed geological and stratigraphic maps that reveal the geologic history of a portion of the earth's surface.

The Real Deal

Modern geologists now understand the full cycle that rocks on the earth go through. In addition to sedimentary rocks, which are formed through processing by water, there are also igneous and metamorphic rocks. Igneous rocks are formed by the heat of volcanic eruptions—raw materials are melted deep beneath the earth's surface, and rise up to the surface where they are erupted as lava from a volcano. These molten rocks flow or are propelled explosively from the volcano, and rapidly cool into a variety of rocks depending on their chemical composition. Metamorphic rocks can be formed from either igneous or sedimentary rocks—they are formed when such initial rocks are buried deeply beneath the surface. The high temperatures and pressures found there cause changes in the physical and chemical nature of the rocks, producing new configurations.

The Nature of Fossils

In addition to studying the types of rocks, Leonardo was keenly interested in the fossils found within them. He was puzzled by the presence of what were clearly sea creatures at high altitudes. How is it, he wondered, that shells could be found in rocks that currently lay atop mountains? Other scientists pondered this central geological question in Leonardo's day, and Leonardo rejected the two main suggestions prevalent at that time. One of the theories of Leonardo's time suggested that the shells had been carried there by the great flood mentioned in the Bible.

The other theory suggested that the sea creatures present as fossils at high elevation had actually formed right there in the rocks. Again, this idea

makes at least some amount of sense—if you are constrained by thinking that the rocks on top of mountains had been there for all time, then the only way for fossils of sea creatures to get inside them would for them to have formed inside the rocks themselves.

According to the Bible, at the time of Noah the entire world was flooded with water, and even the highest mountaintops were covered. If you take this story literally, it makes some amount of sense to assume that the flood could have carried sea creatures up to the mountaintops.

Leonardo considered and then ruled out both of these theories. From his observations of nature, Leonardo knew that shells had to come from living creatures and that these living creatures would have had to move around to eat and grow—they couldn't have formed inside a rock. He also noted that the world probably wasn't ever covered by a single great flood, since the water wouldn't have had anywhere to drain. Even if a flood had taken place locally in biblical times, any shells carried up to the mountaintops would have formed a jumbled mess, not the orderly layers that Leonardo saw.

Weighing the Options

Leonardo's consideration and rejection of these two possible solutions is an excellent example of the new hypothesis-testing kind of science that Leonardo was pioneering. He based his analysis on actual physical observations of the problem at hand. In this case, Leonardo knew from observing living creatures that it would be impossible for them to live inside a solid rock.

In addition, Leonardo knew from his observations of water and fluvial processes that water flowed downhill due to gravity, and thus would need somewhere to drain to in order to disappear. And he knew from his observations of sedimentary rocks that they formed through a slow, orderly process to build up the detailed layers present in the rocks he had studied—not consistent with a global flood.

Leonardo's Version

After dismissing both of the theories of the time, Leonardo tackled the problem himself and came up with an alternative theory. Remarkably, Leonardo's solution to this puzzle came very close to the modern understanding. He suggested that when the fossils had been living sea creatures, they had been in an ocean environment. At some later time, mountains formed, and their gradual formation lifted the ocean sediments up to the mountain peaks.

In fact, we know today that this model is a pretty good approximation of what actually happened. Modern scientists have found fossils of sea animals and plants in deserts and high on mountaintops. We now know that the crust of the Earth is mobile—due to plate tectonics, the surface of the earth slowly moves from places where crust is created (at mid-ocean ridges) to places where crust is destroyed (called subduction zones). Earthquakes happen when the plates of crust slide next to each other or on top of each other.

FACT

Mountains can form when two plates collide with each other—sometimes one plate goes under the other, but sometimes the two plates push each other up and form mountains. If the plates originally had material deposited by an ocean on them, the fossil shells and other items go along for the ride and can end up on mountaintops millions of years later.

While Leonardo solved the mystery of the mountain shells, he didn't have the same good luck with all of his scientific theories. In fact, some of his beliefs were just wrong. Of course, Leonardo didn't have access to the technology that we do today, and his work was largely built up from first principles and his own personal scientific observations. It stands to reason that he wouldn't always get it right.

Astronomy

In Leonardo's day, astronomy was intermingled with astrology, the science that purported to predict events on Earth based on the movements of the

stars and planets in the skies. Leonardo, with his interest in observation and experiment, observed and plotted the positions of the stars and planets in the sky.

Although he tried his best and did conduct some experiments with optics and lenses, telescopes were not invented until 100 years after Leonardo's time. This of course hampered Leonardo's ability to decipher the night skies. However, Leonardo was able to make a number of accurate observations and discoveries. For instance, while many people in Leonardo's time thought that the stars were just tiny dots of light in the sky, Leonardo realized that they were like our sun, only much further away.

Leonardo's studies of perspective in drawing made him realize that objects appeared smaller when they were further away. Thus, he concluded, the sun was really much larger than it appeared in the sky, and the stars themselves must be immensely far away since they appear as small as pinpoints.

Reflections of Leonardo

While Leonardo's observations appear to have been as accurate as possible for the time, his interpretations were not always correct. For example, Leonardo noted that the earth, the moon, and the planets all reflected sunlight. This was significant in that he considered those bodies to reflect the light that shone on them like a mirror, rather than generating their own light like the sun. However, Leonardo seemed to think that the moon reflected the light of the sun because it was covered with water. Of course, we now know that the moon is a cold, dry world.

Leonardo also appears to have believed that the sun and moon both orbited around the earth, although his notebooks do contain his assertion that the sun does not move. This would have been a huge leap forward for the views of the cosmos in his day, to consider that perhaps the earth moved around the sun rather than the other way around. He also stated that the earth itself was shaped like a sphere rather than being flat.

Illusions of the Sky

Less correctly, Leonardo also predicted that the moon had an atmosphere, and thought that when the moon was on Earth's horizon it appeared larger than when up high in the sky because of distortions in the lunar atmosphere. Today, however, we know that this apparent enlargement of the moon is simply an optical illusion.

According to a sketch from 1510, Leonardo did manage to calculate a way to determine the distance from the earth to the moon, and the earth to the sun. He was also apparently one of the first to realize that even when only part of the moon was lit, the dark part of the crescent moon could still be seen faintly. (This illumination comes from sunlight that bounces off the earth and is then reflected off the moon.)

FACT

Two prevailing views of the order of the cosmos were in conflict during Leonardo's day. The geocentric view placed the earth at the center of the solar system, with the sun, moon, and planets orbiting around it. The heliocentric view, put forward by Leonardo's contemporary Copernicus and later supported by Galileo, put the sun at the center of the solar system.

Leonardo even speculated about space travel, predicting that if people were to stand on the moon, they would see the earth shining in the sky due to reflected light from the sun. From his studies of reflection, Leonardo predicted that the oceans would reflect much more sunlight than the land. Thus, he thought that to a person standing on the moon, the earth's oceans would look bright and the land would look dark, much as the moon has both bright and dark regions as seen from the earth. While very good for his time, Leonardo's predictions weren't always right.

It's true that the ocean does reflect water right under the sun. But Leonardo didn't consider clouds—from space, the clouds on the earth look much brighter than either the land or the water.

Distant Viewers

Leonardo also mentioned that to an observer on another planet, the earth itself would resemble a star in the sky, just as the other planets in our solar system look like stars in our night sky without a telescope. In addition, he produced sketches of the geometry of eclipses, including lunar eclipses, when the earth's shadow blocks out the moon, and solar eclipses, when the moon itself blocks out the sun.

FACT

Leonardo invented a lunar clock, which displayed the phases of the moon. Its design was based on Leonardo's detailed understanding of the earth's rotation. Leonardo also understood that due to the rotation of the earth, sunrise occurred at different times in different locations. This observation came long before time zones.

Clearly, while some of Leonardo's achievements in science were noteworthy, others weren't. Looking back, you could say that Leonardo's theoretical studies were generally less important than his practical innovations. However, you can also see that his inventions allowed Leonardo to discover and pursue new theoretical lines of research. Even modern scientists often need both theories and experiments to make breakthroughs.

Geometric Explorations

In addition to his more practical scientific studies, Leonardo was also interested in more theoretical disciplines such as math, and in particular geometry. Leonardo first became interested in geometry while he was working for Duke Sforza during his Milan period, in the 1480s and 1490s. It seems that Leonardo first became familiar with mathematical constructs such as geometry through his study of architecture and perspective painting. In 1496, the well-known mathematician Luca Pacioli was invited to Sforza's court, nominally to teach mathematics there, and Leonardo may have suggested this invitation.

Leonardo and Pacioli became friends in Milan, apparently spending much time together discussing the overlap between art and mathematics. During his time in Milan, Pacioli was writing a book, later published as the first of a three-volume set in 1509, called *Divina Proportione*. Leonardo was so interested in this project that he actually drew the figures for this text.

The Golden Ratio

The book focused on the so-called "Golden Ratio," which Pacioli called the "Divine Proportion." It also included a study of polygons, shapes with multiple sides. Leonardo became more and more interested in geometry as he worked on this project, and it appears Leonardo actually ignored his painting because of his obsession with geometry. In more than one instance, Leonardo's work in math and science got in the way of his paying artistic commissions. While most members of society during Leonardo's lifetime could not understand such a choice, we today can of course appreciate Leonardo's achievements in math and science as well as those in the artistic world.

FACT

A letter has been found dated 1501 from a member of the court where Leonardo resided to Isabella d'Este, who had commissioned a portrait from Leonardo. The letter states that Leonardo's mathematical experiments were taking up most of his time, and that he could not spare any time to paint. Leonardo's priorities clearly show that he was much more than just an artist.

The golden ratio comes from the mathematical expression $a/b = b/(a+b)$. Its algebraic value is equal to about 1.6180. It is a number that occurs in a variety of places in math and geometry, similar to the number pi ($=3.14159$).

Euclid studied the golden ratio, which was considered a particularly elegant relationship in terms of both math and art. Little wonder the golden ratio held particular interest for Leonardo, since he immersed himself in the study of both disciplines, as well as his studies in the natural world. As an added bonus, for Leonardo, the golden ratio also turned out to be important

to the study of architecture, and the second volume of Pacioli's *Divina Proportione* actually focused on architectural applications.

Is the golden ratio useful for anything except for math?
The golden ratio actually occurs in nature, as well as in geometry, in places from the layout of seeds or leaves in a plant to the shapes of seashells. This fundamental relationship is also found in music and in other places where the natural and mathematical worlds collide.

Polyhedra

Leonardo's drawings of three-dimensional shapes called polyhedra (one example is a soccer ball) were the highlight of Pacioli's book. Leonardo came up with a new way of drawing these complicated shapes—he showed them with solid edges and hollow faces that let you see right through them to the structure on the other side. For the book, Leonardo drew about sixty pairs of illustrations. Each pair showed a different three-dimensional shape, in both a solid view and a hollow view. Some of the shapes were new—no one had figured out how to draw them before!

The method of drawing shapes was a breakthrough for the day, and it took a visual artist of Leonardo's talents to come up with it. Sometimes art and math are closer together than you think.

Leonardo's obsession with geometry continued even after he finished the illustrations for Pacioli's book. If you look through his notebooks, you'll find sketches of different kinds of geometric shapes in unlikely places, for example, among studies for military fortifications and designs for a fountain.

Squaring a Circle

In addition to his direct work with Pacioli, Leonardo spent some of his time in Milan conducting his own research into geometry based on that of Euclid and Pacioli. In particular, he was interested in trying to "square a circle," meaning he wanted to find a way of creating a square with the same area as a particular circle, using only drawing tools such as a ruler and compass.

In another intersection between art and math, Leonardo was particularly interested in drawing rosette patterns, and invented a special compass to help him draw them more accurately. He also came up with a proportional compass that let him scale figures up or down. He was interested in drawing ellipses, and sketched a device called an ellipsograph that would help to create accurate ones. An ellipse is a shape that looks like an oval. It is defined mathematically as the set of points for which the sum of the distances from two points in the middle, called "foci," is constant.

You could draw an ellipse by placing two pins on a board, attaching the ends of a string to each point, and putting a pencil in the string and drawing a shape, keeping the string taut. The orbits of the planets around the sun are shaped like ellipses, with the sun at one focus.

Leonardo was also interested in knots, and many of his intricate artistic designs are also interesting from the point of view of the modern field of topology. One particular example of this is Leonardo's design for the ceiling of the Sala delle Asse that he created for his patron Sforza's castle. The ceiling includes interwoven trees and branches, and there is one long continuous strand that can be traced over the whole ceiling.

When the French forced Duke Sforza out of power in 1499, Leonardo and Pacioli fled from Milan together, passing through Mantua and Venice before sharing a house in Florence for a while. While there, Pacioli taught geometry at the University of Pisa (located in Florence at that time). Leonardo also remained in Florence on and off until 1506.

Beyond his theoretical work in mathematics, Leonardo was also interested in the mechanical methods of automating mathematical work, and he designed a machine that could have been one of the first calculators. A working replica was built in 1968, but whether or not this replica actually represented Leonardo's intention is another story. The sketches on which the calculating machine replica was based are unclear, and it's possible that the machine was not, in fact, a calculating machine, but a ratio machine instead. In his typical style, though, Leonardo made real contributions to

just about every part of math that he touched. Pretty amazing for someone who's primarily remembered as an artist.

River Engineering

In addition to numbers, Leonardo was also fascinated with water. Water is the basis for all life on earth, the universal solvent, and a general requirement for all living things. It has fascinated humans throughout recorded history, and Leonardo was no exception. He went to great depths to study water and all its properties. His observations were right on target. For example, he noted that water could easily change in character depending on the environment. Water could be fresh or salty, it could rush furiously or flow calmly, and it could nourish as well as destroy. It was, in other words, the best and worst thing imaginable, all depending on the circumstances.

Especially in a pre-industrial world, you can imagine how important water was as a huge source of natural power. Leonardo studied the various ways in which water came from the heavens, noting that it could fall as rain, melt as snow, run in rivers, and actually well up from the earth itself. He understood the power that water had to revitalize plants and people, but he was also aware of its ferociousness, as we can tell from his studies of storms and his sketches of powerful swirling waves.

FACT

As it turns out, Leonardo's concern about floods was well founded. The Arno River, near Florence and Pisa, erupted over its banks at least twice during Leonardo's lifetime, once in 1466 and again in 1478. These cataclysmic events heavily influenced Leonardo's designs concerning water management and manipulation.

Going with the Flow

Like his interest in blood flow and circulation, Leonardo was interested in river flow and water motion. He studied currents and waves, observing how surfaces that repeatedly came into contact tended to degrade over

time. He may have actually been the first to suggest the concept of erosion. However, he wasn't foolish enough to think that water could do no harm. He realized its violence, and knowing how destructive water can be, he probably feared the disasters that could be caused by swollen rivers.

River Diversion

One of Leonardo's grandest ideas to control water was a scheme to divert the actual path of the Arno River, a large river near Florence and Pisa. Leonardo was in Imola in 1502, working as the chief engineer for Cesare Borgia. During this time he used his skills in cartography to plot out the course of the river, and in 1503 he presented a plan to redirect the river between Imola, Florence, and the sea. Leonardo had the support of one of the most influential politicians and philosophers of the Renaissance, his friend Niccolo Machiavelli. Leonardo and Machiavelli were two of the most respected figures of the day, and their positions lent authority to the scheme they were proposing.

Canal Designs

As a part of the river diversion, Leonardo also decided to revamp the Florentine canal system. The general goal was to construct a series of channels that, passing through Pisa, would eventually lead to the sea. This effort would have improved the city's waterpower and irrigation, in addition to the commercial benefits. These canals would have used steps and locks powered by oversized siphons.

In his engineering studies, Leonardo suggested digging large ditches that would eventually connect to the river. Ships could have sailed through Florence and into the hillier, mountainous areas for easier pickup and delivery of goods. It also would have helped with the Florentine wartime effort. This new flow would have turned Florence into a bustling seaport—the entire nature of the city would have changed.

Theory Versus Practice

Unlike many of Leonardo's projects, this one was at least started. Hundreds of men began working on the canals under the supervision of

Colombino, a master hydraulic engineer. Unfortunately, these canals were never completed correctly, as Leonardo had to return to Florence from Imola in order to continue work on a fresco in the Palazzo Vecchio.

In Leonardo's absence, Colombino took a few liberties with the design and made some disastrous engineering changes. Under his direction, the ditches were dug too narrowly and in the wrong place; he also didn't hire sufficient manpower to come close to completing the project.

According to some reports, the Arno actually did flow into its new path for a short time, but the river promptly reverted to its previous course and the project was eventually abandoned. In this case, what appears to be yet another of Leonardo's failures wasn't actually his fault, but no one knows if his scheme would have worked if it had been followed correctly.

chapter 11

Engineering and Innovation

Leonardo's innovations in engineering and other fields must be viewed against the backdrop of the times. The early Renaissance was a time when innovations were just beginning. It was also a time of warfare between city-states, and even the generally peace-loving Leonardo was forced to devote significant time and resources into military engineering. His inventions and discoveries were both offensive and defensive, and he is credited with creating both dangerous new weapons and new fortress designs.

Before Planes, Trains, and Automobiles

Renaissance inventors were at a crossroads, whether they knew it or not. Europe was slowly emerging from the Dark Ages, and there had already been several significant inventions. At the same time, some of history's greatest achievements were yet to come. Leonardo, living fairly early in the Renaissance period, was on the leading edge of the era's innovation. Against what backdrop can we view his inventions?

Life Without Modern Conveniences

Certainly, Leonardo and his contemporaries didn't have access to most of the modern conveniences we take for granted today. One of the things most noticeably lacking was probably the indoor toilet, which was not mass-produced until the late nineteenth century. And, since electricity wasn't discovered until the seventeenth century and not widely used until the late 1800s, of course Leonardo couldn't turn on the lights.

FACT

The first standardized fuel type was probably the fish oil used by the ancient Romans and those who came after them, so in the absence of electric lighting, fuel-driven lanterns would have been a possibility for Leonardo. In addition, candles, torches, and lamps were other popular light sources during the Renaissance years.

One of the most significant inventions of the Renaissance was the mechanical timepiece. Though Casio calculator wristwatches wouldn't come along for a while yet, society was beginning to place more importance on an easy way to tell the time. Clocks were first created in the 1300s, but it was not until the 1580s that Galileo (a scientist and researcher from Florence) developed the idea for a pendulum.

I Can See!

Eyeglasses were another significant medieval and Renaissance invention. By the 1300s, guilds in Venice were regulating eyeglass production. Like many "optional" devices during this period, glasses were probably considered a luxury item. When Johannes Gutenberg's invention of the printing press made reading into more of a hobby than a luxury, though, eyeglasses came into much higher demand. Everyone wanted to read, and their eyes needed to keep up with them.

Readily available books were a major factor for Leonardo because he was able to read the writings of ancient masters and, in the process, create his own interpretations and additions. And his work didn't stop with reading; if books could be published easily, he could also publish his own writings. In addition to all of these other inventions, Leonardo used the growing worldwide interest in mechanics to utilize and explore water. Naturally, his concepts relied on existing research with water pumps, which were developed in the Middle Ages.

Leonardo was thinking, sketching, and designing with these inventions as his backdrop. Historical developments influenced Leonardo in several ways: They provided inspiration for future designs, gave a context into which Leonardo's ideas would fit, and prompted this Renaissance master to continue pushing the envelope.

Warring Years

Renaissance Italy was essentially a war zone; architects, engineers, and other designers paid a lot of attention to military improvements because it was an integral part of their way of life. Leonardo spent years traveling with Cesare Borgia, and learned all about military life.

Although he lived in a society that required a strong military to survive, Leonardo may have been more of a pacifist. His notes describe how he thought that fighting, death, and survival of the strongest were qualities of animals, rather than people. However, since Leonardo liked his job

and probably wanted to stay employed, it's doubtful that he would have expressed these sorts of views in public.

Hand-powered weapons such as spears and arrows had been around for generations, and gunpowder was in use by the middle of the eleventh century, though it probably wasn't used in Europe until the 1350s. This invention changed the course of warfare because it became nearly impossible to defend against guns with only hand-powered weapons. Leonardo's designs for cannons, for example, were a response to the new way of waging war.

In terms of his innovations in weaponry, Leonardo had the advantage of *not* starting from scratch. Military technology, even in ancient Rome, was years ahead of the general technology available to the rest of the population. Just like today, new inventions and ideas often came about as necessary for military applications, and only later found civilian uses as well.

Under Siege

As engineers rose to the challenge of making more advanced war machines, Leonardo also contributed significantly to this effort. The technology behind artillery was improving, and suddenly wars had to be fought differently. Siege warfare was becoming more common than hand-to-hand combat, although the concept of siege warfare was actually nothing new.

Siege warfare is a method of fighting that involves extensive military blockades and attacks on a city or castle, when battlefield fighting is not an option. The attackers decide that they cannot win through a frontal attack, and the enemy refuses to surrender up front. In a siege, the attackers cut off their enemy's supplies, trade routes, and all communication with the outside world, in addition to making every effort to take control despite the castle's best defenses. The goal is that eventually, the enemy would be forced to surrender simply in order to survive.

Ancient Egyptians had developed techniques of siege warfare, based on evidence of fortifications and other defense architecture. There is also

evidence of medieval siege campaigns. The technique became more commonly used during the Renaissance, as walled cities developed and began to house larger populations.

Typically, a siege could end in one of several ways. Those under attack could hold their positions, eventually forcing the attackers to withdraw. Or, they could somehow get aid from outsiders, thereby relieving the siege. The attackers could gain control of the city, forcing the city to be evacuated. Finally, the attackers could both conquer the city and capture its inhabitants; this last one is clearly the best result for the attackers.

Leonardo was very much aware of the destructive potential of siege warfare. As a designer living in the Renaissance, there's no way he could have been unaware! In an effort to help Italy, he designed both new weapons and entirely new weapons systems. He also came up with ideas for many different kinds of land vehicles.

FACT

Some of Leonardo's vehicle ideas were quite practical, while others appear more inventive, and probably not designed to really be built. They might have been like modern automotive "concept cars" that are fun to look at, and delight car reviewers, but would never be practical on the highway.

Leonardo's Tank

One of Leonardo's largest vehicular designs was for an armored tank. The idea behind the armored car was simple: protect passengers while causing as much damage as possible. While there were, of course, no motorized vehicles in the Renaissance, the concept of an armored vehicle was not entirely new. Roman chariots, for example, were designed to help move people around and keep them safe during battle.

In his tank design, Leonardo didn't specify the powering mechanism, and his notes indicate that his tank could have been either hand-cranked (as with his automobile design) or drawn by horses. If hand powered, the

cranks would have been connected to gears, which, in turn, connected to the main driving wheels.

Tank Details

The entire vehicle would be under a hard shell; physically, Leonardo's drawing looks like a combination of a turtle and an alien spaceship. The structure would have been clad in metal panels and, as in today's tanks, it would have had holes for guns to poke through. There appears to have been no windshield, but the two sections of the tank came apart and visibility may have been provided through the crack.

Of the two possible power sources, the hand-cranked version probably would have worked better than the horse-drawn one; in addition to being vulnerable, horses might not have remained calm enough during battle. The first "modern" tank designs did not come to fruition until the World Wars of the early twentieth century, and they definitely weren't horse-drawn!

Problems

As with the problems facing modern tanks, Leonardo's design would have suffered from a few probably fatal issues. For starters, armored tanks are large and cumbersome. They are also slow, and things which are both big and slow tend to make easy targets. Tanks are limited in the types of terrain they can traverse; Leonardo's tank would probably have had a tough time with the varied conditions of the Italian countryside.

FACT

Winston Churchill actually helped make the ideas of Ernest Swinton and Sir William Tritton for a tank a reality. Churchill himself noted that Leonardo was one of the most brilliant minds of all time; it's very interesting that he ultimately helped realize one of Leonardo's designs.

Unless Leonardo's tank was amphibious, the canals would have posed a major hurdle. In this design, as in many others, Leonardo was far ahead of his time. The armored tank that is used in modern battles is, of course, a

motorized vehicle that runs on high tread tracks. But it didn't come along for nearly another 400 years! The first armored tank to be a direct precursor to the modern tank was created in England around 1916. The idea was developed by Ernest Swinton, and designed by Sir William Tritton.

War Games

Leonardo was as interested in defense as he was in offense. When several Florentine forts were attacked in 1479, Leonardo became interested in ladders for scaling walls during an attack as well as methods for defending against those same efforts. Military engineering was just one of Leonardo's many interests, but as with everything else, he dove into it whole-heartedly and came up with several important designs.

Leonardo's Ladder

Leonardo designed a number of different ladders for wall climbing. Some were stiff, solid ladders, while others were flexible and made from rope. To attach securely to the top of the wall, some of Leonardo's ladders had hooks that could grab the top of the wall; others had spikes on the base to keep them immobile on the ground.

He also thought about flexible ladders that could hang from a wall as well as the type of chain ladder that's often used for fire escapes today. Ladders were, in a way, a symptom of the problem: war. Leonardo got to the root of the issue and also designed entire defense systems.

One of Leonardo's most clever ideas involved ladders lining a wall, where the tops of the ladders were all attached to a bar. Leonardo's assumption was that attackers, thinking themselves sneaky, would rush to climb the ladders in a sneak attempt to overtake the castle inside. Not so fast! Leonardo's defensive soldiers would push the bar out, and any poor, unsuspecting attackers would fall to the ground along with the row of ladders. It sounds complicated, and it was; perhaps this over-design was one of the reasons it was never tested.

Bridge Design

During his time with Duke Sforza, Leonardo also designed a number of bridges for military applications. Some of these bridges were portable; troops could carry the bridges with them and set them up quickly when needed. Others were designed to be particularly strong and resistant to fire or other means of destruction. Leonardo also considered methods to burn and destroy enemy bridges.

Leonardo's military bridges had a number of different designs. One was arched in such a way as to be particularly strong when assembled. Others used traditional pilings, or were flexible so they could swing without breaking. Leonardo also designed adjustable jacks for opposite sides of a river, to be used if the banks were different heights on each side.

Leonardo designed one particularly massive bridge during his time with Cesare Borgia. In order to span the Bosporus at an inlet called the Golden Horn, Leonardo suggested building a huge bridge across the Gulf of Istanbul. This route would have had immense strategic importance, but other engineers vetoed the plan when they saw how large the bridge would have to be.

FACT

Modern studies of Leonardo's design for the bridge across the Gulf of Istanbul show that the structure would have definitely been possible to build with the resources of that era, and the bridge itself would have been solid and well designed. In fact, a smaller version of his bridge was built in Norway 500 years later, in 2001.

Military Chariot

Vehicles that could serve offensive or defensive purposes also piqued Leonardo's design curiosity. Take, for instance, his design for a horse-drawn chariot, which had four large scythe-like blades mounted to the axles. As the horse pulled the chariot, the blades would rotate, slicing off the limbs of enemy soldiers. A variation on the design placed the four large blades at the front of the machine, in front of the horses even, where a screw-type device turned them. This model also included a series of smaller scythe

blades placed at the back of the chariot. This chariot was designed as a brutal weapon, indeed. Even the initial sketches included images of dead and dying soldiers left in its wake. For the peace-loving Leonardo, this was an incredibly gruesome design.

Building a Better . . . Gun?

In addition to his work to support troops with better ladders and bridges, Leonardo also designed or improved a number of different weapons. Guns, cannons, and other artillery weapons were on the rise during the Renaissance. Newer was better, especially when it came to national defense. Leonardo appeared to have had a nostalgic side, though, because he still spent time working to perfect or improve older weapons such as catapults, slingshots, and crossbows.

QUESTION?

Did Leonardo invent the crossbow, or just refine it?
One of his innovations was the rapid-firing crossbow, but his was not the first design for such a weapon. The crossbow had been around, in one form or another, since about 400 B.C. The earliest crossbows were made of wood and designed to be mounted, then fired by a single soldier.

The Crossbow

The early crossbow design was easy to construct and could be shot by just about anyone, so it quickly became a desirable weapon. In fact, the Chinese army utilized crossbows extensively for generations. As crossbows spread to Europe, they were scaled down and re-engineered so that they could be carried by individual soldiers. They were highly effective, and were routinely used throughout the Middle Ages.

Leonardo's design was for no ordinary crossbow—it actually included four crossbows and got its power from a large treadmill. But not the kind you'd work out on at the gym. A number of men walked on steps that were

located around the outside of a large wheel, and as they made the machine rotate, an archer would fire each crossbow, reloading them in sequence.

What was unique about Leonardo's design is that it represented both a technical and cultural shift in thinking. From an engineering standpoint, creating the gears and steps was a doable feat. More importantly, though, it brought soldiers together as they strove to reach their common goal: winning the battle. It also changed the fundamental nature of the crossbow from being a weapon that an individual used on his own, to something that required a collaborative team effort. Leonardo's crossbow was as much a redesign of society as it was a redesign of the weapon itself.

Larger than Life

Leonardo also designed a mammoth seventy-six foot crossbow that required six wheels to maneuver it. This device, also called a ballista, used a series of gears to draw back the bow; a simple strike of a pin would release the shaft. Leonardo believed that this giant weapon would operate in almost complete silence, but his claim was never tested because the device was too difficult to build given the abilities of the day. Similarly, he also designed a giant slingshot that required a series of springs to tighten it.

In the interest of defeating more enemies faster, Leonardo also designed a rapid-loading catapult system. This machine, which could be mounted on top of a wall, consisted of a rope and winding mechanism used to bend back the arm and, in effect, ease the firing process. Leonardo also designed a row of catapults that could all be launched at the same time when hit with hammers. Specially designed missiles with gunpowder inside had fins on the tail for extra stability. When they hit their target, strikers inside ignited the gunpowder and caused an explosion. These sound remarkably similar to modern artillery shells.

Were Leonardo's giant weapons actually usable, or were they just an example of "bigger is better" taken to an extreme? We'll never know, because they were never built.

Leonardo and Cannons

While cannons were first used as early as 1346, they weren't very advanced by Leonardo's time. Chinese engineers performed the first experiments with exploding powders around 200 B.C., but they weren't used for weapons until hundreds of years later. Around 1252, English writers made mention of "gunpowder" that was manufactured by early chemical engineers from a potassium nitrate compound.

During the years that Leonardo was working, the cannon was still a simply designed object: cylinders used an explosion of gunpowder at one end to propel a stone ball out the other.

The name "cannon" comes from the Latin "canna," or reed. In fact, early Chinese cannons actually used bamboo reed tubes as the barrel. The propellant gunpowder was created from saltpeter (potassium nitrate), and burned very quickly once it was lit. The power of the explosion forced a projectile out the other end.

Rear Loading

One of Leonardo's first improvements to cannon design was to create a model that could be loaded from the back, rather than down the front of the barrel. Since the cannons had to be cooled before they could be reloaded, Leonardo suggested putting them in a vat of water to cool them off quickly so they could be reused. Not a bad idea, but would *you* want to be the one to lift a hot cannon into a tub?

In his studies of cannonballs, Leonardo was one of the first to explore ballistic trajectories. He studied such things as how changing the angle of the cannon's muzzle could affect the distance the cannonball traveled, and Leonardo had found yet another untapped area to which he could apply his mathematical mind. In testing his designs, he supposedly launched a test cannonball 10,000 feet high.

Blow Off Some Steam

Another invention of Leonardo's was a steam-powered cannon. The end of the cannon was heated to a very high temperature, and then a small amount of water was placed inside the cannon. As the water turned to steam, the increased pressure shot out the speeding cannonball. Leonardo's notebooks include information on the size of cannonballs that the device could use, and the distance they could travel. These details suggest that, unlike most of his inventions, this one was actually built and tested as well.

One problem that plagued Leonardo was that cannons had a large delay between repeated firings. Leonardo's answer was, in retrospect, pretty obvious: he proposed a system with multiple cannons that could either be fired all at once, or one after another.

> **ESSENTIAL**
>
> Leonardo's multiple cannon system included eleven or fourteen guns in three rows: while the top row was being fired, the middle row could be reloaded and the bottom row cooled off. These systems are considered to be the predecessors of today's machine guns, which allow multiple rounds to be fired sequentially without reloading.

Military Architecture

Military architecture today is a highly specialized field. Can you imagine a painter with no military training just hopping on a flight to Fort Bliss and putting up towers? Leonardo faced no such restrictions. During his time with Ludovico Sforza in Milan, he designed a number of buildings with various military reinforcements. His ability to design for the military endeared him to his patron—never a bad thing for an artist!

One such building was a castle with a triple defense system. Between about 1487 and 1490, Leonardo sketched both a plan and a perspective drawing for one corner of this building. He made a point of showing two different angular fortifications. Leonardo's design for these fortifications had one extending over the corner of the fort and the other (which included a formidable moat) extending over part of the external wall.

The Bastion

In addition, Leonardo designed a triangle-shaped bastion, a structure that allowed the soldiers inside the fortress to defend the entrance. Bastions were typically fortifications that were projected out from buildings, and created a secure defense area for battling soldiers. The word "bastion" comes from the French "bastillon," which comes from "bastille" or fortress.

Leonardo's drawing for this type of structure was probably based on existing buildings, and it dates to his time in Romagna as Cesare Borgia's military engineer (between about 1501 and 1504). The design included three small structures, probably service buildings, on top of the main edifice. There were also a series of embrasures (openings for cannons) along the top wall. Leonardo left no stone unturned, and no detail unaccounted for.

Fortified Stairs

Leonardo also designed an innovative staircase for use in a fortified tower. His scheme included four different ramps. Each path was independent of the others, allowing soldiers to go up or down the four-story tower without running into groups going in the opposite direction. This technique could improve the soldiers' response times, as they would be able to move both troops and weapons quickly during an attack. Leonardo's design for this structure, probably also done between 1487 and 1490, included both a perspective view of the tower with the staircases exposed, and a top plan view.

Ring Around the Castle

In about 1502, Leonardo designed an addition to a moat, which is a ring of water that usually surrounds a castle. Medieval castles were becoming more ubiquitous in eleventh-century England. Local towns were growing larger and larger, and there was an increasing need to create larger defenses. Newly gathered cities became focal points of local wealth and power, and almost immediately became the targets for thieves, villains, and attacking warlords. To protect the castle and its inhabitants, moats were dug in a circle around the entire structure; the only way in was for someone inside the castle to lower a drawbridge.

Leonardo's solution didn't involve just filling the moat with man-eating creatures. He did something much more interesting. He hid a cylindrical tower under the water, giving it a gently sloping roof that stuck up slightly above the water's surface. This system allowed defendants inside the moat tower to fire weapons right across the water's surface. Wet hay would cover the roof of the tower to protect against damage from incoming gunshots.

Leonardo also improved upon the typical fifteenth century water-filled moat by adding an overhanging toe wall and an embankment. His design included a series of cannons located on the overhanging wall, which allowed the castle defenders to shoot directly at all attacking forces. Defense systems were also in place to attack invading troops where they might be most vulnerable.

Repairs and Modifications

Besides designing new military structures, Leonardo also worked to improve existing structures. One of his most interesting designs, done about 1507, shows a mountain castle for which Leonardo suggested various improvements; he aimed to shore up the castle's defenses against powerful cannons. Leonardo designed thick walls to surround the fortress, which consisted of steep walls enclosing a series of circular towers. Nested walls encompassed a central tower, which would have been the residence of the castle's owner. The castle's thick walls could withstand cannon blows, basically assuring the resident king's success.

Another interesting innovation of Leonardo's was the broad, steeply sloping walls at the base of the towers. This design prevented attacking soldiers from hiding and surprising the castle occupants. The wall sloped outward from the castle, meaning any lurking attacker would quickly become a direct target. Leonardo incorporated his knowledge of potential military maneuvers into his architectural designs, making him very valuable to the Italian warrior-kings.

chapter 12

Vehicle Inventions

Leonardo was particularly interested in various ways to get from one place to another. He was obsessed with flight, and spent long hours observing birds and trying to find a way to replicate their effortless flight in a way suitable for humans. He also experimented with a variety of other types of vehicles, from boats to cars to other devices with gears and wheels. Leonardo was a scientist on the go.

It's a Bird. It's a Plane. It's a Flying Machine!

Leonardo had a life-long interest in flight. Whether it was human-powered or machine-aided, taking to the air was a goal that he seems to have had since childhood. His notebooks are full of sketches for various types of flying machines. Some were built in modern times, with varying degrees of success. While Leonardo did not have a full grasp of the principles behind modern aeronautics, his designs certainly got the ball rolling.

Leonardo's first memory, as he tells it in his notebooks, was of himself as a small baby, lying in a cradle outside, minding his own business, when a hawk-like bird called a kite landed on him and poked its tail feathers in his mouth. While it would have been extremely unusual for an infant to retain such a memory (as well as unlikely that such a bird would even land on a baby), it might explain Leonardo's later obsession with flight.

Leonardo started with the assumption that people could eventually fly using their own strength, and he tried to design a device to help them do just that.

ESSENTIAL

Leonardo wrote up his ideas about flight into a treatise now called the *Codex on the Flight of Birds*. In these notes, he summarized his scientific theories about how birds were actually able to fly, including his idea that the wing's movement created circular areas of wind thrust. Not so shabby for a fifteenth-century scientist!

Fly Like a Bird

In the course of his studies, Leonardo determined that human-powered aircraft would be difficult to both build and use. One idea he studied repeatedly in the late 1480s was that of an ornithopter, an aircraft that was almost completely powered by flapping wings. He seems to have been the first person in recorded history to come up with this idea, and it was one that intrigued him for years.

Leonardo wanted to create a machine that would mimic the flight of a bird as much as possible. Other designers after Leonardo continued

research in this area, although it was never very popular once aircrafts with other means of propulsion came along. Notably, Joseph Degan created a winged flying machine in 1808, and it's captured in a lithograph known as *The Aerial Man*. Although he appears to have experimented several times with a wing design, none of them worked well enough to actually allow a person to fly.

Edward Frost

Another major attempt to fulfill Leonardo's dream was conducted by Edward Frost, a magistrate from England. In 1904, Frost actually built a semi-successful ornithopter; the wings had a frame but were topped with silk and actual features. It was built inside of a wheeled cage, and the idea was that the flapping of the wings would make the machine rise and fall. It was reported that the bulk of the machine did rise about half a meter with every stroke, but its immense weight made it unlikely that the machine ever became airborne. Frost ended up president of the Royal Aeronautical Society between 1908 and 1911, where he had the fortune to be involved in the "rise" of the airplane.

Gliders

Leonardo's initial flapping-wing designs required balance, coordination, and strength. Even da Vinci realized that this would be too much to expect from most people. For that reason, Leonardo also focused on simpler designs. One of these was for a glider system with birdlike wings. In this device, which must have been inspired by a bat or other small winged creature, the user would climb in, jump off a mountain or tall tree, and balance himself primarily by moving the lower body in conjunction with the wings. Leonardo thought that this coordinated movement would create both upstrokes and downstrokes. He created another version of the design where the "pilots" moved their legs up and down, and another one in which a spring-loaded mechanism did most of the work.

Leonardo spent a lot of time working on the flapping system mechanism. Unfortunately for him, he paid little attention to the role feathers play in flight. This turned out to be one of his greatest oversights. Plus, as his flying machines got more complicated, they also got heavier and heavier—

and therefore less likely to actually succeed. Aeronautical engineering in the fifteenth century was virtually nonexistent, so history can easily forgive Leonardo's technological mistakes.

Of all his flying machines, the sketches for Leonardo's glider are particularly interesting because he laid out the drawings in plan, section, and elevation on a single sheet. This degree of precision indicates that he probably intended to build a scale model of the idea.

Toward the end of his life, Leonardo focused primarily on fixed-wing craft, such as gliders, that relied more heavily on the concept of lift than on the physical act of flapping. These, at least, had some hope of actually getting off the ground some day.

The *Codex Atlanticus*, one of Leonardo's notebooks, contains many designs and notes on machines. It includes descriptions of flight patterns he observed in birds and displays several designs for aircraft with movable wings. He also mentions test flights that may actually have been conducted from Mount Ceceri—supposedly a student of his broke a leg while conducting such a flight. Unlike most of Leonardo's inventions, Leonardo (or his unwitting students) tested at least a few of his designs for flying machines. How successful they were, though, is another story.

Leonardo's Whirlybird

Why limit yourself to "traditional" flying machines? In addition to parachutes, gliders, bat wings, and other assorted fliers, Leonardo created some of the world's first designs of a helicopter. While he borrowed the form from some of his previous designs, he created something radically different in terms of structure and mechanics. He began sketching and designing machines when he was apprenticed to Verrocchio, and this fascination with aircraft never left him.

Break Out the Corkscrew

Leonardo's helicopter design used a corkscrew-shaped propeller instead of the blades seen on modern helicopters. The occupants rode in a basket that would have been made of wooden poles, with their feet planted on a platform that ended shortly before the screw-shaped blade began. Leonardo's idea, according to his notes, was to use a spring-loaded system that would wind up the helicopter and then release it. He used this idea again in his design for a car. If this screw spun fast enough, he hypothesized, the entire machine would rise from the ground.

E ALERT!

What's unclear from Leonardo's helicopter design is whether or not the occupants would have been spinning along with the blade. The very idea is enough to give most people motion sickness in a hurry, so it's probably good that he didn't make anyone test it out during his lifetime.

The major problem with Leonardo's design was its weight. It simply would have been too heavy to lift off the ground. In addition, while his idea of the human-powered machine was decidedly humanistic in concept, the reality was that no person would be able to generate enough power to actually take his helicopter up into the air.

Though he may not have known it, Leonardo had a little help in the helicopter design department. There were other precedents to the modern helicopter, some dating back to the 1320s. Historians believe that a toy very similar to Leonardo's design made its way from Asia to Europe sometime during the fifteenth century. This toy probably had a large screw-based rotor, with passengers riding in an open basket below.

Later Copters

Helicopter design didn't solidify until the early twentieth century. Noted inventors such as Thomas Edison reportedly attempted to build helicopters, but none of these early attempts resulted in success; it is thought that the

major stumbling block was the lack of a sufficiently powerful motor. Perhaps the most significant innovation that led to the realization of air flight was the internal combustion engine of 1876.

A French inventor named Paul Cornu designed a helicopter as early as 1907, but there were major problems early on. The first helicopter that actually flew was invented by Etienne Oehmichen (another French designer) in 1924, but it only flew about half a mile. After many years of failed designs, Leonardo's dream came to fruition when Igor Sikorsky, a Russian aviator and inventor, studied da Vinci's sketches and notes and, in 1910, began drawing prototypes for a working helicopter. Leonardo would have been proud—and probably would have taken the first test flight.

One of the most significant aspects of Leonardo's design was that he conceived of the helicopter as a single, unified, elegant whole. Though it included a substructure, the screw-like rotor was essentially the entire machine. While modern equipment is, by necessity, a cacophony of moving parts, Leonardo's basic design was clear and simple.

The Ocean Liners of the Future

Being the all-around inventor that he was, Leonardo tried his hand at designing all sorts of vehicles. He sketched schematics for many types of land- and watercraft, including the world's first paddleboat. Leonardo also worked on making boats more efficient and durable, using his knowledge of fluid dynamics to investigate different hull shapes.

Hull designs for ships were not new—even Stone Age humans figured out how to carve out the inside of a tree and use it for a canoe. Leonardo added his own special flare by improving on existing hull designs in both shape and ergonomics.

In addition to his single-hull designs, Leonardo sketched out a double hull that would make the ship stronger and better able to ward off enemies.

This is one of Leonardo's ideas that has been good enough to endure into modern times, and double-hull steel ships are now quite common. He also worked on ways to resurrect sunken ships, one of which involved attaching tanks filled with air to the sides of a ship. The idea was that after an attack, ships could simply use these tanks to float back to the surface.

Paddleboats

While paddleboats are hardly necessary to our survival today, most of us have fond memories of paddling around a lake somewhere, and we owe it all to Leonardo. His three-dimensional pen and ink sketches dating to 1482 show a pointed hull—a very smart design idea, since it both increased speed and enhanced navigation. His sketches were highly detailed in some places; he specified gears, belts, and large cylinders connecting the entire assembly.

Leonardo also designed a paddleboat that had spaces for oarsmen as well. The logic here was that the wheels would have aided the oarsmen, rather than replacing them. Sounds practical, but you have to hope that the wheels were a good distance from the oars. Along this same line, Leonardo also drew a boat that was treadle-powered. The treadles (levers that are operated by foot) pumped up and down, moving a belt around a circular drum. This design was probably the most likely to succeed, but we'll never know—like most of Leonardo's inventions, no full-scale model was ever built.

Commercial Floats

Some of Leonardo's designs for watercraft weren't meant just for people. He knew that Italy was industrializing, and a major side effect was that goods had to be transported. He made some sketches showing a float for transporting building materials down a river. A dropped bottom provided space for either passengers or military personnel.

An interesting part of the design was that Leonardo wanted the boat to be built specifically to meet the needs of the occupants or cargo. Unlike today's mass-produced vehicles, several of Leonardo's ideas were designed to be "one-offs." Not very practical, but then again, Leonardo wasn't in the invention business to make money.

Military Vessels

Another revolutionary design was for a partial submarine, or semisubmersible. Though it was intended for battle, only a couple of people could fit inside it. Like modern submarines, it did have a tower leading to the surface, but the similarity ended there. Leonardo probably developed these ideas toward the end of his life, around 1515. Since his watercraft weren't intended for mass production, you have to wonder how useful a single submarine would have been—who would the pilot have fought against?

Leonardo was definitely a proponent of "think big." One of his largest boat designs was for a warship that basically served as a battering ram. Leonardo's drawings show an oversized rotating scythe, which was operated by a gear-based mechanism that raised and lowered it. Leonardo's attention to detail is evident in this design, which also includes shields for the oarsmen. Modern-day descendents from these battleships were built in the mid-nineteenth century, including the ironclad giants such as the USS *Monitor*. This type of warship is largely obsolete now due to the emergence of more flexibly designed aircraft carriers.

Leonardo also developed designs for various weapons to work with the battleship. For example, he sketched a cannonball attached to a shroud that, when launched into the enemy's sails, would rip the sails open. Leonardo sketched out both offensive and defensive designs, indicating the importance of military success to the Florentine citizen during the Renaissance years. His basic idea was that the best defense is a strong offense—a very modern idea indeed.

Around and Around We Go

The wheel is perhaps the undisputed champion in the world of inventions. It has influenced virtually every part of civilization, from politics and government, to housing and recreation. Wheels are used in almost all forms of transportation: cars, trains, airplanes, and anything else that needs to move along a firm surface. Imagine a modern commute without bicycles, cars, and buses. You'd need some new walking shoes! Though many of Leonardo's vehicles used wheels, he also used wheel, gear, and pulley systems in his other inventions.

History of the Wheel

Wheels are central to manufacturing and mass production, and most of us couldn't earn a living without the wheel. No individual can claim responsibility for the invention of the wheel. It was truly a societal creation. Initially, early humans moved heavy objects by dragging them around on sleds that were usually made of sticks or branches.

At some point, people realized that objects could move more easily when rolled over something round. The first step toward the invention of the wheel was probably to combine these two techniques by putting something heavy (like a tribe's weekly food) onto a sled, and then dragging it over round objects (such as logs) that were placed together. The sleds probably etched indentations into the logs, leading early humans to carve out the extra wood; this was the first step in creating a simple wheel-and-axle assembly.

QUESTION?

Where was the wheel first used, and for what?
The first evidence of using a wheel for transportation dates to at least 3200 B.C. Chariots in ancient Mesopotamia used wheels. Mesopotamian pottery wheels have been found which date back to 3500 B.C. The first spoked wheels probably came from Egyptian chariots, which date to approximately 2000 B.C. European cultures began using wheels around 1500 B.C.

Leonardo da Vinci used wheels in many of his designs. He was interested in ways to increase efficiency and safety by automating mechanical tasks. Automation allowed people to do more of what people were good at—philosophy, art, and other creative activities machines just can't do (even today!). Using machines to make life easier interested Leonardo, and he included the wheel as a foundation in many of his designs.

Many of Leonardo's machines used the wheel-and-axle concept. When fixed to an axle, turning one wheel meant that a second wheel would also turn. Leonardo was also interested in reducing the amount of effort it took to turn something—while a large force was necessary to turn the wheel,

it resulted in a much smaller force required to turn the smaller axle. So by using only a small force near the axle, a larger motion could be created in the wheel itself. Mechanical details like these show that Leonardo was not only interested in how machines worked, he also wanted them to work as easily as possible for their human operators.

Pulleys were also important to Leonardo's designs. At its simplest, a pulley is just a wheel with a cable going over it, with two weights at the ends of the cable. Moving one weight down makes the second weight, on the other side of the pulley, rise. You can even connect pulleys into teams, making it possible to use less force when lifting heavy objects.

Gears Connect the World

Leonardo also used gears in most of his machine sketches. First developed by the ancient Greeks, a gear is a toothed wheel that is placed next to other gears. When the first gear turns, its motion, and the force that goes with it, is transferred to the second gear. This setup is useful because it lets smaller gears use larger forces. You can also put gears at ninety-degree angles to each other.

FACT

In one example of gear usage, Leonardo's design for an adding machine contained an elaborate system of gears and cranks. Historians aren't exactly sure how this machine would have worked, but they think users could have done either calculations or ratios. Toothed gears, though, were essential to the design.

Leonardo used the wheel in other types of devices, such as an odometer. Much simpler than the odometer in your car, Leonardo's idea was just to measure distance. This idea was not new—Archimedes had even created a wheeled odometer in ancient Greece. Leonardo's design was interesting because it had a handle, almost like an old-fashioned lawn mower, that you could hold while you walked.

As the wheel turned, it turned a sprocket, making one stone fall into a basket every time the wheel went around once. You could then figure out how far you had gone just by counting the stones. Perhaps this system was a bit more complicated than looking at the digital display on your car, but it probably would have worked quite well.

Gone with the Schwinn

While Leonardo sometimes designed machines that had no practical use, others were actually quite functional. He sketched mechanical assemblies with no direct purpose, but also worked on inventions with immediate human application. If you were to go to Leonardo's showroom today, you'd find items such as a bicycle, an automobile, and a mechanical loom.

Out of all his sketches, Leonardo's bicycles were some of his most advanced. The most famous of these, found during a restoration of the *Codex Atlanticus*, shows a device with two wheels connected by a chain, plus a seat and handlebars. It probably would have been made of wood, including the wheels. It looks eerily like a modern bicycle, although its rigid frame would have made it very hard to steer.

Just to give you a sense of how far ahead of the pack Leonardo really was, he designed this sketch in 1493 and the next official bicycle design didn't come until the 1860s. These designs (by the Michaux father-and-son team of Pierre and Ernest) made use of the same basic idea: pedals and cranks. The Penny Farthing bicycle (with the very large rear wheel and high seat) came a few years later, in 1871.

Were They For Real?

Don't get too excited, though: there are some questions about the authenticity of Leonardo's bicycle sketches. The sketch had never been seen before its discovery in the 1960s, and some historians think that, based on the ink type, drawing style, and extreme similarity to modern cycles, monks in possession of Leonardo's notebooks may have added this sketch. The drawing hadn't been seen before this point, which is why some historians think

it was snuck in later. Of course, it's still possible that the drawing was just stuck in between the pages of the notebook for centuries.

ALERT!

Forgery alert! It is also possible that one of Leonardo's assistants added this sketch to the collection. Since these notebook pages have been sealed for preservation, it may be impossible to determine their original date. Still, if the bicycle design is authentic, then it just shows Leonardo's amazing foresight, and if it's a fake, it just adds to his air of mystery.

The Loom

In addition to the bicycle, Leonardo drew several mechanical looms around 1495. His was hardly the first design for a loom; weaving had been around since the Paleolithic and Neolithic ages. This ancient art is simple in concept: two sets of threads are placed into the loom and they are woven together to make cloth. Unfortunately, weaving was not always considered the most pleasant task, and during the Sumerian period, female slaves were often made to do the town's weaving. Loom work was done in teams, usually of several women.

Weaving In and Out

Leonardo's weaving machine, very intricately detailed, was intended to be completely automatic. It's clear from his design that Leonardo paid a lot of attention to how traditional weavers performed operations by hand. He actually devised gears and other machinery to achieve the same results, combining different actions into one that could be controlled by a single crankshaft. This device was to be built on two levels, one for weaving and one for removing the resulting fabric.

Leonardo went all out on this design, considering it one of the most important of the day. In a not-so-rare glimpse of hubris, he thought that it rivaled the recent ability to print using movable type.

The National Museum of Science and Technology (in Milan) seems to agree; they built a full-scale modern reconstruction and found that it worked

perfectly. While Leonardo did not supply dimensions in his original drawings, the museum staff was able to determine the size of the machine, working backwards based on the dimensions of a finished piece of cloth. Like so many of his designs, it's truly a shame that his loom was never built during the Renaissance—imagine how the course of history, or at least fashion, might have changed!

A Coach Fit for a King

Besides his designs for the bicycle and paddleboat, Leonardo also created a number of drawings of other vehicles. He was very interested in increasing the efficiency of civilian jobs and, as a result, he designed vehicles for non-military usage.

Cars on Springs

While Leonardo designed several horse-drawn carriages, he also leapt into the future with some sketches for a spring-driven vehicle, which could actually be forebearers of the modern automobile. One of Leonardo's drawings shows self-propelling vehicles that used a wheeled platform and coiled springs that were attached to gears, which had to be "wound" by the user. This design is actually similar to those of early automobiles in which drivers had to manually crank the car.

The winding only took care of half the problem, though, since the driver also had to steer. Do you know anyone coordinated enough to sit, steer, stand, and wind all at the same time? We can breathe a collective sigh of relief that Henry Ford didn't steal Leonardo's design.

Give It a Lift

Leonardo also thought about how to make construction easier. As architectural technology developed, the construction trade had to keep up. Lifting heavy materials to increasing heights was a well-documented problem throughout the medieval period (just think about all those cathedrals!) and even earlier; consider the issues that arose with building the Pyramids of Giza. Cranes had been developed by earlier cultures; the Romans used a

type of crane in building their monumental buildings and arches, and medieval cathedral builders designed lifting cranes with varying success.

Leonardo came up with several ideas to improve the situation. He sketched a number of designs for cranes that could be used for quarrying. The crane would lift a stone block out of the ground, and then a mechanism would automatically release once the load was out.

Leonardo also drew three-dimensional designs for cranes that pivoted on a platform, which would have been useful for constructing tall buildings. One design was actually mounted onto a trolley. One of the most interesting aspects of Leonardo's crane design is that, while there don't appear to have been any crane models built during Leonardo's lifetime, later engineers have built them from his specifications and found them to be nearly flawless.

FACT

Modern crane designs use some of Leonardo's basic principles, but are adapted to current materials. Today's cranes generally have a telescopic boom, or steel truss cage, that is mounted on top of a rotating platform. Caterpillar-type tracks allow cranes to maneuver through construction sites, and a big hook at the top works on a system of pulleys and cables.

So Little Product

You might wonder why so few of Leonardo's designs were ever built during his lifetime, if so many of them have been built in modern times and found to work. Part of the story is probably Leonardo's secrecy—he just didn't want to share his ideas with anyone. And the other part of the story is probably that Leonardo's designs were just ahead of his time—while we can build them today with modern techniques, many of them would have been impossible to actually build during the Renaissance.

Other Inventions

Compared to, say, the history of architecture, the field of robotics is relatively new. Most development in this area has happened in the twentieth century. However, leave it to Leonardo to be at the front of the pack. He was one of the first to have an impact on robotic design. In other fields, ranging from parachutes and skydiving to scuba and walking on water, Leonardo came out with a series of firsts, some of which actually would have worked!

13

Leonardo's Robot

Leonardo was one of the first to study robotics, but not *the* first. The first known foray into what would become modern-day robotics was a steam-powered bird developed by the ancient Greek mathematician, Archytas of Tarentum. About a hundred years later (around 220 B.C.), a mechanical water-clock design was developed by Ctesibus, an engineer and inventor in Greece. His clock designs contained statues and other moving figures.

A Non-Human Man

In 1495, Leonardo sketched out an idea for a mechanical robot that may have been the first such design in history. It was a mechanical, humanlike figure whose purpose was somewhat unclear—maybe Leonardo designed it just for fun. Leonardo's robot could turn its head via a bendable neck, open and close its jaw (which was close to being anatomically correct), move its arms, and sit up and down. Gears had been in use since first century B.C. Greece, and it is likely that Leonardo's robot design would have used accurate mechanical parts; Leonardo's later sketches certainly incorporated gears and pulleys.

In the drawing, the robot looks like a knight, since it appears to be wearing a suit of armor. It was designed with at least two gear systems that operated separately from each other: one to control the lower body (legs, feet, hips) and one for the upper body (arms, shoulders, hands).

FACT

You could say that Leonardo's robot design was a culmination of his research into anatomy and geometry. What better way to combine mechanical science and human form? He took the proportions and relationships inherent in Roman architecture and applied them to the movement and life inherent in all living beings. In a way, the robot was *Vitruvian Man* brought to life.

The robot served as a steppingstone in Leonardo's research into human anatomy. His sketches from the early 1500s focus on the circulatory and reproductive systems, showing incredible detail on parts of the human body that had been previously unexplored. Maybe his idea for the robot, with parts interconnected by cords, influenced his later sketches (which all show this same idea of systems being connected to each other by flexible channels).

Build It, They Will Come?

Historians are not certain that a physical model of Leonardo's robot was ever constructed. The design was misplaced for many years and was only discovered in the 1950s. Computer models of Leonardo's design have since been constructed, attempting to show how his robot might have been realized in sixteenth-century Italy.

One of the first modern precursors to the mechanical robot was created two hundred years after Leonardo. Jacques Vaucanson (1709–1782), a French engineer, built a mechanical duck with hundreds of moving elements. The nineteenth century introduced the idea of fantastical human-like machines in Mary Shelley's seminal work, *Frankenstein*. Robotic development took off in the twentieth century, and robots are now used in everything from children's toys to manufacturing to space exploration—they are, in many ways, a tie between science fiction and science.

Chutes (We Already Covered Ladders)

Leonardo was always interested in flight—human and otherwise. As a child, he spent hours watching birds. He drew every kind he saw, and this fascination stayed with him throughout his life. He was particularly interested in wings, and they occupy page after page of his notebooks. He did more than draw, though—he actually set out to make himself a pair of wings. The design matured into something resembling a modern parachute. Probably the first of its kind, this design depicted a fabric-based device that a person could use to float from the sky to the ground.

Construction

His first parachute, seen in one of his early notebooks, probably dates to 1485. This design looks a lot like a modern kite, with a person dangling from an airborne fabric structure that was held together by rigid poles. The parachute itself would probably have been made of linen, sealed at the edges so it wouldn't unravel or fray during flight. The poles would have been arranged in a pyramidal shape, with a maximum length of about twenty feet. (In contrast, modern parachutes all use flexible structures and fabric.)

Twenty-first century researchers have recreated models of Leonardo's parachute based on his sketches and notes. Some designs looked like an inverted ice cream cone. More advanced sketches showed a human sailing through the air suspended from large "wings" made of fabric. The adventurer could maneuver his way through the sky by leaning one way or the other, and the result resembled modern-day hang gliders.

Safety (Or Lack Thereof)

Today, we parachute from cliffs or airplanes, making sure that harnesses are safely attached. Not the least of our concerns are legal ones: If someone falls out of your airplane because it didn't have a door, for example, you'd be hit with a tornado of lawsuits. Not so in Leonardo's day! Unlike the parachutes of today, most of Leonardo's designs made no real provisions for personal safety. His notes suggest that the parachute could be used from any tall outcropping, and the user would be perfectly safe upon arrival back to earth:

> *"If a man had a tent made of linen, of which all the apertures have been stopped up, and it be twelve* braccia *[twenty-one feet] across and twelve feet in depth, he will be able to throw himself down from any great height without sustaining any injury."*

However, the rigid structure probably could have caused serious injury if it crumpled on top of the passenger inside. Like most of his other inventions, however, Leonardo's parachute was never built and tested during his lifetime. One of the biggest hurdles was probably finding something high enough to jump from.

Real Attempts

The first known attempt to build Leonardo's parachute came in 1617 at the hands of an Italian designer, Fauste Veranzio. He supposedly built a parachute based on Leonardo's drawings of 120 years earlier, testing it by jumping from a tower in Venice. By the late eighteenth century, parachutes were also starting to be used as emergency devices. A Frenchman named Jean Blanchard experimented with parachuting small animals off of buildings in the 1780s. Andrew Garnerin developed the first non-rigid-frame parachute design in the 1790s. Safety equipment, such as harnesses, was not added to parachutes until the end of the nineteenth century. Until then, parachutists had to hang on for dear life.

Leonardo's design was more fully tested in June of 2000 by a skydiver and camera flyer named Adrian Nicholas. After constructing a version of Leonardo's design using canvas, wooden poles, and ropes, Nicholas landed safely after jumping from a hot air balloon at 10,000 feet (for safety reasons, he broke out a modern frameless parachute 2,000 feet from the ground). Leonardo's parachute actually floated to the ground more slowly than a traditional parachute would have. While most people thought that Leonardo's design wouldn't work or would spin too much to keep the occupant from excessive nausea, Nicholas proved that the master's design was flight worthy. A model of Leonardo's parachute currently hangs in the British Library in London.

Modern Adaptations

The parachute, as first designed by Leonardo, has had enormous cultural and scientific impact. Parachutes were used on the Apollo and Mercury space capsules; they slowed the capsule down enough so that it could splash into the ocean. They are also used when landing fighter jets onto short runways, such as those on an aircraft carrier. Parachutes are used routinely as life-saving devices on airplanes, and for military paratroopers; they were also required in landing the recent robotic space missions on Mars. Leonardo's design, while not directly linked to these later iterations, certainly provided both the inspiration and the knowledge that such a revolutionary concept could actually work.

The World Before Xerox

Take a trip to your local neighborhood library. The shelves are filled with row after row of material—hardbound books, paperbacks, encyclopedias, atlases, audio tapes, videocassettes, CD-ROMs, and DVDs. They are all reproductions upon reproductions; there is, most of the time, no appreciable original. In the Middle Ages, you'd have a very hard time finding a library because there weren't any—the typology didn't exist because there wouldn't have been anything to put inside.

Early Copies

The responsibility for producing written works prior to the fifteenth century fell to monks, who were both literate and skilled in the art of transcription. Their task was not an easy one; they had to copy each word and illustration by hand from one piece of paper to another. Without even getting into the terrible inefficiency, there were several obvious problems with this method. The monks made lots of mistakes, and they were hard to fix. In addition, the paper used most often in the pre-Renaissance era was parchment made from animal skin, and like most things of natural origin, it simply didn't last forever. The fact that each and every book had to be made by hand created very high costs, making literature unaffordable for most people.

FACT

Reproducing illustrations by hand certainly presented challenges. With each copy, all the illustrations had to be completely redrawn, and it's unlikely that the transcription monks were artists of Leonardo's caliber. While the transcribed drawings were probably not horrendously terrible, there was also little point in reproducing a book of drawings if the point was to enjoy the original artwork.

Gutenberg

Things began to change for printed matter, though, in 1446 when Johannes Gutenberg (1334–1468) came roaring into the world of reproduction, creating the first printing press and, in the process, altering the courses of literature, education, and society at large. Gutenberg was actually a goldsmith by trade; he was the son of a merchant who had an interest in inventing from a very young age. He studied the existing method of printing known as "block printing." In this method, wooden blocks were carved by hand and stamped onto sheets of paper. It had been in use for generations in China, but was horribly inefficient because each wooden block had to be created by hand.

The invention of moveable type (also from China) was a huge breakthrough because it reduced some of this inefficiency. At first they used clay type, which was something of a problem because clay is easily cracked; metal type came later.

Gutenberg combined the existing movable type with oil-based ink, brass plates, and paper to create an array. The letters were then placed into a frame; these letters could be formed into words, and the results could be printed over and over again.

Printing Implications

It's impossible to overstate the importance of the printing press; its outcome was both immediate and immense. All of a sudden, people could afford to buy books. Kids had no excuse not to go to school. Many more people learned to read and write, and society had to keep up with this influx of newly educated workers. The fun didn't stop with books—both text and music could be printed, and more and more people wanted sheet music. And don't forget about the paper-making industry—they developed new

methods for creating paper more quickly, cheaply, and efficiently. There was money to be made here, and everyone wanted a share.

Revival of the Ancients

The ability to reprint ancient treatises and documents also factored in to the aims of the Renaissance—the classics could be brought to life. People could read Vitruvius, Aristotle, and other ancient Greeks and Romans. In addition, wealthier people who already had access to books started requesting a greater variety of literature, in different languages. There was suddenly a demand for poetry! Almanacs! Many new types of books were created, and they quickly became popular.

Leonardo's Take

Always true to form, Leonardo approached the printing press critically. The predecessor to the printing press was block printing, a method where a block of wood would be carved out to leave raised letters. In Gutenberg's updated printing press model, letters (type) were placed by hand along a track, and these letters were movable, meaning they could be reset for each new page of text. While Leonardo didn't propose completely reinventing the printing press, he had an idea to add a second track that would increase the machine's efficiency. He wanted to publish a treatise on this idea, but like most of his works, it remained hidden until well after his death.

QUESTION?

How did the printing press affect Leonardo?
The invention of the printing press actually had immense ramifications for Leonardo's future work. The technology of reproduction is the only reason that we're able to read his notebooks today. And everyone—future artists, inventors, school children—has benefited from being able to read the master's original work.

Under the Boardwalk, Down by the Sea

Leonardo was a considerate soul. Not only was he interested in the design of boats and other watercraft, he also thought about the needs of the sailors themselves. One thing we can't credit Leonardo with, though, is inventing diving. The ancient Greeks used a technique called breath-hold diving to search for food, gather sponges, and perform military reconnaissance. Folks as early as the Greeks and Romans swam underwater to escape enemy detection, probably by breathing through reeds. Some early inventors supposedly experimented with breathing from an air-filled bag underwater, but the recycled carbon dioxide likely put an end to those trials.

Swimming, diving, and generally working with water were ideas that Leonardo pursued constantly. He tried to expand the length of time someone could stay underwater, and he also wanted to find ways to protect the submerged diver. Aside from dangerous fish, there were underwater plants to brush against, sharp rocks to step on, and too many other obstacles. Many of Leonardo's oceanic inventions were never tested, but some are quite similar to actual devices that can be purchased today.

Diving Suit

One of his most futuristic ideas was that of a full deep-sea diving suit. Preliminary research into deep-sea exploration was beginning to take hold in the Renaissance, and Leonardo's ideas were influenced by this new interest in visiting the ocean depths. As with many things of a technological nature, the primary impetus (and, in most cases, funding) was likely the military. Italians had to become smarter about their battles, and water approaches were one way to take advantage of the natural terrain.

Leonardo's sketches show divers who were basically frogmen, prepared for land and sea at the same time. Their diving suits included land requirements such as regular clothes, ropes, and weapons. He also sketched out an "air sack" that may have sparked later inventors to create oxygen tanks. One such diagram shows the diver with a large, impact-resistant air tank attached to his chest so that he could dive far beneath the surface, but this chamber was so bulky that swimming with it might have been impossible. This idea of a wineskin containing air for divers was further explored in the

nineteenth century; Jacques Cousteau and Emile Gagnon came along and saved the day in the 1940s, with their development of the necessary valve.

Modern scuba diving was greatly aided by the 1771 invention of the air pump. John Smeaton created this device, connected a hose between the pump and diving barrel, and voila! Divers could actually breathe underwater. This setup was fairly cumbersome, though, and in 1772 the French inventor Sieur Fremient came up with another device that was more workable. As the technology gradually improved, so did diving capabilities.

Leonardo's suit was to be made of leather or other durable animal skin, and cane hoses allowed the diver to move and breathe easily. He tried to reinforce these connections with metal, so that the pressure of being deep underwater wouldn't threaten the safety of the diver. It seems that Leonardo intended this suit for relatively shallow diving, because the pipe providing air to the diver went directly to the surface. The top of the tube also featured a bell-shaped float, so that the air openings would always remain above water. Modern divers have actually built a suit from Leonardo's notes, and they reported that it functioned quite well.

Walking on Water

In true biblical spirit, Leonardo developed ideas in 1480 to let humans walk on water. Unlike certain well-known religious icons, though, Leonardo's water walkers had to use special floating devices to keep them from sinking. This addition probably kept Leonardo from being deemed a heretic, and also added a touch of practicality. These floats would have been attached to the feet of the user, who would have balanced by holding on to long poles.

Why invent a way to walk on water? What was Leonardo hoping to achieve with this design? From his notes, it appears that he simply wanted to master the art of free movement, despite the apparent obstacle of an unstable surface. Leonardo believed that motion should be free

and unencumbered, whether it was on foot, on water, or by air. His float design was, in a sense, something Leonardo believed should come naturally. In his notebooks, he writes of water as "the vehicle of nature"—as water circulated, it was actually a vehicle for life itself.

Don't try Leonardo's walking-on-water trick at home. Even Leonardo himself doesn't seem to have ever built or tested a real version of this device. The National Museum of Science and Technology, located in Milan, has a model of Leonardo's float design. Their model looks like someone cross-country skiing, and it matches Leonardo's sketch to a T.

Water Gloves

Many of Leonardo's sketches for water-based machines focused on convenience. For example, he designed a glove with webbing in between the fingers, imitating a duck's webbed feet. These gloves would have been worn in the water, creating smoother and faster self-powered transportation. They also would have spared the wearer's hands from sticks, stinging fish, and other hazards. One of Leonardo's sketches shows gloves that are proportionally as large as the flippers that swimmers wear on their feet.

Harnessing the Power of Water

When it comes to water, there aren't many simple solutions. Leonardo had to investigate many different aspects of underwater mechanics. On dry land, Leonardo spent a lot of time studying and designing aircraft, including elaborate helicopters, gliders, and parachutes. Never one to limit himself, he was also fascinated with water and devoted years to designing machines that worked with water. Given the sheer amount of water surrounding Italy, he picked a great hobby! It is likely that he was first exposed to aquatic engineering while apprenticed to Verrocchio, who was, among other things, a hydraulics engineer.

The Appeal of H$_2$O

So why the interest in aquatics? From his observations, Leonardo knew that water was inherently contradictory. He described it as the *vetturale di nature* (vessel of nature). And it's only fitting that such a force of nature would have intrigued Leonardo. Studying for its own sake was never enough for Leonardo; he had to be making something. Between about 1485 and 1490, Leonardo developed several schemes for machines that worked in water. One design was for a type of water pump that could actually drain an entire port. This pump would have been useful when pylons had to be driven into water, or when a building's foundation had to be built underwater. He also developed pumps that could remove water from a ship (or anyplace else) through a valve.

Leonardo's *Codex Atlanticus* contains many designs for water-controlling devices. For example, he came up with several ideas for sluice gates, or movable panels, that could drop down to divert the flow of a river or canal. He also made detailed three-dimensional sketches for dredges (machines that could clean the bottom of locks and canals), which used mooring ropes to wind up the dredge and force it along the shoreline to the next point.

Measuring Water

Leonardo also invented a variety of devices for his experiments with water, including a machine that measured the expansion of hot water during the production of steam. The device consisted of a bucket for cold water that, when heated, expanded and caused an exterior weight to fall. These sorts of measuring devices helped his experiments succeed.

Some of Leonardo's drawings show machines that use water to achieve another purpose. He sketched a hydraulic saw that used water to power the blade; this device could have been used for cutting logs and other large objects.

Archimedean Screw

He also worked on a design that improved the Archimedean screw. This was an ancient device that used a turning handle to pump water out of a well or uphill. It was reportedly developed by Archimedes (287–212 B.C.), a

Greek mathematician who many consider to be the father of modern mathematics. Like Leonardo, Archimedes had an intense interest in water and developed the first principle of buoyancy. He also created designs for levers, and these combined interests led to the development of the water-pumping screw.

Leonardo's take on the Archimedean screw was similar to both his helicopter studies and a later waterwheel design. He designed a very large screw which terminated in a handle; inserted into a well or lake, water would be pumped up at a moderate angle. Variations of his design are actually still in use in some countries; the Archimedean screw provides an inexpensive way to irrigate crops, and it can be powered by either people or animals.

Leonardo's Waterwheel

Waterwheels were developed years before the Renaissance. A waterwheel is essentially a very large wheel with paddles mounted around its circumference. Water was used to spin the wheel, thereby moving the paddles. Writings from as early as 400 B.C. mention the waterwheel, which was used in those days to irrigate fields and provide fresh potable water. They were also used for grinding up grains and for other productive tasks.

As Leonardo probably realized, there were several different ways to use a wheel in the harnessing of energy. One used a vertical wheel, like those in Leonardo's designs. A variation on this design was actually used to transport objects vertically, more like a lifting tool. Yet another variation used a horizontal wheel that drove a millstone, which traveled vertically through the wheel.

Waterwheels in general were of great interest to Leonardo. They had the capacity to quickly replenish supplies (such as the local water tower) that could be exhausted during battle, and therefore had a utilitarian purpose; Leonardo was always keen on inventions that had immediate practical applications. He used the idea of the waterwheel in the design for a mill which rested on either side of a canal; the paddles on the waterwheel therefore had a naturally occurring power source (the canal), which could operate for as long as the canal held water at a sufficient height.

Telling Time with Water

Leonardo also created a water clock, which set off an alarm based on the amount of water flowing from one container to another. The history of timepieces is, compared to the history of the universe, relatively short; people don't seem to have had much of a desire to know the time until about 6000 years ago. Around 4000 B.C., as cultures started coming together more and creating standards for government, it became necessary for people to have set times for meeting each other.

There is evidence of obelisks dating back to around 3400 B.C. These sun clocks were basically just large monuments; as the sun cast a shadow from the obelisk onto the ground, people could plan their schedules around group meetings. Obelisks were also useful because as the sun started traveling lower in the winter, people could tell which were the long and short days—very useful for farming and other outdoor activities.

Of course, it wasn't always practical to have a clock that relied on the sun. What happened during cloudy days? Or nighttime? While it appears that there was some Egyptian experimentation with water clocks, they were used more often in the Greek period, around 300 B.C. In full keeping with Renaissance tradition, Leonardo looked to his ancient Greek predecessors for a starting point.

At its most basic, Leonardo's water clock consisted of a stone jar or other container from which water dripped. A second vessel was filled at a continuous rate. As the volume of water increased, people could use markings inside the container to see how much time had passed. While Leonardo produced designs for other types of clocks, such as a sand clock, he focused his timepiece design on the water clock.

Leonardo's water clock might not have the cachet of an hourglass, but it apparently worked quite well if you didn't mind the sound of dripping water. What's interesting about Leonardo's method is that it was developed around the same time as the probably fictional "Chinese water torture."

chapter 14
Leonardo's Notebooks

Leonardo was practically Shakespear-
ean in the volume of written work he
left behind. His notebooks contain thou-
sands of pages of writing and draw-
ing and capture both fact and intent.
He documented scientific experiments
and more casual thoughts on art and
science, using both text and accompa-
nying illustrations. On more than once
occasion, Leonardo strove for fame (if
not fortune) by organizing his thoughts
for future publication. With the excep-
tion of his *A Treatise on Painting*, however,
little of his writing was ever published
until modern times.

The Leonardo Diaries

Notes were Leonardo's method of choice for recording his observations about the world around him. He began this habit when he was about thirty-seven years old and continued it for the rest of his life. They didn't have spiral binding in the Renaissance, nor could Leonardo hit up the local art supply store for a diary. Instead, he composed on loose pieces of paper of varying sizes. You can imagine Leonardo jotting down his latest inspirations on whatever pieces of scrap paper he had lying around—the Renaissance equivalent of cocktail napkins and envelope backs, perhaps? These notes reflect Leonardo's own spirit: instead of being an orderly progression of thoughts, they appear more like an unedited outpouring of Leonardo's brilliance.

In addition to his writings and sketches, Leonardo's notes also contain many drawings. Some were studies for eventual paintings, while others were portraits or self-portraits. In addition to all his artistic works, he composed a variety of fables and short stories probably meant for the amusement of royal courts.

Leonardo's notes were somewhat of a mess, but that was fine—no one else had to read his private records, or so Leonardo intended. They were practically written in a new language, anyway. As mentioned previously, Leonardo wrote in Italian, but he wrote backwards, from right to left (perhaps because he was left-handed) and in a mirror fashion, where all the letters were backwards as well. He also invented his own shorthand, abbreviating and combining words, or in some cases dividing one word into two. And just to make matters more difficult, Leonardo also abstained from punctuation.

Maintaining Order

Due to the scattered nature of Leonardo's notes, individual pages may deal with a diversity of topics. For example, a page that begins with an astronomical study of the motion of the earth can end with a discussion of the mixing of colors. Similarly, a page on the structure of the human intestines might finish as a discussion of the relationships between art and poetry. Even pages that consider one main topic are often covered with sketches or doodles of unrelated subjects.

Fortunately, Leonardo's observations are mostly self-contained on a single page of his notes. Leonardo was very careful to note if they continued to the back of the page or to a different page altogether. Aside from this care in continuation, however, there is almost no overall order or numbering to the pages—few are even dated or numbered at all.

Because of their general disorganization, it is clear that Leonardo never intended to publish his notes in their raw form.

FACT

Leonardo apparently was trying to collect his scientific thoughts and discoveries into a series of treatises, a sort of encyclopedia of his knowledge. Imagine how amazing and influential such an *Encyclopedia da Vinci* would have been! Unfortunately, except for his so-called *Treatise on Painting,* none of Leonardo's work was published until very recently.

A Treatise on Painting

Leonardo's first published book, *A Treatise on Painting*, appeared as a 1651 French book. The work became extremely popular. Reprinted in six different languages, it would have definitely been on the Renaissance bestsellers list, if there were such a thing. Unfortunately, however, this book wasn't actually based on Leonardo's original notes, but on copies that only had a few small parts of the original. The published version didn't even use Leonardo's original order or try to combine ideas logically. Instead, it was just in the random order of whomever it was that made a copy in the first place. Sure sounds like a mess—it's amazing that this work was published at all, let alone popular.

The next significant development with Leonardo's published works occurred in 1880. A da Vinci specialist named Jean Paul Richter, who was inspecting a Leonardo manuscript from a private collection, discovered a large fragment of the text from *A Treatise on Painting* in its original form. What a find! Richter continued his scavenger hunt throughout Europe, eventually discovering many parts of the work. Richter was able to create a new version that was very close to resembling Leonardo's actual intentions. This

"new" treatise includes many drawings and sketches to illustrate various points, and discusses perspective, light and shadow, color theory, the proportions of the human figure, as well as botany and landscape painting.

Other Topics

In addition to his notes on painting, which were the best developed of his notes and clearly destined for publication, Leonardo also wrote about many other artistic topics. For instance, Leonardo jotted down his thoughts on sculpture, with particular emphasis on his great, unrealized work, the Sforza horse.

Leonardo's discussions of sculpture also include detailed notes on heating and working with metal and alloys at various temperatures. Talk about thorough. His interests were wide-ranging, and the care he took in recording them contributes greatly to our understanding of Leonardo's work today. Wouldn't it be great if every genius documented his thoughts so completely?

Notable Notebooks

Leonardo's most formalized notebooks comprise *A Treatise on Painting*, but what about the other thousands of pages he wrote? They cover a wide range of subjects, including architecture, anatomy, zoology, physiology, astronomy, time, water, boating, musical instruments, and various fables and stories. Leonardo may even have intended to turn his observations on various subjects, especially those sections on architecture, astronomy, and water, into entire books. Leonardo was, in many ways, a walking encyclopedia.

Architectural Musings

Scattered throughout Leonardo's writings are many notes on architecture, accompanied by detailed sketches. Leonardo may have intended to collect these notes into a treatise on architecture, which would have put him

in good company with other famous architects of the day. Unfortunately, he wasn't quite as careful with his architectural notebooks as he was with the ones on painting; the building and design pages are scattered and much less well developed. His architectural notes are a mixture of reality and fantasy: They contain both practical sketches of existing buildings, and experimental drawings of problems such as how buildings crack.

His notes range from almost boring to completely out of this world. While some comments were pretty abstract, he also made really useful suggestions. In one of his more practical moments, Leonardo notes that any room or building that serves as a dance hall should be located on the ground floor, so as to avoid the danger of dancers stomping their way through the floor.

FACT

Leonardo studied the strengths of materials, although his methods were only experimental and not theoretical. Leonardo wore many hats throughout his life, and Lab Rat was one of them. He also studied science from other perspectives, combining theory and experiment to come up with comprehensive ideas about how the world worked.

Where Babies Come From

Leonardo's notebooks reveal his fascination with the process of conception—from a medical standpoint—and the layout of a fetus in the womb. He didn't stop there, though, and continued to chronicle the lives of people from infancy into the teenage years. He knew that adults were physically unlike children; he studied their anatomical composition of muscles and bones, and understood that our bodies undergo many changes as we age.

Leonardo also studied four of our most common human conditions: laughing, crying, fighting, and working. To finish off his work, he described human movement as a mechanical system of interlocking parts. While we as humans are definitely not as predictable as machines, Leonardo was one of the first to come up with this idea. What an amazing combination of engineering and medical knowledge!

Time

Leonardo also had some interesting ideas on time. And no, he didn't invent the wristwatch. He made a geometrical comparison to time, thinking that an instant of time is like a single point, while a particular interval of time is more like a line. Can you imagine other Renaissance painters going into this kind of philosophical depth? He also realized that time could be subdivided into smaller and smaller portions, just like a line can be divided into smaller and smaller lengths.

Nature

Leonardo was always a keen observer of the natural world. Throughout his notebooks, he made frequent, scattered references to water, showing his underlying obsession with it. He even laid out notes for a book on his observations of water. He was incredibly thorough here, and made comments on everything from the ocean to rivers, from gravel to sand, and from conduits to canals. Never one to take the easy way out, Leonardo kept going and made notes on machines run by water and erosion. While this outline could have expanded into a bestseller, it apparently never quite made it into full book form.

ESSENTIAL

Some of Leonardo's notes are part of our common knowledge today, such as his observation that water always runs downhill. His notes also mention various geographical locations, many of which Leonardo visited and surveyed himself. Was there anything Leonardo didn't do?

Leonardo also considered himself an amateur mariner and wrote about several matters related to ships, such as how to figure out how fast a ship is going. He considered swimming and ways for people to survive in and under water, and noted that humans seem to be the only toed species that isn't born knowing how to swim.

The Quotable Leonardo

Leonardo's notes contain a number of philosophical statements and maxims. These pithy comments span such topics as religion, morality, science, mechanics, politics, speculation, spirits, and nature. His writings also include a number of mathematical tricks and rebuses.

In addition, he constructed a number of short fables, mostly featuring animals. Leonardo probably recited these to amuse the courts of various monarchs and rulers. He also wrote a variety of jokes and other amusing stories, such as this one:

"It was asked of a painter why, since he made such beautiful figures, which were but dead things, his children were so ugly; to which the painter replied that he made his pictures by day, and his children by night." (from *The Complete Notebooks of Leonardo Da Vinci,* translated by Jean Paul Richter)

Transfer of Knowledge

Upon his death, Leonardo probably wanted to leave his notebooks to a close personal ally, someone who would never sell them or lose them in the basement. And whom did Leonardo trust with this weighty responsibility? None other than his pupil and close friend (and probable lover) Francesco Melzi. Leonardo's last will and testament reads, in part:

"The aforesaid Testator gives and bequeaths to Messer Francesco da Melzo, nobleman, of Milan, in remuneration for services and favours done to him in the past, each and all of the books the Testator is at present possessed of, and the instruments and portraits appertaining to his art and calling as a painter." (from *www.gutenberg.org/dirs/etext04/7ldvc09.txt*)

Trust in Melzi

Since he had no wife, children, or other close relatives that we know about, Leonardo chose to leave the bulk of his estate to Melzi. This included

the remainder of his pension and all his clothes. He also named Melzi the executor of Leonardo's will.

Scholars believe that Leonardo left at least fifty (and perhaps as many as 120) complete notebooks to Melzi. Today, unfortunately, only twenty-eight survive in various versions. There aren't very many notes left from before 1500, so most of what's available are his writings from about 1500 up until his death in 1519. In addition to notes, there are also drafts of various letters that Leonardo composed as well as financial statements showing how much he paid, or was owed, by various people.

After Leonardo's death in France, Melzi brought the pages back to Italy with him, keeping them with him until his death in 1570. There is some evidence that Melzi attempted to organize and excerpt some of Leonardo's writings, as well, including discussions that became *A Treatise on Painting*.

A Lost Treasure

By the time of Leonardo's death, unfortunately, much of his fame and reputation had been forgotten. He died as a recluse in France and didn't produce much in his final years. His choice of heirs didn't help much in spreading the word of Leonardo's good name—Melzi was a minor noble, but of little importance. When the notebooks were discovered after his death, their value was not recognized. Because of Leonardo's mirror writing, they appeared to be gibberish to the untrained eye, and many people probably thought they were mere scribbles.

ALERT!

Make sure you write a good will! Melzi's heirs certainly didn't help the situation with Leonardo's notebooks. They left the precious documents in an attic. They later gave away or sold many of the individual sheets, without any idea of what they were actually worth. It would be like selling off your grandmother's precious silverware, fork by fork, rather than keeping her collection intact.

Scattered in the Wind

It was through this combination of blunders and ignorance that Leonardo's notebooks, sketches, and writings became scattered. Many were probably discarded, and some of the remaining pages show notes in other handwriting in various places—meaning someone else (a monk, perhaps) made their own notes on top of Leonardo's. Can you imagine doing your homework on top of the *Mona Lisa*?

Tragically, only a small percentage of Leonardo's prolific written output was saved, and these pieces have been collected over the years in volumes called codices. Probably the pages with particularly interesting sketches were kept more often than the pages and volumes with only text, since at least it's easy to tell that the sketches were something worth looking at. It's frustrating to wonder what treasures must have been lost over the years, though. This dilution of Leonardo's body of work also reduced the impact that his intellect had on history, particularly in the sciences.

The Price of Secrecy

In the end, many factors doomed Leonardo's prolific scientific output to obscurity: his secretiveness in recording his observations, the lack of publication, and his many incomplete projects. Because very little of Leonardo's work was ever published or shared, his discoveries actually had little impact on the progress of science. How would anyone have known what Leonardo was thinking if he never shared it with anyone?

Scientific discovery and invention, in fields from military engineering to human anatomy, proceeded in the slow, steady pace typical of history—unfortunately, it proceeded without the benefit of Leonardo's great leaps of intellect. Maybe history just wasn't ready for Leonardo, but we'll never know because Leonardo gave so little of his work a chance to be studied.

Because of his lack of influence on future generations of scientists, Leonardo is sometimes called the last of the ancient scientists (because of technological and political limitations, these scientists tended to work in isolation). Today, the progress of science is much more collaborative—scientific discoveries are all based on the theories that came before. A truly innovative thinker like Leonardo, who basically invented most of his work

from the ground up, would have had a very different place in a modern scientific world.

Decoding the Codices

About 5,000 pages of Leonardo's notes still exist today. Originally written on loose sheets of paper, these notes have been bound over the years into notebooks called "codices." And what is a codex, you ask? It is, simply put, a collection of manuscripts. The word codex is a useful one to apply to Leonardo's books because they've been arranged into separate volumes. Each codex has a name, and it's easy to identify which particular sheet belongs to which group. The modern arrangement of the codices is somewhat haphazard, though, and the current volumes probably bear no resemblance to the actual order in which Leonardo wrote them. He should have numbered his pages!

Leoni

Perhaps the person most responsible for this erratic mess was Pompeo Leoni, a sculptor at the royal court of Spain in the seventeenth century. Leoni collected many of Leonardo's writings, but while trying to organize them, he cut and pasted pages from various notebooks and sections of Leonardo's writings, organizing them into separate volumes arranged into artistic, technical, and scientific sections.

Leoni's method destroyed the original order, but at the same time provided us with a convenient cataloging system. From Leoni's efforts sprang the *Codex Atlanticus,* and the so-called Windsor collection. Both of these codices are notable because they consist mainly of drawings and sketches that Leoni cut out of other places in Leonardo's writings. When Leoni died, some of the manuscripts were brought back to Italy, while others remained in Spain.

Codex Atlanticus

The *Codex Atlanticus* is currently located in the Biblioteca Ambrosiana in Milan. One of its most wild ideas was Leonardo's plan for a self-moving car. This volume contains hundreds of sheets of Leonardo's original notes,

most of which date from between 1480 and 1518. The codex was donated to the library in 1637, but was taken to Paris along with other notebooks of Leonardo's when Napoleon conquered Milan in 1796. There, the notebooks were kept in the National Library of Paris and the Institute of France.

In 1851 the *Codex Atlanticus* was returned to Italy, but twelve other manuscripts remained in France at that point. Primarily, the *Codex Atlanticus* contains the technical, mechanical, and scientific drawings from different notebooks, while the artistic, natural, and anatomical drawings are part of the collection at Windsor.

About 400 pages of the *Codex Atlanticus* are currently available online, although only in Italian at the moment. The site is ✍*www.ambrosiana. it/ita/ca_principale.asp*. Even if you can't read Italian, the site is well-worth perusing for a glimpse of some of Leonardo's amazing sketches and other ideas.

Diving into the dusty library stacks isn't always a thrill, but the folks in Madrid are sure glad that they did. Some of Leonardo's most valuable writings remained safe but unknown in the Biblioteca Nacional, in Madrid, until they were found by chance in 1966. These documents are now known as the *Madrid Codices*. The two volumes include work on mechanics, dating from 1490 to 1496, and geometry, from 1503 to 1505. What a find!

Codex Arundel

Leonardo's other codices are located all over the world. One particularly interesting volume is currently housed in the British Library. The *Codex Arundel* consists of 238 sheets that were removed from various other notebooks, forming a hodgepodge of drawings and notes. Leonardo wrote in this volume that he began collecting various comments and sketches into one place, which he wished to later organize according to subject. Of course, he never actually got around to finishing this project.

Leonardo started the collection in 1508, while he was living in Florence. Like most of Leonardo's other codices, this one was put together after his death from sheets of various sizes. While most of the contents come from around 1508, other pages were written at different points in his life. The subjects include everything from mechanical designs to studies on the flight of birds.

Parts of the *Codex Arundel* are currently available online from the British Library, in a shockwave format that allows you to turn pages and translate text, at this site: ✎*www.bl.uk/collections/treasures/digitisation.html*. This amazing site lets you browse through the codex like a virtual book, and gives you an authentic experience of studying Leonardo's works.

Minor Codices

A more minor codex, called the *Codex Trivulzianus,* currently makes its home in the Biblioteca Trivulziana at the Sforza Castle in Milan. This selection of fifty-five sheets contains Leonardo's notes on architecture and various religious themes. These early works are thought to date from between 1487 and 1490. Another minor codex, called *On the Flight of Birds,* is in the possession of the Biblioteca Reale in Turin. Consisting of seventeen pages, dating from about 1505, Leonardo used this codex to make a rigorous study of the details of flight, including wind and air resistance.

MicroCodex

The only codex that is currently in the United States is the *Codex Leicester,* which was written between 1504 and 1510. Software giant Bill Gates paid $30 million to purchase the "Codex Leicester" in 1995. This seventy-two-page codex consists of double-sided sheets of linen paper, and its main topics include studies of water, rocks, light, and air. Like most of Leonardo's works, it was done in Leonardo's signature mirror writing. The *Codex Leicester* was one of the few manuscripts that was not inherited originally by Melzi and, at the moment, is the only manuscript of Leonardo's that is privately owned.

Leonardo's Other Artistic Accomplishments

In addition to his more well-known talents, Leonardo also spent time in a number of other artistic pursuits. He created both portraits and self-portraits. His notebooks show his love of story-telling and performing, as Leonardo created fables to recite and music to perform at the courts of Europe. As a teacher, Leonardo seems to have had mixed ratings from his students. While many people wanted to study with him, his genius proved hard to share, and he had no real artistic heirs.

Portraits

Portrait painting is in a different league from landscapes or religious scenes. The artist had to have the skill to create a reasonable likeness, or else the subject would not be satisfied. Then, of course, there was the difficulty of being the subject. He or she had to stay still for extremely long periods of time. Leonardo was sought-after as a portrait artist, and his particular ability to capture not only the likeness but also something of the personality and inner spirit of the person being painted made him even more celebrated.

QUESTION?

How are portraits different from photographs?
Portraiture is not the same as photography. The goal isn't just to create a mirror image of the original; the artist also has to capture some aspect of the subject's spirit, in addition to selecting a proper pose and background. And, of course, in the Renaissance photographs weren't an option—the only way to record someone's likeness was in a portrait.

The Gab on Garb

Should the subject be nude or clothed, dressed to the nines or in everyday garb, sitting or standing, holding a favorite pet or other object, seated by a window or lying in a bed? The portrait artists of the Renaissance had to go back and forth with the subject, making compromises but also trying to ensure that the final painting was a good one. That's a pretty huge checklist—which is why good portrait artists were few and far between.

Portraits were typical early commissions for a young artist, and Leonardo seems to have gotten a number of such requests. His portraits weren't the typical flattering ones that portrayed the subject dressed in her finest jewelry and robes with an enhanced smile on her face. Rather, Leonardo seems to have portrayed the subjects of his work with a touch of realism that was rare in the Renaissance. Most portrait recipients seem to have been pleased with the completed product, although, of course, any portraits that were not well-received probably would not have survived to modern times.

FACT

The portrait painters of the Renaissance were not above a little artistic license in improving upon the appearance of the person they were painting. Successful portrait artists often took liberties with a person's appearance to come up with a flattering portrayal. Of course, this still happens today even in the age of photographs—photos of fashion models are routinely airbrushed to achieve perfection.

Calling All Ladies

Leonardo painted a number of portraits of women during his early years, including *Ginevra de'Benci* of 1480 and *La Belle Ferronniere* of 1495. The portrait of Ginevra de'Benci is one of his earliest preserved works that is actually completed, and shows his different approach to portraiture. The subject of the painting has what might be called a less-than-flattering look on her face—she looks almost like she's grumpy about something. Not much is known about the story behind this early portrait, so we can only speculate about the reason for her expression. Perhaps she was not excited about her impending marriage? Or perhaps the weeks of sitting quietly to pose for the portrait took their toll?

And Now the Gents

Leonardo did paint male portraitures as well, but not nearly as many as those of women. One well-known male study is the *Portrait of a Musician* from 1483, which is also one of his best-preserved paintings. Ironically, we know very little about it—we don't even know who the person in the picture was! Some historians believe it to be Ludovico Sforza while others think it is Franchino Gaffario, Milan's most famous choirmaster.

Special Portraits

Leonardo's celebrated *Mona Lisa* is a hallmark of portraiture because it captures the subject's essence so unforgettably. Leonardo's technical painting abilities helped him make her appear unfathomably real, but her eyes,

mouth, and other facial features also give her a mystery that is rarely captured in a painting.

Lisa's portrait may not be as true to life as it seems. Modern-day historians have aligned the *Mona Lisa* with Leonardo's own self-portraits, showing that the features line up nearly precisely. Maybe this suggests that Leonardo included a bit of himself in his historic work.

In addition to his finished paintings, Leonardo also made chalk studies of other wealthy individuals, some of which he probably planned to copy and paint later. One such study is the *Isabella d'Este* chalk and pastel drawing, dating to about 1500. Lack of interest (or perhaps the unavailability of the subject) seems to have prevented drawings such as these from reaching completion. While unfortunate, it's hardly surprising to see even more unfinished works from Leonardo.

In addition to portraits, and in contrast to his favored portrayals of angels, Madonnas, and other figures of extraordinary beauty, Leonardo also sketched wanderers and gypsies. One of the most unusual of these portraitures is his *Grotesque Head* chalk drawing of 1504. He did a number of pen-and-ink caricatures in the 1490s, most of which show distorted facial features and hair. Biographer Vasari has addressed this dimension of Leonardo's work, noting that Leonardo was very interested in odd people and would often follow them, committing their features to memory. His original *Grotesque Head* image is nearly life-sized and seems to have set a trend; other painters around Europe soon began creating their own versions of grotesque portraits.

Leonardo's exaggerated sketches showing the grotesque side of human nature were some of the first caricatures. By focusing on particular features, Leonardo was able to draw attention to parts of a person which were uncharacteristic of the whole. It is possible that these drawings provided one of the earliest foundations for modern-day political cartoons.

Self-Portraits

Artists are luckier than the rest of us. They can use their tools of the trade to memorialize themselves for all eternity, preserving their image for future generations. Self-portraits as propaganda have been around for hundreds of years—ancient Roman emperors and other politicians routinely had themselves impressed onto coins, which guaranteed that their image would be in the hands (and pockets) of the masses. Many emperors even took credit for the artwork themselves. Painters and sculptors throughout history have created images of themselves as a way of ensuring a legacy while simultaneously advertising the artist's skills. Self-portraits also reveal how the artist sees himself, and can be particularly intriguing to trace throughout an artist's career and life.

Precedents

Most famous artists have painted at least one self-portrait. Goya, Rembrandt, Durer, Van Gogh, and many others chose to focus primarily on self-portraits. While Leonardo was busy with bigger (and better?) tasks, he did create several self-portraits over the course of his life that, in a prephotographic world, give viewers some insight into his more personal side. Who isn't curious about what the great genius actually looked like? Fortunately, it's not that much of a mystery.

The Master's Softer Side

Not all of Leonardo's self-portraits are pretentious and formal. One of Leonardo's best-known self-portraits contains his own annotations, dating to about 1512, and was done in red chalk on paper. In this drawing, he has a full, flowing white beard and is clearly getting on in his years. Leonardo may have created several other sketches of himself, though it's a bit tricky to confirm that he actually drew them. One example is a sketch named *Old Man Sitting*. It's most likely from the late 1400s and appears to be Leonardo sitting along the bank of the River Loire.

Another example is *Profile of a Warrior in Helmet*, a silverpoint drawing Leonardo prepared in 1472. Given the time period in which Leonardo created this work, it is possible that this drawing was actually one of

Verrocchio's models; it resembles similar figures in Verrocchio's bronzes and doesn't really look much like Leonardo. Some historians, though, believe that it was actually a self-portrait.

Self-Inclusion

In addition to these standalone self-portraits, Leonardo also included himself in several of his most famous paintings. He was clever enough to sneak himself in as a bystander—the patrons probably never even knew that Leonardo was in the paintings. One of the best examples is his *Adoration of the Magi*, into which most historians think he painted himself as one of the shepherds. The figure in question is in the bottom right corner of the painting, and the shepherd is facing away from the main crowd. Just another indication of Leonardo's slightly devilish sense of humor!

His self-portraits weren't just limited to paintings, either. In 1496 Leonardo illustrated a mathematics book for Fra Luca Pacioli (1445–1517), a mathematician who wrote several books on geometry, arithmetic, and proportions. Leonardo may also have included a self-portrait of himself in the book, which was called *Divina Proportione*.

Leonardo the Model

While Leonardo enjoyed painting himself, he also extended this privilege to others, and at various points in his life, Leonardo posed as a portrait model. Verrocchio probably based his 1466 sculpture of *David* on a young Leonardo. Raphael likely used Leonardo as the model for Plato in his 1510 painting *The School of Athens*. Also around this time it is thought that Leonardo's student and companion Francesco Melzi drew a red-chalk image of Leonardo, as he would have appeared in his final years. Because the quality in this drawing is so high, it is thought that Melzi may have actually traced over a self-portrait Leonardo created a few years earlier.

Leonardo's Fables

In addition to his copious notes on various topics that he studied, Leonardo also turned his hand to fiction, writing a number of fables that were

intended to illustrate a particular moral point. These fables are found scattered throughout his notebooks. Many of Leonardo's tales involve intelligent animals, perhaps another indication of his interest in and admiration for the natural world.

Telling Stories

When it comes to ancient arts, nothing goes back further than storytelling. Some of history's oldest religious and civic documents were originally passed from tribe to tribe (and generation to generation) by the elders recounting stories to the younger members. It wasn't all work, though; storytelling was fun and brought the entire community together.

Ancient Egyptian papyruses indicate that royal families (the only ones documented at the time) told stories to their children. Everyone else probably did too, but we don't have any record of it. One of the oldest historical epics, *Gilgamesh*, was written on stone tablets and can be dated to twelfth century B.C. Babylonia. Over time, many other societies have developed epic tales that defined and described popular aspects of their culture; these tales include *The Iliad* and *The Odyssey* from ancient Greece, as well as more modern stories such as *The Merry Adventures of Robin Hood*.

Short and Sweet

Leonardo was *not* a writer of epics. Instead, he dabbled in the field of fiction writing, gracing us with a number of short stories. We're not even sure that Leonardo wrote them all himself; some of them might be stories that friends of Leonardo wrote in his name, or stories that Leonardo simply wrote down after hearing someone else tell them.

FACT

Many of these stories are still told today, and most people don't even know that they came from Leonardo da Vinci; they are simply known as Italian folk tales, beloved by children and adults alike. Yet another instance of Leonardo's influence on history, however unknown.

Leonardo wrote at least thirty stories. As with his notes and sketches, he illustrated most of his stories. One of his first was a fable called *The Testament of the Eagle.* As the story goes, an old eagle nearing his deathbed calls his children together and tells them that he is approaching the end of his life. He then describes how he intends to die: by flying so close to the sun that it will burn his feathers, thus sending him into the ocean. He will then rise from the water and begin life anew.

Of Spiders and Grapes

Another of his famous fables was that of *The Spider and the Grapes.* A clever spider, seeing how bees and flies feasted on the sweet grapes of the vineyard, decides to spin its web right next to the grapes. Flies would get stuck in the web, and the spider would have a meal. One day, the owner of the vineyard cuts down this particular grape stem. The flies are rescued from their certain doom, while the spider is punished for his trickery. Like most of Leonardo's stories, there is a definite moral here: preying on the innocent can lead to no good.

The Mouse and the Cat

The Mouse and the Cat is another fable about intelligent animals. A mouse is trapped in its hole by a stalking weasel. While the mouse pleads with the weasel to leave, a cat, which has been lying in wait, pounces and devours the weasel. Thinking the coast is now clear, the mouse celebrates by rushing out of his hole—only to be promptly eaten by the same cat. The enemy of your enemy is not always your friend!

A final fable that was close to Leonardo's heart is *The Goldfinch.*tt A mother goldfinch returns to her nest one day to find all her babies missing. She eventually discovers them caged and hanging outside a farmhouse window. Try as she might, she can't open the cage. The next day she returns to feed her babies through the bars. But they die soon after because their mother has fed them poisonous berries. Her final words: "Better death than loss of freedom." Perhaps Leonardo felt that if artists couldn't be free to design as they wished, then they shouldn't produce art at all?

Music

Leonardo was both a performer of music and an innovator of new musical instruments and forms. Of course, no court entertainment would be complete without a musical performance, and unsurprisingly Leonardo excelled there as well.

Music was a very important part of the Renaissance culture. During the Renaissance, people took more of an interest in all things relevant to society and culture. Art, theater, literature, philosophy, and music uplifted Italians both culturally and politically. This new, universal enjoyment of music represented a shift from the Middle Ages, when music was only performed for the royal courts. Can you imagine what the world would be like if music today were only performed for a president or king?

Itinerant Musicians

The Renaissance gave birth to a culture of traveling musicians. These wanderers went from city to city, performing for new audiences everywhere. They were often accompanied by a patron, and would meet up with musicians traveling from other cities and countries. These local gatherings made Renaissance music more "international," and musicians incorporated themes and instruments they had seen being used by foreigners. Vocal music (singing and speaking) was more common than instrumental works. In the seventeenth century, as instruments were used more and more, composers began to write music specifically for different instruments.

The Lilting Lyre

As a child Leonardo showed interest in a widely diverse range of musical activities. Apparently he was a good singer and liked to spend evenings entertaining friends and relatives. Singing was a well-respected pastime during the Renaissance; most educated people could either sing or play a musical instrument. Besides singing, Leonardo taught himself to play the lyre, a stringed instrument that had been around since at least ancient Greece (though it was probably invented in Asia).

FACT

A lyre looks a bit like a rounded harp and consists of a hollow body with two semicircular arms connected by a crossbar. Strings start at this crossbar, go over a bridge, and terminate at the opposite end of the lyre. They came in different sizes and with different numbers of strings, usually four, seven, or ten.

While Leonardo focused most of his attention on drawing, painting, and designing, he kept up his skills with the lyre. He was also known for making up his own songs, complete with rhyming lyrics, on the spur of the moment. Perhaps he was the world's first improvisational artist!

During his patronage years with the Sforza family, Leonardo was sent to Milan to play the lyre for Ludovico Sforza. The soon-to-be duke had fought (and won) political battles to reach this new station in life, and a celebration was warranted. For the occasion, Leonardo brought a special lyre that he had made himself. It was silver, designed in the shape of a horse's head. This detail is pretty spectacular, since most lyres of the day were of a simple wooden design.

His performance was rumored to have been far better than that of any of the court musicians, endearing Leonardo to the royal family (but perhaps not to the musicians). Stories of this performance prompted Michelangelo, one of Leonardo's biggest rivals, to refer to Leonardo as "that lyre-player from Milan."

Music by Design

Some historians think that Leonardo not only played instruments, but helped design them, in particular an early predecessor to the violin called the *viola da gamba*. During his lifetime, Leonardo built several string instruments, and his notes indicate an interest in studying their acoustical properties. Leonardo's studies in tone, sound, and related instrument properties surely influenced the artists who would go on to create the violin, cello, and other stringed instruments. Some of the first violins were created by Gasparo da Solo (1542–1609), and while da Solo was born after Leonardo's death, Leonardo may have had conversations with da Solo's father.

FACT

The medieval period saw the development of stringed instruments with bridges. A bridge is a vertical piece of wood that the strings are stretched across; they allow bowing in addition to plucking. The first real predecessor to the violin was called the *viola de gamba*, which was first created in the fifteenth century and became more widely popular in the seventeenth century.

Leonardo the Teacher

Wish you could have signed up for painting classes with the Great Leonardo? Even if you were alive during the Renaissance, you would have had a tough time. Leonardo never established a formal school or workshop. However, he did instruct plenty of students and apprentices over the years. During Leonardo's years in Milan at the court of Sforza, he probably had a number of apprentices and pupils. He even wrote a series of training books specifically for these students, and these documents were later collected in book form as *A Treatise on Painting*.

The Da Vinci Method

Leonardo was a very hands-on teacher and also collaborated on a number of works with his students during this period, some of which still have questionable attributions. Several of his students' works have even been incorrectly attributed to Leonardo himself. This collaborative style makes it hard to place blame for mistakes, and also makes it hard to really give credit where credit is due.

Da Vinci's pupils during this Milan period included Giovanni Antonio Boltraffio (his earliest pupil); Bernardino de'Conti; Giacomo Caprotti (nicknamed Salai); Giovanni Agostino da Lodi; Andrea Solario; Ambrogio de Predis; Francesco Napoletano; and Marco d'Oggiono. While Leonardo was in Milan in the early 1500s, Bernadino de'Conti and Salai continued as his apprentices. He also had a new crop of assistants, including Bernardino Luini, Cesare de Sesto, Giampetrino, and Francesco Melzi. (Melzi later became his personal companion, heir, and likely lover.) Some of these

pupils eventually succeeded in their own right, painting famous works such as *La Belle Ferronniere* and *Lucrezia Crivelli*.

Leonardo reportedly chose some of his assistants for their good looks rather than their artistic abilities (Francesco Melzi and Salai in particular). Melzi, unlike Salai, did produce a few paintings during his many years with Leonardo, so we know that the relationship was at least slightly more than personal.

Co-Working

The commission to paint *The Virgin of the Rocks*, one of Leonardo's early major works, was actually given to both Leonardo and his assistant, Ambrogio de Predis, in 1483. Ambrogio served as a court painter to Ludovico Sforza and hosted Leonardo in his home when Leonardo first came to Milan. The two collaborated on a number of paintings throughout the 1490s, and *The Virgin of the Rocks* is the best known of these collaborations. In this work, Leonardo painted the central picture, while de Predis painted two side panels showing angels playing musical instruments. Two versions were eventually completed, thanks to a resulting lawsuit. Although in the later version the angel kneeling behind the infant Jesus is undoubtedly Leonardo's work, he most likely did not finish it. The Madonna and landscape aren't as good technically, suggesting that a student probably painted them.

One of Leonardo's students from Milan, Andrea Solario (1460–1524), made his own style by mixing elements of Leonardo's work with the contemporary Lombard and Venetian schools of painting. His bright colors, fantastical landscapes, and harmonious groupings of figures emulate Leonardo, while some of his naturalistic details echo the Lombard and Flemish traditions.

Another of Leonardo's Milan students, Boltraffio, was, in fact, one of Leonardo's first students after his move to Milan in 1482. Leonardo probably used Boltraffio as a test case for his teaching, and it seems to have paid off. Boltraffio's training is visible in many of his works, including his 1495

painting *The Virgin and the Child*, which he may have based on Leonardo's sketches.

Later in Leonardo's life, during his final years in Rome (around 1509–1516), he continued to have many students. In fact, Leonardo's students copied his final painting, *St. John the Baptist*, many times. Since many of Leonardo's original works are now lost, in many cases, only copies done by his pupils allow us to see the true scope of his work.

FACT

Though Leonardo's students spent much time copying the master's works, few of them ever transcended his direct influence to become well known in their own right. Only two of Leonardo's followers, Bernardino Luini and Sodoma, seem to have developed well-respected careers independent of Leonardo.

Conspiring with Luini

Bernardino Luini, a Milanese painter, was born sometime between 1470 and 1480, and lived until 1530. It's assumed that he was Leonardo's student, though there's no actual evidence to support that claim. A number of Luini's works, including *Christ Crowned with Thorns* and some of his paintings of the Virgin and Child (such as those at Saronno) show a style very similar to Leonardo's in terms of color choices, overall design, and the sense of depth given by elements of relief in the paintings. In these aspects, Luini came closer to replicating Leonardo's style than any other contemporary artist.

But Luini's style was, in many ways, distinctly his own. For one thing, his works have a sweetness that Leonardo's more ambiguous paintings lack. Also, Luini's works are generally more religious than Leonardo's. Many of Luini's frescos are well known, and while Luini certainly was not a master of many fields as was Leonardo, his works do an admirable job of instilling a sense of religious stillness in observers.

The Student Bazzi

Giovanni Antonio Bazzi (1477–1549) is another artist whom Leonardo influenced significantly, although once again, there is no evidence that he studied directly in Leonardo's studio. Known by his nickname, Sodoma, Bazzi came to Milan in the late 1400s as a glass painter's apprentice. Sodoma was a natural at drawing, but he learned several things from Leonardo, including color selection. He used lavish, sensual colors in his paintings. His works are often charming and poetic, and the faces of the women and children he created are quite beautiful. However, none of his works have the timeless mystery and appeal of Leonardo's.

chapter 16

Other Renaissance Artists

What fun is being a genius if there's no one to brag to? Leonardo's work was of legendary appeal, but he wasn't the only great Renaissance artist. Some of the others were his friends, some were his enemies, and some he barely knew. The Renaissance was a time of artistic genius, and even a bona fide celebrity like Leonardo had to share the spotlight occasionally with other great artists such as Michelangelo, Botticelli, Titian, and Raphael. Leonardo was certainly in good company!

Michelangelo: The Renaissance's "Other Great Artist"

Was anyone greater than Leonardo? A better painter, per chance? It depends on who you ask, of course, but Leonardo was certainly not without his rivals. Michelangelo Buonarroti (1475–1564) was one of the major architectural/artistic forces in the Renaissance—in addition to Leonardo, of course! Leonardo's most famous rivalry was probably with Michelangelo, creator of *David* and purveyor of the fig leaf. These two legends competed for a variety of projects, and it was a healthy competition; they didn't sing each other's praises in private or public.

Michelangelo's Early Years

Michelangelo was born in Caprese, Italy. He spent his earliest years in this region of Tuscany, and was under the influence of its beautiful landscape from the very beginning of his life. Michelangelo's father was a Capresian judge, and he led his son through a fairly rigorous upbringing. Michelangelo was raised with a strong work ethic from his earliest days.

For much of his childhood, though, Michelangelo lived in Florence. There he was entrenched in the glory of the Renaissance, and gained early exposure to many different arts. He was apprenticed at age thirteen to painter Domenico Ghirlandaio, although this particular apprenticeship went against the desires of his father. Michelangelo stayed with Ghirlandaio for three years; by this time, the master was more than impressed with his young student, and Michelangelo was sent to Lorenzo de'Medici.

ESSENTIAL

While in Rome, Michelangelo produced some of his first marble statues, including the *Bacchus*. As he refined his sculptural skill, he went on to sculpt such masterpieces as *Pieta* (1498–1500), which is one of the best-known sculptures from the entire Renaissance period. Michelangelo was coming into his own as an amazing sculptor and artist, and he was well-positioned to gain recognition for his talents.

Michelangelo then worked in the Medici's sculpture gardens, and it was there that he began creating marble relief sculptures, which gave a glimpse into his future talent. His major achievements during these years were the *Madonna of the Steps* and the *Battle of the Centaurs*. Michelangelo moved on to Bologna for a few years following Lorenzo de'Medici's death, but it wasn't long before he was requested yet again for a more prestigious position. In 1496, Michelangelo moved to Rome at the request of the Cardinal, San Giorgio.

The Traveling Artist

In typical Renaissance fashion, Michelangelo didn't stay in one place for any great length of time. After Rome, he returned to Florence, where his most famous creation was the marble *David* of 1501. Because it was simply a tremendous work of art, it quickly became his best-known sculpture. Michelangelo then went back to Rome in 1505 at the request of Pope Julius II. After beginning work on the design and sculpture of the pope's enormous tomb, he began work on the painting of the Sistine Chapel's ceiling. These intricately detailed scenes from the book of Genesis kept him busy between 1508 and 1512, as he spent days upon days painting on his back.

FACT

In *The Last Judgment*, a quintessential Renaissance painting, Michelangelo also manages to incorporate a cleverly disguised self-portrait. This was a common trick that Renaissance artists employed as a way of infusing their paintings with a more personal touch, and it's one that Leonardo also embraced; he painted himself into his *Adoration of the Magi*. Great minds truly did think alike!

Michelangelo was in Rome again by 1536, working on the *The Last Judgment* fresco for the Sistine Chapel. This powerful work was completed by 1541 and, as one might expect, focuses on the biblical scene of the Last Judgment. One of the most interesting aspects of this fresco, aside from its immense display of technical merit, is the references that Michelangelo

incorporates. There are the required figures of Christ and the other biblical players, but there is also a reference to Dante's *Inferno* in a scene where Charon, Dante's guide, is shown with his oars.

From Artist to Architect

Around 1519 Michelangelo began to shift his focus to architecture. Leonardo never found particular fame in this realm because most of his architectural designs were either never built, or remained isolated to his notebooks. Michelangelo, on the other hand, worked as an active architect for many years. He designed a new façade for the Florentine church of San Lorenzo as well as the abutting Laurentian Library. Between 1519 and 1534, he worked on the Medici Tombs, designing both the architecture and the sculpture within.

Michelangelo's best-known architectural work was at St. Peter's Basilica. This immense church, one of the largest in the Christian world, is built on the site of St. Peter's crucifixion, and has an extensive construction history. It was begun in 324 A.D by Constantine, then was officially rebuilt starting in the fifteenth century. Many different architects played a role in its design; Donato Bramante (1444–1514) was one of the first head architects, then Michelangelo took responsibility for the dome in 1546.

The dome was one of the most remarkable architectural achievements of its time. It was built as a double brick shell and reached a height of about 360 feet from ground level. It's supported by four major piers and vertically oriented, so Michelangelo was able to maximize the vertical interior space. It was an achievement truly of epic proportions.

Like Leonardo, Michelangelo was a productive artist for years and years; his age didn't seem to slow him down. He was still an active artist late in his life, creating frescoes for the Vatican's Pauline Chapel. In what could, however, be an accommodation to his advancing years, he painted these works on the walls rather than the ceiling.

Competition

There is nothing like good rivalry to make you want to work hard and succeed, and Renaissance artists were subject to more than a little healthy competition. While they knew each other by reputation, it appears that Leonardo and Michelangelo may not have crossed paths until 1500, in Florence. The two had much in common; they were two of the most celebrated architects and artists of the day, and various ruling parties recognized their fame. Both created pieces of historic proportions, and both were prolific with their skills. Additionally, they were both leading the way in terms of anatomical research; their representations of animals and people were far superior to most of those done by their contemporaries.

Leonardo and Michelangelo had at least one project in common: at the Palazzo Vecchio, in 1503, both won commissions for murals to be themed with Florentine military victories. Leonardo's design was a representation of the Battle of Anghiari, a scene in which the Florentines defeat Pisa. Leonardo completed sketches for this painting, but unfortunately, the painting itself suffered from yet another of Leonardo's design innovations, and nothing remains of it today.

Michelangelo's mural for the Palazzo Vecchio would have represented the Battle of Cascina, but his also only remains in cartoon form since Pope Julius II called him away before he was able to create the actual painting. This project seemed cursed from the beginning. Michelangelo and Leonardo must have had at least one other run-in around this time, since Leonardo was on the 1502 committee to decide where to place Michelangelo's *David*.

Trouble Afoot

It wasn't all peace and love in the Renaissance art world. There was a rumor that Michelangelo may have mocked Leonardo about the failure of his massive equestrian statue of Francesco Sforza—negative attention that Leonardo (and his reputation) certainly didn't need. The fact that this sculpture never was built was definitely a thorn in Leonardo's side, and it probably just made the rivalry between the two artists even worse. It appears that

Michelangelo might have made other disparaging comments about Leonardo over the years; while the real source of these comments is unknown, it is likely that the two great artists considered each other far more as rivals than as friends.

The Young Master Raphael

In addition to Michelangelo, Leonardo had a number of other rivals in the painting world of the Renaissance. One of the most famous painters during the fifteenth and sixteenth centuries was Raphael, or Raffaello Sanzio (1483–1520). Though he only lived for thirty-seven years and didn't produce the same volume of work as his rivals, Raphael created some of the best-known frescoes from the Renaissance period.

Rafael's Youth

Like Leonardo, Raphael wasn't born with a silver spoon in his mouth. He spent his early years in the city of Urbino, where he was already becoming recognized for his artistic abilities. Raphael received his first lessons in painting from his father who, while apparently never becoming a famed artist by profession, was a good enough teacher to inspire Raphael to further studies.

Around 1495, Raphael moved to Perugia. He was almost immediately given a commission for work on an altarpiece, his reputation from Urbino having preceded him. By 1502 he earned a commission to paint for the Oddi Chapel in the San Francesco church, for which he produced *The Coronation of the Virgin*. This painting was followed by *The Marriage of the Virgin* in 1504, which shows a detailed attention to both the perspective and the quality of the figures; they appear mobile, attentive, and genuinely involved in the scene.

Early Works

By 1504, Raphael had moved to Florence. Could he have lived in ignorance of Leonardo's and Michelangelo's respective masterpieces? Probably not, and odds are that he moved there to work closer to these great masters. Leonardo's

influence is evident in several of Raphael's paintings of the Madonna. These include the *Madonna del Prato* (1505), *Madonna of the Goldfinch* (1505), and *Madonna and Child with the Infant St. John* (1505–1507).

Raphael typically used a rolling, somewhat fantastic landscape setting for his Madonna paintings, indicating that he had carefully studied Leonardo's emphasis on botany and nature. It appears that Leonardo's *The Virgin and Child with St. Anne* served as a model for Raphael—many of his paintings imitate the figural style that Leonardo used in that work.

More Traveling

All good artists had to be willing to pack up and move on at a moment's notice, and Raphael was no exception. Pope Julius II called him to Rome in 1508, and off he went to create murals for the papal residency in the Vatican. His major paintings for this period include the *Stanza della Segnatura* and the *Stanza d'Eliodoro*. The size, quality, and attention to detail of these murals are truly remarkable. Their subject matters stems from both ancient Rome and the Bible. The walls are a living testament to the history, culture, and variety that characterizes the Renaissance.

Like Leonardo, Raphael was a true Renaissance spirit: he could do more than just paint, and was determined to showcase his abilities. After Bramante's death in 1514, Pope Leo X gave Raphael more responsibilities as a court architect. The transition was natural, since Raphael was already working on St. Peter's Basilica alongside Bramante.

FACT

During his time working for Pope Leo X, Raphael was also involved with excavations around Rome, searching for remains from classical antiquity. Raphael likely had much interaction with Leonardo da Vinci during this period, since he was also in Rome under the patronage of Giuliano de Medici (brother of Pope Leo X).

How was Raphael different from every other great Renaissance painter? He set himself apart from the crowd with the overall tone of his paintings.

Where both Leonardo and Michelangelo tended to portray the darker side of humanity, Raphael's works often showed scenes where the people were cheerier and in brighter colors. Most of his paintings are bright and suggestive of an upbeat, even lighthearted style, perhaps in an effort to make painting (and art in general) more accessible to the common man.

Botticelli on a Half-shell

The Renaissance art explosion made room for plenty of up-and-coming artists to crawl out of the woodwork. Along with Leonardo, another Florentine artistic force was Sandro Botticelli (1445–1510). His father was a craftsman, and Botticelli was surrounded by artistic culture his entire life. Like Leonardo, he went the apprenticeship route and had several masters early on, including Fra Filippo Lippi and Antonio del Pollaiuolo. Pollaiuolo was an engraver (an unusual choice of master for a young painter), and Botticelli got a very specialized education here.

Another Student of Verrocchio

Botticelli also worked in the studio of Andrea Verrocchio for a time. In fact, Leonardo probably studied alongside the older Botticelli. Verrocchio must have been some teacher! Botticelli learned much from the teachings of Verrocchio, which is evident in several aspects of Botticelli's painting. In particular, Botticelli learned an aggressive style where he could represent motion, flight, and the elements simultaneously; these techniques would serve him well in his future hallmark paintings.

A Florentine Devotee

By the time he was twenty-five, Botticelli had his own workshop in Florence. While Leonardo worked for various rulers and popes over the course of his life, Botticelli found his own way by sticking mainly with wealthy, powerful Florentine families such as the Medicis. He had a better reputation for finishing his projects and probably didn't have to keep switching employers. One of Botticelli's most famous portraits was of Giuliano de Medici. This painting, from 1475, is thought to be the most accurate painting in existence

of this powerful Renaissance figure. It is more stylized than the works of Leonardo, though, and it doesn't match the skill and technological mastery of Leonardo's works.

Did Leonardo paint the only *Adoration of the Magi*?

Surprisingly, no! Botticelli also painted a version of the *Adoration of the Magi*. It seems like every Renaissance master painted one of these. His version was commissioned for the Epiphany Chapel in the church of Santa Maria Novella. This tempera-on-wood painting is closer to completion than Leonardo's version and, like Leonardo's, contains a self-portrait of the artist amongst the crowd.

Signature Paintings

In 1482 Botticelli created his best-known painting, *The Birth of Venus*. It's studied in virtually every art history class today and is one of the most recognized icons of the Renaissance. This painting shows Venus standing on a shell as she rises from the sea and nymphs wait for her arrival onto land. Venus (also known as Aphrodite) was the ancient goddess of love; renowned for her beauty, she is rendered here with grace and elegance.

One of the things that makes Botticelli so interesting is that he painted both pagan and Christian scenes with equal skill. On the Christian side, he painted a beautiful series of Madonnas, including the *Madonna of the Pomegranate* from 1486. The colors are bright and the figures sharply defined; Mary is seen with a faint glow over her head.

Botticelli also painted religious frescoes of saints, including *St. Augustine* (1480) and *St. Sebastian* (1473). In one of his few ventures outside of Florence, Botticelli went to Rome in 1483 to help decorate the Sistine Chapel. His presence was requested by none other than Pope Sixtus IV, and he went alongside Ghirlandaio, Rosselli, and Perugino as part of a team of artists. Their work along the walls took only a year; the Sistine Chapel is, however, much better known for its ceiling painted by Michelangelo.

Savonarola and a Crisis of Faith

Botticelli had a crisis of faith in his later years, and some historians think that he joined the religious reformation in following the teachings of Girolamo Savonarola (1452–1498). Savonarola hailed from Ferrara, and was known to be a particularly intelligent student of philosophy. He became part of the Dominican order and both studied and taught the works of philosophers such as St. Thomas Aquinas and Aristotle.

ALERT!

Going against the status quo can be an uphill battle. Girolamo Savonarola became an extremely popular lecturer, and set about overhauling the life of the monk. He forced his fellow monks to lead extremely simple lives, and demanded that they learn trade skills. He preached loudly against the extravagances, fancy clothes, and other amenities that his audiences were privy to.

Savonarola (who was eventually excommunicated and hanged) was responsible for the 1497 Bonfire of the Vanities, in which he and his followers collected and burned items associated with moral weakness: mirrors, poetry, art, and anything that may have had a "pagan" association. While Botticelli's actual involvement with Savonarola would have been minimal, it is thought that he did begin to question Italy's heavily Christian influence.

Staying Still

A major difference between Botticelli and Leonardo can be seen in their travels (or lack thereof). Leonardo spent years in many different cities throughout his career. He gained exposure to critics, earning the respect and admiration of the clergy and powerful families as he traveled. He observed people from many walks of life, learning the music and culture of his international contemporaries. Botticelli, on the other hand, was content to stay in one place.

Botticelli, unlike Leonardo da Vinci, did not seem to have the restlessness that affected his counterparts. While Leonardo traveled constantly during his

lifetime, Botticelli remained in Florence for most of his life. While he may have missed out on a more multicultural experience, he displayed a particular single-mindedness that is evident in the style and subject of his work.

Titian, His Own Personal Giant

Leonardo da Vinci spent most of his career working in Milan and Rome. However, he didn't have the market cornered on Italian art. Titian (1490–1576), another artistic hero of the Renaissance, was Venice's major player. Titian's work complemented Leonardo and the other Renaissance greats, though they may not have met during their lifetimes. These two giants, with a little help from their friends, created the aura of Renaissance art that we know and admire today.

Apprenticeships

Titian (whose full name was Tiziano Vecellio) was born near Venice. Like most Renaissance greats, he was tagged to be an artist early in life and was apprenticed to Gentile Bellini (1429–1507). While Gentile was never as well-known as his father, Jacopo Bellini, he did produce an impressive collection of oil paintings during his lifetime. He is best remembered for the physical composition of his paintings; he made several improvements to the growing art of perspective.

Titian was later apprenticed to Gentile's brother, Giovanni Bellini (1426–1516). Giovanni was also tutored by their father Jacopo, but he favored tempera painting more than oil. He had a solid mastery of painting history, and became most famous for a series of historical paintings for the Doge's Palace. Unfortunately, these paintings do not exist today; they were ruined in 1577 during a fire in the palace.

In his later years, Giovanni Bellini painted many landscape scenes with a high degree of realism; these sorts of techniques made a strong impression on Bellini's favored disciple Titian. Bellini is known as the father of "Venetian Humanism" because he was one of the period's most prolific painters, and his style was in keeping with other Renaissance developments. He had a renewed interest in nature, and used his mastery of the art to present landscapes that were strikingly beautiful.

While under the tutelage of the Bellini brothers, Titian worked on several different paintings. He initially based his own style around his masters'. Titian's first known work was a series of frescoes on the Fondaco dei Tedeschi. A variety of painters worked on these frescoes, so historians struggle to identify precisely which paintings were done by Titian. One that is usually attributed to him is the *Fête Champêtre* of 1510. The scene combines nature and mythology: lush landscapes and herdsman are seen next to nude poetry muses.

Frescoes

Titian's next works were frescoes for the Scuola del Santa, which represent scenes from the miracles of St. Anthony. These works also show a symbiosis between highly stylized landscapes and a humanlike God. Titian continued this theme in 1518, when he painted bacchanalia scenes for the palace of the Duke Alfonso d'Este. One of these, *Bacchus and Ariadne*, is especially representative of Titian's style; bright colors separate the figures in the scene, and he fully captures the wildness of Dionysus and his followers. Titian is perhaps best known for these paintings because he was one of the first to show the revelry of bacchanalia in a distinctly Renaissance humanist setting. His work demonstrates daring accompanied by amazing skill: a winning combination.

FACT

An interesting note is that Titian's use of color was sometimes more dramatic and even more cutting edge than Leonardo's. Working with Venetian raw materials, Titian developed both bright and dark colors that really grabbed the viewer's attention. One of his shades of auburn is so original that it is known today as simply "titian."

On Assumptions and Venuses

In addition to paintings of frivolity set in the rural countryside, Titian painted a number of religious scenes. *The Assumption of the Virgin* (1516–1518) was one of his first works that was clearly non-Venetian in nature,

which gave him more credibility with guildsmen and patrons from other areas. The apostles in the scene are rendered in powerful motion, similar to the religious painting style of masters such as Raphael. The force and tension in the scene became a distinguishing characteristic of Titian's later religious paintings.

As he moved further into his career, Titian's paintings began to reflect a calmer atmosphere. The *Venus of Urbino* (1538–1539) was done for a specific client: Guidobaldo della Rovere, heir to the Duke of Urbino. The Venus conveys an intimacy seen only rarely in other works; Leonardo's *Mona Lisa* is another example of the emotional warmth and mystery that can be conveyed through painting.

Titian was, like most other Renaissance painters, also a capable portrait artist. By 1516 he had been named the state painter of Venice, and in the 1540s he traveled to Rome to do a portrait of Pope Paul III (it is thought that he might have met Michelangelo during this period).

Later Works

Toward the end of his life, Titian's style changed once again. His later works such as *Rape of Europa* (1559–1562) and *The Flaying of Marsyas* (1575–1576) show an increasing formlessness; shapes blend together and his scenes, though representative, become more abstract. His work displays a progression that you don't see as strongly in the more consistent work of Leonardo. Luckily for the history of Western art, we don't need to choose one or the other. These two artists together create a rounded picture of what was possible during the Renaissance.

Other Contemporary Famous People

While Leonardo da Vinci was on top of the art world during the Renaissance, there was a lot more going on in other realms. Arts, sciences, philosophy and music all underwent radical growth during this period. In order to place Leonardo in his proper historical context, it's important to get a sense of what else was happening in the world. And Leonardo was aware of advancements outside his field, to varying extents. Read on to learn how he was affected by his contemporaries and, in turn, how they may have affected his life and work.

Machiavelli: The Literary Prince of the Renaissance

Hard as it is to believe, artists did not carry the complete weight of the Renaissance on their shoulders. Poets, philosophers, historians, dramatists, and authors had their own parts to play. All these professions contributed to the increasing Renaissance interest in the humanities. Niccolo Machiavelli (1469–1527) was a poet-philosopher with a particular knack for pushing the boundaries of what was acceptable.

FACT

Educated in Greek and Latin, Machiavelli had deep roots in history and philosophy. He read the books in his father's library and was always interested in understanding how society's problems were based on historical events. Machiavelli was a Florentine at heart, devoted to enhancing and protecting the image of Florence as one of Italy's greatest cities.

The Prince

Machiavelli's best-known work is *The Prince*, written in 1513 as a critique of Renaissance politics. According to his observations, the powerful Italian ruling families were essentially modified versions of Attila the Hun: they were instigators of invasions, attacks, and general corruption. Some historians believe that this treatise was based on the life of Cesare Borgia, a powerful yet cruel warrior with whom Leonardo traveled for many years. In *The Prince*, Machiavelli tried to define rules for the politician: how to gain power and how to keep it. The work was, in many ways, a model of behavior for the selfish ruling families of the day.

Public response to *The Prince* was, to put it mildly, less than congratulatory. Many people thought Machiavelli was cruel and harsh in his judgments, most of which were probably true. He appeared to have been an ardent supporter of political families such as the Medicis, a view that was becoming increasingly unpopular. Machiavelli was ousted from Florence several years

later, and though he wrote more treatises, he was not well-liked during his lifetime because of the negative public perception surrounding *The Prince*. Fortunately, history has taken a more objective view of his writings.

Friends and Businessmen

Leonardo, always one to seek out a fellow artist, was rumored to have been friends and business partners with Machiavelli. They probably met while working with Cesare Borgia; Leonardo was traveling with Borgia between 1500 and 1506, and Machiavelli went to study his army sometime during the early 1500s. Both men were patriotic, and both considered Florence their home. Though their professions were different, their perspectives on Italian Renaissance humanism were remarkably compatible.

In 1503, Leonardo and Machiavelli collaborated on Leonardo's scheme to reroute the Arno River. This plan would have given Florence both a seaport and an entirely new role as a city. Unfortunately, this project never reached fulfillment, but Machiavelli's involvement surely lent credibility to Leonardo's scheme.

FACT

Machiavelli researched the river diversion project politically and militarily, coming to the conclusion that such a diversion would benefit all of Italy, and he actively promoted the plan to the governing bodies. Of course, given his reputation with the ruling class, he may not have been the best person for the job!

The Battle of Anghiari

In addition, Leonardo and Machiavelli had another common project: the depiction of the Battle of Anghiari. Though Machiavelli helped Leonardo to obtain this commission, their recordings of the event differed. Leonardo's painting shows the success of Florence in claiming this medieval town from rival Italians. Machiavelli, rather than blindly praising the Florentines, writes of their confusion in battle and their less-than-skilled armies.

While Leonardo may have taken artistic liberties with this patriotic rendering, his freedom of expression complements Machiavelli's more factual recounting; both portrayals were important as this battle was recorded for history's sake.

Machiavelli had contact with other Renaissance artists as well. He was, for example, on the board that deposed Girolamo Savonarola in 1498, and may have interacted with one of his followers, artist Sandro Botticelli. Philosophy, politics, history, and art were intertwined during the Renaissance, and it is not surprising that Machiavelli crossed paths with Leonardo and other artists who defined the spirit of the Renaissance.

The Protestant Reformation

The biggest religious upheaval of the Renaissance came in the form of the Protestant Reformation of Martin Luther and John Calvin. These events post-dated Leonardo's career slightly, though the growing battle within the Catholic Church probably influenced him. Between indulgences and the Ninety-five Theses, it's hard to imagine that Leonardo could shove his head in the sand and ignore what was going on.

Interestingly, in spite of Leonardo's wide range of interests, he was relatively ignorant of other major discoveries of the day, such as the heliocentric solar system of Copernicus and Columbus' discovery of the Americas. Historians haven't found much record of these events in his notebooks, and don't have any other way of telling how much Leonardo knew about world science and politics. However, it is likely that Leonardo was affected by the religious turmoil of the day.

Talking about a Religious Revolution

The Renaissance was a fountain of artistic growth and innovation. However, that doesn't mean it was peaceful. City-states and powerful families were constantly fighting each other over territory and wealth. The Church was, of course, the guiding light behind Renaissance painting and architecture, but even it was subject to considerable challenges. The strongest of these was the Protestant Reformation of the sixteenth century. While

Leonardo played only a small roll in this revolution, it's impossible to discuss the Renaissance without at least mentioning this major upheaval.

The leader of the Protestant Reformation was a German named Martin Luther (1483–1546). He diligently studied various parts of the Hebrew Bible as a child and was skilled in several ancient languages. He attended the University of Erfurt, studying philosophy and law; his father wanted him to be a lawyer, so he pleased his parents by going to law school.

However, Luther realized that he was more interested in a different path in life. By 1505 he had joined the Erfurt Augustinian monastery, where he learned about a new side of religion. In 1507, he was ordained as a priest, and up until this time he seems to have fit into the lifestyle of a monk quite well. He enjoyed philosophical discussions and studied many aspects of religion.

Luther On a Rampage

In 1509, Luther went to Wittenberg, where he both taught philosophy and studied religion. His visits to Rome showed him first-hand how the Church was focusing more on money than religion. How could that be? Church officials were selling forgiveness from sins such as theft, adultery, and even murder. These atrocities forced Luther to start doubting the very tenets of his religion, and he found himself disregarding the rules of the monastery in search of explanations that he could both justify and accept. He became increasingly critical of the Church, particularly with regard to the indulgences (forgiveness for sins) he had seen. In 1517, he made a list of these indulgences, dubbed the Ninety-five Theses, and reportedly tacked it to the door of the church in Wittenberg.

Martin Luther probably hoped to start some Church reform with this act, but instead it led to his excommunication in 1521. Seems harsh, but what else was a Renaissance church to do? Holy officials couldn't tolerate dissenters, so they did the next best thing: shoved them under the carpet.

Luther is most famous for beginning the process of questioning the Church. He took a stand and, unfortunately, paid a heavy price for it. Luther

was more than a religious critic, though. He also produced the first full translation of the Bible into German, publishing his version in 1522.

Calvinism

John Calvin (1509–1564) was another major player in the Protestant Reformation. He had a middle-class French upbringing and, like Luther, eventually became an Augustinian monk. He had been trained in law and humanism, in the full Renaissance spirit, and came out in strong favor of the views that had been set forth by Luther. In fact, his speeches are the main reason why Luther is famous today.

Around 1532, Calvin experienced a religious conversion of sorts and became more interested in religion than law. France's King François I (formerly Leonardo's patron) saw him as a threat, though, and Calvin was forced to leave France in 1536. He officially severed ties with Roman Catholicism and moved to Geneva. Calvin did not want to abandon Catholicism or the Church; quite the contrary! Instead, the Reformers wanted to change the Church's sinful ways. While change is usually good, it isn't always appreciated and Calvin's ideas simply weren't welcome.

ESSENTIAL

How did Calvin and Luther relate to Leonardo da Vinci? While the main part of the Reformation took place after Leonardo's death, he was aware of the impending rebellion and its associated turmoil. He probably heard of the theses-tacking incident and was aware that his beloved Church was coming under fire. Did it make him more religious, more observant? Or did it feed his inner rebel?

Eventually, Switzerland had also had enough of Calvin's criticism; he was kicked out of the country and was forced to move to Strasburg, where he worked for the reform movement and got married. In 1541, he returned to Geneva to set up a school for training reformed Christians (Protestants); this school eventually became the University of Geneva. It had an inauspicious start, perhaps, but went on to become a major university.

Center of the Universe

Still think that art was the only thing going on in the Renaissance? Prepare to be proven wrong. Science was a fast-growing field, and many discoveries were made that changed the course of the world, literally. Nicolaus Copernicus (1473–1543) was one of the Renaissance's foremost scientists and astronomers. Born in Poland, Copernicus was trained in mathematics, science, and philosophy.

In 1488, Copernicus learned the basics of philosophy and other humanistic fields in Wloclawek, then attended the University of Krakow in 1491. His diverse education allowed him to study astronomy, mathematics, geography, and Latin. While Latin may not be the most exciting of subjects, he persevered in the study of languages and eventually read the treatises of ancient Greek and Roman mathematicians such as Euclid and Ptolemy.

The Sun and Planets

Copernicus' crowning achievement, and the one he's most famous for, was the development of a heliocentric model of the solar system. Earlier scientists had thought that the entire solar system revolved around the earth, a model known as the "geocentric view." Copernicus showed that the planets actually orbited about a point slightly offset from the sun. This is called the "heliocentric view." He also showed that the earth rotated about its own axis once a day, while also revolving around the sun every year—just the way we learn in school today.

Unfortunately, Copernicus' entire scientific theory was heretical in the eyes of the Church. According to traditional religious belief, God was the center of the universe and, therefore, so was earth. For this reason, Copernicus did not publish his ideas until shortly before his death. Had he published them sooner, his death might have been hastened. After his death, a student named George Rheticus took on the editing and publishing responsibilities.

Why do we care about Copernicus? Who cares about planet rotation? As it turns out, we all do! Copernicus' discoveries revitalized science and research—areas that had stagnated during the Middle Ages. He brought them to life, but more importantly, made science interesting to the common

person. This was probably the most important thing he could have done for science—make it interesting enough that people actually *want* to learn.

Copernican Diversity

Like Leonardo, Copernicus was a true Renaissance man. He studied many different fields and used them all in the course of his research. He combined physics, math, and studies of the cosmos into a new field of astronomy; this area of research had been more or less dead since the early thirteenth century. Like most of his contemporaries, however, Leonardo had a geocentric view of the solar system, believing that the planets and celestial bodies rotated around the earth. Copernicus and Leonardo probably never crossed paths, and since Leonardo was championing the older view, he was probably not influenced much by Copernicus—or modern astronomy, for that matter!

The Start of it All

Copernicus and Leonardo had at least one common bond: they both created a starting point. Leonardo developed techniques such as *chiaroscuro* and *sfumato*; he set the standard for his contemporaries, and most painters after him followed his example. Similarly, Copernicus laid the foundation for a correct understanding of the mechanics of the solar system. Galileo Galilei (1564–1642), Johannes Kepler (1571–1630), and Isaac Newton (1642–1727), major mathematicians and scientists in their own rights, took Copernicus' ideas and developed deeper, more accurate models of the solar system. Without Copernicus, we might never have made it to the moon; without Leonardo, your living room walls would be blank and cheerless. Three cheers for innovation!

Renaissance Musicians

While science and literature were important Renaissance innovations, let's not forget music! Up until the invention of the printing press, music was more or less transferred via an oral tradition. In the Middle Ages, musicians started putting notes down on paper, but they weren't in an organized form that were easily read by others. As the medieval period progressed, music

became more codified; time values were assigned to different notes, and music began to follow a more structured pattern.

By the early Renaissance, printable music enabled composers to become more and more complex in their works, and these works were performed further and further from their home origin. Leonardo dabbled in music, as a composer, performer, and innovator of musical instruments. He was likely influenced by the many other stars of Renaissance music.

Johannes Ockeghem

Johannes Ockeghem (ca. 1420–1495) was one of the most influential Renaissance composers. Born in the Netherlands, Ockeghem probably studied music in a cathedral school. He was a member of a large choir in Antwerp in the early 1440s, so he probably had extensive vocal training as well. By 1448, he was singing in the court of the French Duke of Bourbon, and he appears to have spent most of his adult life in France composing chansons and other music.

QUESTION?

What is a chanson?

Chanson means song in French. In the context of Renaissance music, a chanson refers to a type of polyphonic French song. They were usually sung by several different voices, and sometimes had an instrumental accompaniment. Some of the early composers of chansons include Guillaume de Machaut, Guillaume Dufay, and Gilles Binchois. Johannes Ockeghem and Josquin Desprez further developed the genre.

Ockeghem actually held several different professional roles, in true Renaissance fashion. He was at one point the Treasurer for the Abbey of St. Martin. However, he was most well-known as a musical composer. He spent much time developing masses and motets (pieces with one or more voices), but he also produced secular chansons. He wrote, for his time, very complicated pieces of polyphonic music. With the development of Gutenberg's printing press, it's likely that some of Ockeghem's major compositions were heard across Renaissance Europe.

Leonardo was an extremely prolific artist; Ockeghem, on the other hand, appears to have produced considerably less in volume. Of his surviving work today, there are only about ten finished masses and twenty chansons. Of course, since much of Leonardo's work has been lost over time, it's possible that we are missing many of Ockeghem's compositions as well.

Guillaume Dufay

Another famed Renaissance composer was Guillaume Dufay (1397–1474). He preceded Leonardo by about fifty years, but comparisons are often made between the two artists because both were at the forefront of their fields. Dufay was a French composer, singing in the chorus of the Cambrai Cathedral at a young age. By 1428, after a brief stint in Italy, he was a member of the French papal choir. He eventually became the Cambrai Cathedral canon, though he had other jobs singing in Florence and Bologna. In the Renaissance, artists and musicians traveled to where the work was, and Dufay's success led him to a variety of locations.

Like Leonardo, Dufay was a prodigious artist, producing volumes of music that went far beyond his contemporary composers. He was skilled in many different areas of music, producing all the popular musical pieces of the day: masses, motets, and chansons. Also like Leonardo, Dufay made a name for himself with the head politicians of his time; in addition to being commissioned to lead the papal choir, he held several important religious posts as well. The Renaissance was certainly a haven for over-achievers!

Josquin Desprez

Josquin Desprez (1440–1521) became known as one of Western music's leading musicians. Desprez was born and raised in northern France, but he reached great fame throughout Europe. He became a court musician for the Sforza family in Milan (who were also Leonardo's patrons), and sang at the Milan Cathedral; he also worked in the court of the France's Louis XII. He ultimately became provost at the Collegiate Church of Conde.

A one-time student of Ockeghem, Desprez made major innovations in counterpoint, a musical technique that has to do with separate lines of music joining together. He completed around twenty masses that have survived through the years, and it's clear that he had a fine education. His works make

reference to past Dutch composers, as well as using the modern musical techniques that were developed in the Renaissance. Desprez composed secular music as well, including chansons and vocalizations of Italian works.

FACT

Like Leonardo and most other famous artists, Desprez made friends with those in power; he was one of Martin Luther's favorite musicians. In fact, Luther said of Desprez, "Josquin is master of the notes."

Music for the Masses

But where would all these musicians be without printing? Back in the Middle Ages! It was largely through the efforts of Ottaviano de'Petrucci (1466–1539) that music became widely distributed during the Renaissance. Petrucci was one of the first printers to use moveable type for the creation of music books. Music could finally be shared outside of the small circle of a composer's friends. This created a new sense of independence that, as with the rest of the humanist movement, fostered individual confidence.

As with the inventions Leonardo was producing in the art world, musical printers were not without their own innovations. One of the most complex hurdles Petrucci had to overcome was the sheer complexity of his task. Music at the time consisted of monophonic chants such as the Gregorian, plus polyphonic music being produced by composers like Dufay. Petrucci solved the problem with moveable type, which allowed him to churn out all sorts of compositions with relative speed.

Leonardo Praetorius

Another notable Renaissance musician, Leonardo Michael Praetorius (1571–1621) was a German composer, though he was a musician by trade. He wrote a *Treatise of Music* in 1618, which was one of the first written works that chronicled the state of Renaissance music. In his book, he described the different types of instruments that were in common use during his lifetime. These included the harpsichord, cornetto, flute, recorder, and dulcimer. And

even though Praetorius lived about 100 years after Leonardo, many of the instruments he wrote about were in use during Leonardo's lifetime.

Across the Channel

While Leonardo and other Italian artists were busy making headlines on the continent, what was going on in England? The Italian Renaissance is perhaps the best known of any contemporary cultural revolutions, but there was an English Renaissance all the same. Its heyday was between the sixteenth and seventeenth centuries, so it occurred in Britain roughly a hundred years after the start of the Italian version. It did, however, share many features with its Italian counterpart: a revival of interest in the human arts, with a few outstanding individuals who paved the way for generations of followers.

William Shakespeare

Whereas the Italian Renaissance is known for sculpture, painting, and other visual forms of art, the English Renaissance was largely dominated by literature and philosophy. The author who is today most recognized as being a stand-out from this period is William Shakespeare (1564–1616). He produced an incredibly large volume of work, similar to Leonardo. Shakespeare's achievements ranged from poetry and plays to other forms of dramatic literature. He produced both comedies and dramas, and clearly had a mastery of both literary forms; in the same vein, Leonardo was proficient in painting, sculpture, and just about every other art there was. Both men were truly masters in their genres.

Of particular interest with respect to Leonardo is the quality of Shakespeare's work. He did not write as a simple observer, or recorder, of history. He had an unparalleled insight into human nature which came out in his stories, characters, and settings. Leonardo, too, had the gift of being able to depict the essential qualities of his subjects.

Today, Shakespeare has the reputation of being one of the most influential writers to come out of Western civilization. During his own lifetime, though, Shakespeare was much less well-known. In this respect, his career resembles that of Leonardo; both artists became more and more famous over time, as their followers rescued gems of their work and made them public.

Francis Bacon

In addition to literature, the English Renaissance was particularly known for its creativity in the realm of philosophy. One of the best-known philosophers from this period was Sir Francis Bacon (1561–1626). Though he started out as a lawyer and eventually became a member of Parliament, Bacon was best known as a philosopher who both participated in and defended the scientific revolution. This period began with the mathematical and planetary truths presented by Galileo, and ran through Isaac Newton in the late seventeenth century.

Bacon contributed several over-arching philosophical ideas to the rapidly developing pool of thought. His most famous contribution was the idea of "induction," or a scientific method, as applied to philosophical thought. He saw the world as a problem, rather than a fixed solution. He rigorously collected his observations and data, designed experiments, and kept notes to help him understand the fundamentals of nature. While he had no direct connection to Leonardo, their Renaissance ways of thinking led them both to achieve new heights in their fields.

Where in the World Is Leonardo Da Vinci?

While Leonardo traveled throughout Europe in his wanderings as an artist, scientist, and inventor, the Renaissance was also distinguished by explorers who took a much more difficult path. Christopher Columbus (1451–1506) took an entirely different route, literally, in his quest for greatness. He was the discoverer of the New World and one of history's most famous explorers.

Columbus is thought to be an Italian by birth, born in Genoa to merchant parents. He moved to Savano in 1470, joining his father in the wool trade. During these years he also learned cartography, the art of making maps. He started sailing in his late teens.

Sailing 'Round the World

By 1474, Columbus had joined a ship's crew and spent a year sailing around the Aegean Islands. In 1476, he first sailed to the Atlantic. This voyage didn't go as planned because the ship was attacked by the French, and

Columbus actually had to swim for his life! He lived in Portugal in the following year because it was fast becoming a central location for maritime exploration. Columbus joined a crew that was sailing to Madeira in 1478 and went on several other voyages over the next few years.

America, Ho!

Columbus is, of course, best known for his legendary 1492 voyage to the West Indies. Life wasn't easy for a Renaissance sailor with a dubious track record, and he was rejected over and over. But Columbus refused to quit and finally he turned to Spain where King Ferdinand and Queen Isabella eventually agreed to provide funding.

An elated Columbus was equipped with a crew and a year's worth of supplies. He set out with his three famous ships, the Nina, the Pinta, and the Santa Maria; he and his crew crossed the Atlantic and landed on an island that historians believe to be the modern-day Bahamas. This was not a pleasure cruise, however, and Columbus' crew was homesick, tired, and ready to give up when they finally sighted dry land.

Once news of his success reached Europe, Columbus was considered an international hero. He was funded for later voyages and again sailed for the Americas in 1493. He was crowned viceroy of the Indies and kept up his search for the Orient.

Leonardo's Role (or Not)

As for Leonardo? It's interesting that he didn't seem aware of Columbus and his discovery of the Americas. If he did, he didn't record these events in his notebooks, nor did he make any sketches of what he thought the West Indies might have looked like. It's not that Leonardo couldn't draw maps; his sketchbooks are full of maps of cities that contained detailed rivers, lakes, mountains, and other features. So, how could he not have been aware of Columbus? It's a mystery that adds yet another level of intrigue to Leonardo's life and career.

chapter 18

Leonardo's Personal Life

Leonardo was an intensely private person, and much of his personal life remains a mystery. Through his notebooks and other clues, though, we can assemble bits and pieces of his personality. From what we do know, Leonardo was a gentle person, fond of animals, and partial to good-looking young men. We can't be sure that he was homosexual, but evidence supports it, ranging from an early arrest, to his young male long-term companions, to his writings about women and sexuality, to his erotic drawings and beautiful paintings of androgynous men.

The Basics

In a world where there were few certainties, here are some facts. Leonardo was a vegetarian who loved animals. He was strikingly strong and handsome in his youth, enjoyed fashionable clothes, and had the voice of a songbird.

Animals were an important part of Leonardo's life. He sketched and painted from nature frequently, studying animal movement closely to allow accurate representations. Later in life he performed animal dissections, learning ever more about anatomical systems and how they related to the whole body. His first memory, the fabled bird feather waving in his face, was an image that spurred both his love of animals and obsession with flight.

FACT

Leonardo was particularly fond of horses. He designed elaborate stables with archways and ventilation systems. Horses were actually important to all Italians because they played essential military and civilian roles. Leonardo took great pride in the appearance and comfort of his animals; he realized that they were separate living creatures who deserved the same comfort and humane treatment as people.

Leonardo the Vegetarian

In keeping with this deep compassion for animals, Leonardo was a vegetarian, probably for most of his life. His notebooks and other writings even contain a few vegetarian recipes! He also mentioned vegetarian chefs by name, including Bartolomeo Platina (1421–1481), in his notebooks. Common vegetarian recipes of the day focused on innovative combinations of herbs and spices with vegetables and pasta.

He seems to have felt a particular kinship for caged animals. Perhaps he felt trapped by many of Renaissance Italy's conservative tendencies, or perhaps his motley upbringing led to his feeling stifled. In his adult life, he was known to purchase cages full of animals and set them free.

Leonardo the Handsome?

During the Renaissance, good looks were important. Handsome artists were more likely to secure patronages than those who weren't as easy on the eyes; equitable or not, the royal families of the day preferred to surround themselves with fine-looking craftsmen. Leonardo was in good stead in this regard, plus, he was comfortable around royalty and had no qualms about dressing to the nines; he clothed himself in fashionable gear and was known for his jokes, stories, lyre playing and songs. While he was intensely private about personal matters, Leonardo was fully capable of working a crowd.

Leonardo was one of the most dashing painters of his time, and his good looks served him well. He made friends easily and had little trouble finding work. His physical appearance can be contrasted to that of Michelangelo who was, it seems, considerably less good-looking. Michelangelo was known to have been rude to his schoolmates, perhaps because he was often teased about his looks.

Composure and Kindness

Generally speaking, Leonardo was regarded as a humanitarian. He was not known for fits of temper, and despite his inability to finish many projects, he was easy to work with and enjoyed collaboration. He was also kind to his servants; in his will, he remembered several of them. His will also provided candles for a number of beggars to carry in his funeral procession; he was thoughtful enough to take care of these sorts of details. Leonardo was the sort of person who would have made an excellent friend: loyal, kind, and considerate.

Highly Personal Accusations

Some people write tell-all memoirs, while others keep their personal lives to themselves. Although we might wish that he had been a bit more open,

Leonardo was always very secretive about his personal life. Though thousands of pages of his writings survive, he mentions almost nothing about his innermost thoughts and feelings. It is thought that this intense privacy could date from an incident in 1476, at the very beginning of Leonardo's professional career as an artist.

An Uncommon Affair

In 1476, the twenty-four-year-old Leonardo was still officially part of Verrocchio's studio, but was beginning to take on outside commissions. On April 8, 1476, an anonymous accusation was placed in a wooden box, which had been put up for this purpose in front of the Palazzo Vecchio, in Florence. Someone, who remained anonymous, had accused Leonardo and three other young men of having a homosexual affair with a male model and suspected prostitute, seventeen-year-old Jacopo Saltarelli. A second anonymous accusation against Leonardo was made on June 7.

ALERT!

The fifteenth century was not exactly liberal. In the Renaissance, a charge of sodomy was a serious offence. In Florence, homosexuality was common and not particularly stigmatized, and the authorities usually ignored such conduct. However, sodomy was technically a criminal offense, and once formal charges were made, they had to be prosecuted.

Leonardo and the others were actually taken into custody by the authorities and held for two months in confinement. Can you imagine Leonardo held in jail for two months? Fortunately for Leonardo and the other three accused, the charges were dropped later in June due to a lack of conclusive evidence and witnesses, and all four men were released.

It is also possible that the powerful Medici family influenced the outcome; one of the other young men accused along with Leonardo da Vinci was Lionardo de Tornabuoni, a relative of Lorenzo de Medici. This acquittal was conditional, however: it only applied if Leonardo and the others were never again subject to a similar accusation.

Officers of the Night

Because of this scandal, Leonardo and the others ended up being targets of the Officers of the Night in Florence, which was a loosely run organization that was the Renaissance equivalent of a vice squad. This group, known as the Uffiziali de Notte in Italian, was created in 1432 specifically to find and prosecute crimes of sodomy. Florence was the first European city to have such an authority.

Perhaps due to the accusation, there is no record of Leonardo's work or even his whereabouts from 1476 to 1478, although it is assumed that he remained in Florence. Leonardo appears to have recovered his equilibrium by 1478, however, for it was in that year that he received his first official commission, the *Adoration of the Magi*. This work, while never finished, appears to have launched Leonardo on his way to becoming an acclaimed artist.

A Private Artist

While Leonardo appears to have put the accusation of homosexuality behind him fairly quickly, it is also likely that it influenced him for the rest of his life. Leonardo's intense privacy about personal matters likely dates from this period of his life.

FACT

Leonardo's general paranoia could have been expressed in his mirror writing, which served as a foil to casual observers. His grotesque drawings of gossiping village people show exactly what he thought of rumor mongers. In his writings, he also mentions the spreading of malicious rumors as a highly evil trait.

Leonardo may have eventually left Florence, his home city, to escape the memory of such accusations. While there was little social stigma to being homosexual in Florence at that time, it is likely that when the accusations reached the public, Leonardo became the subject of general gossip and

speculation. As a budding artist, Leonardo needed a solid reputation, and escaping the Florence rumor mill may have put him back on the right track.

Friends or Lovers?

Leonardo was not what you would call a playboy. He wasn't hanging out in the bars, picking up gorgeous women, and taking them home for the night. In fact, he didn't have any relationships with women that we know about. He did, however, have two long-term male companions during his lifetime.

Salai

The first of Leonardo's long-term companions, Gian Giacomo Caprotti da Oreno, was brought into Leonardo's household in 1490 when he was ten years old. He had a changing role in Leonardo's life, though few details are known. Was he an adopted son, an art student, a servant, or an intimate companion? Given the indulgence that Leonardo showed him, and the length of their twenty-five-year relationship, it seems clear that he was much more than just a common servant.

Giacomo was quickly nicknamed Salai, which means "little satan," or "devil," and this fellow lived up (or down!) to his nickname. Leonardo's notes describe his early antics, especially his thievery. Salai began stealing from Leonardo as soon as he moved in; he even stole the money Leonardo had given him to buy new clothes. Not exactly the way to repay someone's kindness!

Salai continued to steal at every opportunity. We know from Leonardo's notes that in Salai's first year in the da Vinci household, he went through over twenty-four pairs of shoes; he probably sold or stole many of those. Leonardo also noted that Salai stole a piece of leather that Leonardo had planned to have made into boots, and sold it to buy candy. It is unlikely that Leonardo would have put up with such behavior from a mere apprentice or servant.

Leonardo tried to teach Salai to paint, but he does not seem to have been particularly talented. Under Leonardo's tutelage, he did produce a few paintings, which Leonardo himself is rumored to have retouched. The affection between the two men seems to have been genuine, and Salai remained with Leonardo until almost the end of Leonardo's life, over twenty-five years.

Many marriages today do not survive that long! In Leonardo's will, he left Salai a house and half of his vineyard.

Undoubtedly a large part of Salai's appeal, in addition to his apparently indomitable spirit, was his beautiful appearance. His long, blonde curls were a favorite with Leonardo, and a number of his sketches of Salai show off his fine features. In particular, Salai was likely the model for the young man in Leonardo's *Portrait of an Old Man and a Youth*.

Francesco Melzi

Leonardo's second long-term companion was Francesco Melzi, a minor noble from Florence who joined Leonardo's household in 1505, at age fifteen. Melzi appears to have been a more talented painter than Salai, and less of a handful! Melzi was also supposedly a very handsome young man, like Salai.

A number of paintings and drawings by Melzi survive, including a portrait of Leonardo. Leonardo-inspired elements are clearly visible, such as the serene smiles on the faces of the women, and fantasy backgrounds with craggy mountain peaks and sinuous rivers. Melzi's work, however, lacks depth. His paintings appear almost flat, and his sense of proportion is less well defined. His women appear sweet, not mysterious like those in Leonardo's paintings. Clearly, Melzi had only a minor talent when compared with his master painter.

Melzi remained with Leonardo until Leonardo's death, upon which he became the executor of Leonardo's will. Leonardo left the bulk of his estate to Melzi, including his clothes, the paintings in his possession, and perhaps most importantly, his notebooks. Melzi faithfully kept the notebooks safe until the end of his life, around 1570, and is thought to have organized some of them into a longer version of *A Treatise on Painting*. Unfortunately, by the time of Melzi's death the importance of the notebooks had been forgotten, and they were scattered by Melzi's heirs.

The long-term relationships that Leonardo maintained with both Salai and Melzi indicates that while they were perhaps apprentices, they were probably his lovers as well. Both were reputed to be particularly handsome, as was Leonardo himself in his youth. Such teacher-student relationships were not uncommon in the Renaissance. Both men traveled with Leonardo around Italy, and Melzi accompanied him to France at the end of his life. Although no direct evidence exists to prove that Leonardo and Melzi had a sexual relationship, the fact that Leonardo named Melzi as his heir and left his precious notebooks in Melzi's care indicates the deep love and trust he felt for his former student.

Let's Talk About Sex

Today, the sex lives of celebrities are fair game for tabloids, TV talk shows, and dinner table discussions. In the Renaissance, gossip was probably a similar occupation, although without the modern media frenzy the pace of the rumor mill was probably a bit slower! Even so, Leonardo was notoriously secretive about his personal life. It's possible to read between the lines, however, and try to figure out what was going on in Leonardo's personal life.

Was He or Wasn't He?

Many aspects of Leonardo's life indicate that he was most likely homosexual, although there is no direct evidence of this allegation. In addition to his likely long-term relationships with Salai and Melzi, there are also indications of Leonardo's sexual orientation throughout his work and life.

Leonardo never married, and he is never recorded as having shown any nonprofessional interest in women whatsoever. He even expressed his disgust for male-female sexual intercourse in his notebooks. A famous quote from his notebooks reads:

"The art of procreation and the members employed therein are so repulsive, that if it were not for the beauty of the faces and the adornments of the actors and the pent-up impulse, nature would lose the human species."

The Evidence

Some evidence of Leonardo's views of the female sex can be found in his drawings and paintings. Leonardo's anatomical sketches include drawings of both male and female genitalia. While the drawings of male sexual organs are detailed and accurate, the female genitals are depicted with less detail and accuracy; more often Leonardo used them for his medical studies. Perhaps Leonardo had more ready access to male models than to female ones, but this disparity could also indicate Leonardo's disinterest in the female body.

Leonardo drew both male and female nudes, but there are fewer female drawings and they are much less detailed. Unlike other Renaissance painters, who were much more prolific in their renderings of the female body, Leonardo produced only one formal painting of a female nude, *Leda and the Swan*.

Some of Leonardo's drawings may also suggest, in a more symbolic manner, his distaste for heterosexual intercourse. Many of his sketches and paintings depict phallic rock formations and womblike tunnels and caverns, rendered so as to appear harsh and unappealing. Is this analysis the product of modern interpretation, or was it Leonardo's original intention?

Androgynous Art

In spite of Leonardo's seeming preference for the male figure, he did not always portray these figures as hyper-masculine. For example, in Leonardo's famous work *The Last Supper*, St. John is very effeminate-looking and appears even somewhat androgynous. This portrayal has actually led to talk that the figure at Christ's right is actually a woman, with some art historians speculating that the figure may have represented, not St. John, but Mary Magdalene. This scenario is particularly unlikely, however, given the influence of the Church and the subsequently strict adherence to traditional

renditions at that time. The more likely explanation is simply that Leonardo enjoyed painting good-looking men, and took advantage of every opportunity.

Leonardo's notebooks show many drawings of beautiful young men, often with cascades of curly hair and sultry eyes. Many of his more erotic sketches appear to show hermaphrodites or androgynous figures; one in particular, dubbed the *Angel in the Flesh*, shows a figure with a feminine face and chest, but with other clearly masculine features.

Beautiful Men

Leonardo's final painting, *St. John the Baptist*, was one of the few artworks that was physically in Leonardo's possession when he died; it was likely a personal favorite. The painting was created during Leonardo's last years in Rome, between about 1509–1516, and was brought with him to France. Contrary to usual portrayals, St. John (who is supposed to be living in a desert) appears in Leonardo's depiction as smooth and almost womanly in appearance. The long curly hair is a trademark of Leonardo's, and his beautiful face bears an enigmatic smile similar to that on the *Mona Lisa*. One of his hands appears modestly bent across his chest, while the other points upward in a traditional indication of the coming of Christ.

A sketch for a similar painting of Bacchus shows a figure with a comparable appearance to St. John. This naughty mythical figure is painted with the same pointing finger, same inviting tilt to the head, and a similar expression on his face. A difference, though, is that Bacchus is depicted as being sexually aroused. This detail indicates that, at the least, Leonardo had no qualms about depicting male sexuality.

FACT

It is clear that Leonardo enjoyed painting and drawing beautiful men. It seems almost ironic that he also painted one of the most celebrated and beautiful women of all time with the *Mona Lisa*. Perhaps he was capturing the true inner beauty of the model, or perhaps the *Mona Lisa* is a subtle self-portrait of Leonardo himself as a woman.

The Question

So, was Leonardo gay or not? There is an undisputed lack of any documented relationship between Leonardo and a women; this fact, combined with his stated dislike for heterosexual relations, suggests that Leonardo preferred men over women. Further evidence is seen in his long-term relationships with two handsome young students. Of course, notions of sexual identity and terms such as "homosexual" or "gay" did not exist at Leonardo's time, and therefore it is difficult to place him into modern ideas of sexuality.

Leonardo on the Analyst's Couch

With all of his oddities and eccentricities, Leonardo is a psychoanalyst's dream. He has been studied by artists, architects, historians, inventors . . . everyone wants a piece of him. His expertise was virtually unmatched, and artists today study his work as if it were scripture. Is it any surprise, then, that psychoanalysts want to take a turn? Sigmund Freud conducted a thorough study of Leonardo's life, using his notebooks to try and figure out what could have made Leonardo the genius he was. Freud being—well, Freud— the analysis was certain to be of a sexual nature.

Freud's Background

The good Dr. Freud (1856–1939) was born to a Jewish family in Moravia, and moved with his family to Vienna at the age of four. He was said to be humorous yet pensive as a child. He was fond of telling stories and was always ready with an anecdote. There was said to have been a great love between Freud and his mother, and he considered himself her favorite child. Freud married young, at seventeen, and had two children; he remarried twice more during his lifetime.

The Ego and the Id

In 1923 he published *The Ego and the Id*, which looked at the composition of the human mind. One of the main points was that personal history contributed to one's psychological well being. This idea was new to Vienna and wasn't immediately accepted. In fact, even modern psychologists and

psychiatrists take Freud with a grain or two of salt. Freud published other works later in his life that were even more controversial; they dealt with the nature of women, the invalidity of religion, and general disaster theory (this last idea is not particularly surprising, since Freud was living in Vienna during Hitler's rise to power).

For whatever reason, Freud became deeply involved in the life of Leonardo. He did a massive study of the Renaissance master in 1910 called *Leonardo da Vinci and a Memory of His Childhood*. As was his custom, Freud mainly studied Leonardo's sexuality. He came to the conclusion that Leonardo had homosexual tendencies because his mother wasn't around very often and, as a consequence, Leonardo lived with his father for most of his childhood. His father was frequently away on business, so Leonardo spent considerable time with uncles and other male relatives.

FACT

His illegitimate birth, according to Freud, gave Leonardo an obsession with sex and sexuality. Perhaps true, but who needs an excuse for this particular interest? Freud's other big idea was that Leonardo idolized/ desired his mother; becoming romantically involved with any woman would have, per Freud's analysis, been out of the question, thereby leaving homosexuality as Leonardo's sole recourse.

Leonardo Studied

So how exactly did these facts contribute to Leonardo's homosexuality? While being gay was fairly common during the Renaissance, its practice was a crime that could be punishable by death. Freud's opinion was that Leonardo's many unfinished projects were evidence of sexual tension caused by his inability to fulfill his sexual desires in public. Boy, that's a good excuse for not finishing a project!

The main value from Freud's study is that it was the first comprehensive attempt to understand Leonardo's sexuality. Since sexuality certainly wasn't discussed openly during Leonardo's lifetime, we don't have any better information on the subject. If nothing else, Freud's work was the catalyst that allowed this very discussion to take place.

Leonardo, the Odd Genius

What creates and stimulates the mind of a genius? What stultifies it? How did Leonardo manage to create such a mastery of work over such a wide area of interest? Simply put: he was a genius, and, as such, he was entitled to his fair share of eccentricities. And he sure had them—from mirror writing to possible psychological disorders, Leonardo was nothing if not interesting.

19

Warning: Genius at Work

Do you remember every person that you've ever met? Odds are, you don't. While families and social groups remember their own, history books tend to record only the people who have made such a significant contribution that they cannot be forgotten. Geniuses such as Leonardo da Vinci are at the top of this list: They innovate, the rest of us copy, and eventually a new style is born. This pattern repeats itself until eventually we have enough to call it "history."

QUESTION?

What makes a genius?
We generally consider a genius to be someone who shows an intellectual prowess that really makes him or her stand out from the crowd. Geniuses are extraordinarily skilled in at least one area; they're often outstanding in multiple fields. They also tend to have skills that come naturally—they create works of amazing impact with seemingly little effort.

Skill Overload?

Leonardo's genius is obvious. He was a skilled painter, architect, inventor, scientist, and geometrician. He performed dissections to learn about anatomy, and tried to reroute rivers. His interests and skills were diverse. But did he actually have *too* many artistic gifts? Many of his projects went unfinished, and many of his skills could have been further developed. If Leonardo had only been good at painting, for example, he probably would have finished more works and, in turn, these pieces might have been of an even higher quality. But because Leonardo was good at so many things, he simply did not have time to focus on all of them.

Rather than focusing on one particular art or skill, Leonardo chose to spend time with each of them—he was what is known as a polymath, someone who has myriad talents in many different areas. Essentially, he was good at just about everything he tried. Other geniuses throughout time, such as Isaac Newton, Benjamin Franklin, and Thomas Edison, exhibited some of these same features.

Comparison to Einstein

Unlike Leonardo, geniuses often choose a particular field in which to apply their talents. Albert Einstein (1879–1955) is considered one of history's greatest geniuses, perhaps the greatest scientific mind of the twentieth century. Einstein was known for his theories that revolutionized the study of space and time. He developed the General and Special Theory of Relativity, which showed that space and time were not absolute as had once been thought. Hundreds of years earlier, Leonardo had also compared space and time in some of his writings; he noted that time could be divided into smaller and smaller pieces, just as a line could be infinitely divided into smaller and smaller lengths. He thought that a single instant of time could be considered as a point. Much later, it was Einstein who showed that space and time were not the invariant quantities that Leonardo, and most other scientists, had assumed them to be.

Like Leonardo, Einstein had varied interests, although they weren't quite as far ranging as Leonardo's. Also like Leonardo, Einstein enjoyed music, appreciating the mathematical order and harmony. Leonardo had his lyre; Einstein treasured his violin. Both geniuses based their science and theories on simple observations, ones that they could make with little equipment. But even in light of history's most intelligent people, Leonardo's genius stands apart.

FACT

Both Leonardo and Einstein asked questions, and both sought answers. Leonardo asked, "How do birds fly?", while Einstein asked, "Why is the sky blue?" Both Leonardo and Einstein were able to create complicated science from these very simple statements, and that reasoning required both high intellect and astounding creativity.

Minor Errors of a Major Genius

Leonardo, being human, was not exempt from making mistakes. Though it sounds trite, the old saying is true: even geniuses make mistakes. Einstein, one of history's greatest intellectuals, was eventually proven wrong on certain

parts of his theories. Leonardo also made several known errors. But did he let his mistakes rule his life? Read on to see how they affected his reputation.

Everyone Makes Mistakes

Some of Leonardo's errors were due simply to lack of information. The precise nature of human anatomy, with all its functioning and interrelating systems, was only starting to be understood in the fifteenth century. Leonardo performed "autopsies" on cadavers and made careful studies, but he had no formal medical training and was likely missing the big picture. For example, Leonardo made several sketches of a woman's womb, complete with uterus, fetus, and umbilical cord. However, he misjudged the size and shape of the placenta, and actually drew it more like a cow's.

Theories in Name Only

Along those same lines, Leonardo occasionally championed popular but flawed theories. He was, for example, a fan of physiognomy, which held that it was possible to determine a person's personality and character by studying his facial features and head shape. This theory was first published by Barthelemy Cocles in 1533, though the ideas had already been floating around for some time. In the nineteenth century, some physiognomists used this theory to try to predict who would be a murderer or thief. Sounds dangerous, doesn't it?

This concept was, of course, fundamentally biased and had no basis in science. In this specific case, Leonardo committed an error in judgment by believing that there was actual science involved in physiognomy. He wasn't alone in his ignorance, though; physiognomy was held up as a valid analytical tool until the twentieth century.

Technical Errors

One of Leonardo's more technical mistakes concerns his design for a military armored tank. If you examine the details of his system of wheels underneath the carriage, it is clear that the wheels would have actually been turning in opposite directions. The wheels would have spun harder and faster until the entire tank collapsed in a heap of metal and smoke. There are two

theories about this peculiarity: some think that Leonardo genuinely made a mistake in the design, while others feel that he probably made this error deliberately, so as to ensure that his design could not be stolen and copied later. You have to wonder, though, why he would go to all the trouble of sketching and detailing something that he probably knew would never work.

One thing to remember about the errors in Leonardo's work is that, during the Renaissance, artwork was often done collaboratively. Works that are attributed to Leonardo may actually have been done by others in his workshop. He had a number of students throughout his lifetime, and their skills were less developed (and more prone to error).

Consider Leonardo's drawing of Isabella d'Este from 1500. The cartoon sketch showed some of the figure, notably the arm, out of proportion; the musculature was also incorrect, and the figure would not have seemed lifelike. Given Leonardo's careful attention to anatomical detail, it seems likely in this case that one of his students made these mistakes in the sketch.

The vast majority of Leonardo's work was of superb quality and highly accurate. The only reason we're able to find these few flaws is because they stand out—his mistakes were quite rare. Of course, in the case of a genius such as Leonardo, his work has been scrutinized to a very high degree, and thus every possible error has been found.

In the Beginning, There Was Religion

Many of Leonardo's paintings concern religious subjects, and he even worked for the pope for a while. But what did Leonardo actually think of religion? Was he a true believer, or was he just another sheep in the flock?

Leonardo the Christian?

Most scholars believe that Leonardo was a practicing Christian. He spent much of his life working under the pope's influence, so his frequent meetings with the clergy probably influenced him. The facts here, though, are few and far between.

Little is known about Leonardo's religious upbringing. His grandfather arranged for his baptism, and the church of Santa Croce is said to contain the font where Leonardo was baptized. That fact alone supports the possibility that he was indeed raised in the Christian tradition. His father, Ser Piero da Vinci, was not a religious man by profession; he was a notary, and there is nothing to suggest that Leonardo's father was particularly religious. Some of Leonardo's early training may have come from local priests, but that is also not known for certain.

Given that Leonardo's grandfather appears to have been a religious man, it is likely that his father was at least nominally Catholic, and his mother was either Catholic or Jewish. There are stories that his mother had been a slave in the Middle East. She was probably an Italian peasant girl who may or may not have been of Jewish descent. In support of the rumors is her name, Caterina; that particular name was apparently a common choice of Jewish slaves when they converted to Christianity.

You Are What You Paint

We do know that Leonardo wasn't averse to painting biblical subjects. Many of Leonardo's paintings were of a religious nature, which was certainly to be expected while he was under the patronage of the Medici family. *Baptism of Christ*, *Annunciation*, and *Madonna and Child with a Pomegranate* are just a few examples of the religious themes Leonardo was commissioned to paint. Given the time and place, though, he probably didn't have any choice. Religion, power, and culture overlapped significantly during the Renaissance, and support of the clergy was an important part of any patron's lifestyle.

FACT

Leonardo does seem to have believed in God. His writings refer to God as the creator of the universe, and the heartfelt spirit of his religious paintings reveals his devotion. Although Renaissance humanism promoted the spirit, determination, and abilities of man, it also tied man's development to ongoing worship and religion; Leonardo embraced all these aspects of the Renaissance.

A New Twist on Tradition

While not an out-and-out heretic, Leonardo did act in ways that you could call "free-thinking." The fact that he may have included images of himself in several of his paintings (including *Adoration* and *The Last Supper*) could have annoyed the religious orders, since scenes representing holiness did not usually include mere mortals such as Leonardo.

Distinction as a Vegetarian

Leonardo's vegetarianism also made him stand out from the crowd. In Leonardo's day it was thought that God gave man free reign over the animals, and choosing to abstain from their consumption might have been seen as offensive to God. Vegetables in general were looked upon with suspicion, particularly root vegetables which grew under the ground (in the devil's habitat). His eating habits notwithstanding, Leonardo did respect some traditional religious boundaries. He does not appear to have delved into magic, astrology, or other "black arts" of the day.

Last Rites

Leonardo's will also made provisions for a Mass to be said in his honor. Candles were to be lit in a number of different churches. This act confirms that he was, to the end, in basic keeping with the Christian religion. In addition, upon his deathbed Leonardo repented for his sins and asked to be instructed in the last rites of Catholicism. He seems to have felt that he had much to repent for, but ultimately he professed his commitment to God.

Why Be Normal?

Many artists are known for their eccentricities. Whether they're wearing an off-fashion goatee or a lopsided beret, artists march to the beat of their own drums. The creative mind doesn't always follow convention, and society tends to give artists special dispensation to do things their way. Luckily, Renaissance patrons were somewhat tolerant as well. Leonardo exhibited several oddities in his mannerisms and artwork, none of which seriously

detracted from his fame or popularity. In fact, his weirdness might have even added to his mystique.

Handwriting Extraordinaire

Conventional Westernized languages are written from left to right—as in this very book. Some Aramaic languages, such as Hebrew, are written in the reverse with characters reading from the right side of the page over to the left. It's too bad Leonardo wasn't raised in Israel! Leonardo's notebooks, in contrast to most Western styles, are mostly written from right to left. In addition, his letters are also written backward. To properly read one of his manuscripts, the untrained observer must hold it up to a mirror; experienced historians claim to be able to read it as easily as traditional writing. Leonardo even made up his own spellings for some words, and wasn't particularly fond of punctuation either.

There are several theories as to why Leonardo wrote this way. Some say that it was a code; he was very protective of his ideas, and he didn't want contemporary artists to steal his inventions or copy his sketches. In addition, some of his religious theories were not completely in keeping with the teachings of the Church, and he may have deliberately recorded his personal thoughts so that his patrons (and the clergy) could not easily decipher them.

There were rumors that Leonardo, though apparently a practicing Christian, disagreed with some stories from Genesis; he probably would not have wanted to voice these dissentions and chose the mirror writing as a way to disguise his thoughts. What you can't read, you can't disagree with!

Why Write Backwards?

Another possible explanation is that, being left-handed, writing backward was simply easier and more natural for Leonardo. Many left-handed people find it easier to write from right to left, if for no other reason than to

avoid the inevitable ink smudges. Leonardo obviously didn't have access to smudge-proof ballpoint pens, and writing right to left probably just suited him better. He not only wrote with his left hand, but also used it for painting and sketching.

During the Renaissance, some people believed that left-handed writers bore the mark of the devil. Do you think that we in modern times would be shocked and aghast at such treatment? Think again! In American schools up until the mid-twentieth century, many left-handed kids were forced to write with their right hands, spawning a generation of disgruntled adults with illegible handwriting. This aversion to the left hand makes no sense, but it sure lasted a long time.

Though it is doubtful that Leonardo himself believed that left-handers were evil, he probably felt some discrimination. The mirror writing, then, could have been Leonardo's own response to the idea that being left-handed was somehow worse than being right-handed; by writing in his own special way, it reinforced the privacy that Leonardo strove for. One thing is fairly certain: Leonardo probably did not write this way because of any severe mental impairment, and he appears to have known what he was doing. When he had to write notes for his patrons or others in the general public, for example, he wrote in the traditional left-to-right style.

Artistic Liberty

Leonardo's eccentricities extended beyond his handwriting style. He often took liberties in his paintings that more traditional artists might have avoided. Leonardo was, in his own way, a risk taker. While he had to keep up a certain amount of convention in order to please his patrons, he seems to have bent the rules whenever possible. For instance, in his painting *Annunciation* (1487–1485), the angel's wings resemble an actual bird's wings. Leonardo may have simply wanted to experiment with his animal drawings, but the result is that the wings seem oddly discordant in this otherwise religious scene.

It seems clear that Leonardo's own study was of more importance than the final appearance of the work, and this unconventional attitude would definitely have made *Annunciation* something of an oddity considering the Renaissance emphasis on both beauty and harmony. Eccentricities of this

sort might not have been tolerated with lesser artists, but in Leonardo's case they only served to increase his appeal.

Crazy Like a Fox

Leonardo was different. Very different! His ways of thinking and working were very dissimilar from other people, both during the Renaissance and today. Since doctors love to study people who are different, a variety of twentieth-century mental health professionals have tried to diagnose Leonardo with various illnesses. The diagnoses range from more common ailments, such as dyslexia and attention deficit hyperactivity disorder, to more exotic conditions, such as bipolar disorder (formerly known as manic-depressive disorder).

Did Leonardo Have ADHD?

Attention Deficit Hyperactivity Disorder (or ADHD) is a relatively new diagnosis, but the fact that it has only recently been defined does not mean that people throughout history haven't suffered from it. Classic signs of ADHD include being easily distracted, often failing to finish projects, and frequently shifting from one activity to another. However, you will also find these characteristics in many creative people, who often have a large range of interests and switch frequently from one to another.

Leonardo certainly fits the pattern of finishing little that he started. He left behind many incomplete paintings and other projects he never even started. Leonardo, however, explained his apparent inability to finish things by stating that his range of interests was so large and varied that he simply had too much that he wished to do.

FACT

Perhaps Leonardo's flitting from one project to another indicates symptoms of a disorder like ADHD, but maybe it was really just one more element of his brilliant, but unorthodox, mind. In the end, does it matter? Do we appreciate his artwork any less, or does his talent awe us any less?

The Dyslexic Artist

Another modern disorder that could have affected Leonardo is dyslexia. Leonardo's mirror-writing could have been his version of a code, to keep his notes from prying eyes, but it could also be a sign of a different trait: dyslexia. Dyslexia is a learning disorder that causes you to transpose the locations of letters within a word, or write individual letters backwards. It can also cause difficulties in reading; dyslexics can see words as a jumble of letters in a mixed-up order, rather than a particular pattern.

Many dyslexic people who are left-handed actually write in a backwards mirror writing similar to Leonardo's. Some dyslexic people who write like this do it entirely unconsciously, without even being aware that they are writing in an unconventional manner. In addition, Leonardo's spelling was often strange and erratic. Another trait of dyslexia, it could also be another result of Leonardo's self-education.

An interesting fact about dyslexia is that people in general seem to favor one of two modes of thinking: either they are verbal or visual thinkers. Some preliminary research seems to suggest that those who are dyslexic often have enhanced visual-spatial thinking skills, which would go along with a particularly visual method of seeing the world, rather than a verbal one. Leonardo would seem to fit this pattern.

ALERT! Organization isn't everything! Leonardo's notebooks pioneered the method of technical drawing with pictures as the primary focus, in contrast to more traditional works, where sketches served only to illustrate the main text. Leonardo was certainly a particularly gifted visual thinker. Perhaps the disorganized notebooks, and his unorthodox method of writing, were just consequences of the way his brain worked.

The Plight of Bipolar Disorder

A third modern diagnosis that has been applied to Leonardo is bipolar disorder. Formerly known as manic-depressive disorder, this psychological condition produces periods of manic behavior, during which the individual

is full of ideas and enthusiasm and often works nonstop on various projects. These periods alternate with times of depression, where the individual seems unable to accomplish anything.

It is possible that this condition could explain some of Leonardo's behavior. Reports of his work habits indicate that he did go through long periods of not working, followed by times of obsessive work where he would toil on a project day and night. Observers particularly reported this behavior during Leonardo's creation of *The Last Supper*, when he would stay away from the site for days at a time, then arrive and work furiously on a tiny portion of the painting. Other times he would arrive, stare at the work for hours, then add a single brush stroke and leave again.

This sort of behavior could certainly be a hallmark of a bipolar-type disorder, but then again it could also just be a typical artistic temperament. Other facets of Leonardo's work habits and personality also fit the bipolar diagnosis, such as the fact that he didn't finish things he started, and his grandiose plans that never seemed to come to fruition.

Despite any modern psychological diagnosis that you might try to apply to Leonardo, it is clear that he was a supremely talented and productive individual. Perhaps we should think of him as an example of what can be done if you focus on your gifts, and not your shortcomings.

Leonardo's Legacy

Socrates once said, "The way to gain a good reputation is to endeavor to be what you desire to appear." Clearly, Leonardo endeavored to be quite a lot during his lifetime, from artist to architect, and everything else in between. So how did he appear to his contemporaries, and were their feelings about him different from our view of him today? Leonardo was a Renaissance celebrity. How did Leonardo build up this reputation, and what kind of influence did he have on the generations to come?

Life and Death

Fortunately for us, Leonardo appears to have led a generally healthy life. He didn't succumb early to illness, as did so many people in the fifteenth century. His vegetarianism may have contributed to this good health, since he does not seem to have had any trouble with his heart or other major organs. Of course, most people didn't live long enough to worry about things like heart attacks. Leonardo was said to have been exceptionally good-looking, so it is also unlikely that he had any major physical problems. He was, it seems, an all-around healthy individual.

Leonardo was also rumored to have been very strong. He had well-defined musculature when he was younger, and was known for his physical appeal. Supposedly, one of his favorite "party tricks" was to bend a horse-shoe using only one hand. He was proud of his strength and it probably came in handy; working with heavy wooden panels could not have been easy, and any young painter would have had to make and carry his own supplies. In addition, traveling with Cesare Borgia's army required large amounts of physical labor, and he had to be in good shape just to keep up with the warriors.

QUESTION?

Did painting masterpieces help Leonardo to live longer?
Life expectancy in the Renaissance was around forty years. By living to sixty-seven, Leonardo far exceeded the average for his time. And his profession probably did have something to do with it; he wasn't out plowing the fields, fighting in battles, or otherwise doing things that might have shortened his life.

It was rumored that Leonardo suffered from the paralysis of his right hand in his later years. This injury, if it existed, may have happened during his warrior days with Cesare Borgia. It's possible that his hand troubled him during his later years, which may have been another reason for his slower pace while working under François' patronage.

Leonardo is believed to have had a stroke around 1516. Some historians think that this could have been what caused a partial paralysis of Leonardo's right hand, if the damage had not already been done by his time with Borgia. Though he was not required to do any commissioned work during his final years with François, Leonardo still had full use of his left hand and spent considerable time sketching and working on his notebooks. Even a potentially devastating illness could not completely slow down Leonardo, nor could it cease his artistic activities.

Leonardo's health became progressively worse in his last few weeks in 1519. He was apparently frail enough that he wasn't able to stand without being supported. Leonardo was so grateful for King François' periodic visits that he would sit up in bed whenever the King came to his side. There are reports that François remained by Leonardo's side as he died, holding his hand and offering final words. Historical evidence indicates that the king wasn't at his royal palace on the day of Leonardo's death, however. The story, even if apocryphal, is quite sweet because it emphasizes their close relationship.

During his final days, Leonardo amended his will, taking care of his final religious and civic responsibilities. With Leonardo's death, the world lost one of its greatest artists; but Leonardo would leave a marvelous legacy for future generations.

"R-e-s-p-e-c-t"

Leonardo was especially esteemed as a painter; even with his track record of seldom finishing paintings, he was sought after for commissions throughout his life. He was also held in a position of high esteem as an engineer, especially during his years with Duke Sforza and Cesare Borgia. In contrast, Leonardo's scientific pursuits seem to have been more solitary. Because his anatomical drawings required the dissection of cadavers, a practice that was forbidden during his time in Rome under the patronage of the pope, this work had something of an illicit nature. Combined with Leonardo's general secretiveness, the lack of approval likely made him even less inclined to share it with others.

Today, Leonardo is largely remembered and celebrated as a painter—his masterpiece *Mona Lisa* is one of the most recognized paintings in the world, gracing everything from postcards to mouse pads. His other works aren't known as well, perhaps because many of them were unfinished or poorly preserved.

The handfuls of surviving paintings that remain today are sufficient to cement Leonardo's place as one of the most masterful artists of all time. The limited quantity of paintings, along with their mysterious, haunting nature, seems to increase both Leonardo's mystique and the desirability of his preserved works.

Extreme Caution

In large part because of Leonardo's secretive nature, few of his inventions or scientific discoveries have had much historical influence. Most of his inventions were never built; rather than sharing his plans and designs with others, Leonardo kept them to himself in his notebooks. There is evidence that he planned to publish many of these notebooks at a later date, but this was yet another project that Leonardo never finished. Coupled with the code-like mirror writing of his notebooks, which likely caused their value to go unrecognized after his heir Francesco Melzi's death, Leonardo's caution in sharing his discoveries actually led to the dispersion and loss of much of his work.

Leonardo could have rightfully taken his place as one of the fifteenth century's primary innovators, ushering in a new age of invention and innovation in the Renaissance. Instead, Leonardo stands in history as a man both ahead of his time and out of step with the world around him. It is astonishing to look at the creations in his notebooks, some of which were not reinvented for 500 years!

Lack of Practical Experimentation

His notebooks contain many inventions that the techniques of the time were simply too crude to build, and others whose importance was just not

recognized. His design for a bicycle, assuming that it wasn't merely a modern hoax, is eerily similar to modern bicycles, right down to details such as the chain assembly. Leonardo's invention of a multi-barreled gun wasn't reinvented until modern times. His helicopter design was also remarkably innovative for the sixteenth century. In fact, a skydiver tested Leonardo's parachute in the year 2000 and, while impractical due to its weight, he found that it worked perfectly. Unfortunately, in Leonardo's day, it just wasn't possible to get up high enough in the air to test it properly.

Due to his idiosyncrasies, as well as the progression of society at the time he was born, Leonardo truly stands as a man out of time. It's too bad that much of his work was not publicly available, since some of his inventions surely would have changed the course of history. Perhaps the Renaissance world just wasn't ready for many of his innovations.

Sincerest Form of Flattery

If Leonardo was truly such a genius, who wouldn't want to study with him? Lots of students seem to have tried, hoping that some of the great master's genius would rub off on them. Unfortunately, while Leonardo was certainly good at doing what he did, it's not clear that he was so good at actually explaining what he was doing. One of the downsides of genius is that it's hard to share.

Impossible to Emulate

At various points in his life, Leonardo had a studio or workshop full of students, assistants, and apprentices. Especially during his long stay in Milan, Leonardo appears to have had quite a number of students associated with his work in various ways. Most artists at the time had workshops full of students, and you can see the influence of the teacher in many of their works.

Yet Leonardo's style proved more than just a new method to copy, and none of his students seems to have fully mastered his complete technique.

Many copies of Leonardo's works exist. This artistic plagiarism is actually fortunate because in some cases, as with *Leda and the Swan* and *Madonna of the Yarnwinder*, Leonardo's original has been lost over time, and all that remain are the copies.

ALERT!

The mark of the master is upon us! Many works by students in Leonardo's studio bear trademarks of Leonardo himself, and it is easy to imagine the master reviewing the unfinished paintings of his students. He may have even applied his own brush to a troublesome area in order to demonstrate a technique to his students.

Distinctive Marks

One such painting, which is clearly not by Leonardo and yet bears some traces of his style, is *Portrait of a Young Woman*. This painting, a stiff profile view, is utterly unlike the naturally posed three-quarters views that Leonardo favored in his portraits. It was most likely painted by Leonardo's collaborator and student Ambrogio de Predis between 1495 and 1500. Yet some details of Leonardo's influence are visible in the elaborate headdress worn by the young woman, as well as her pearls and elegantly tied ribbons. Leonardo was particularly known for his skill in painting knots.

Leonardo's influence clearly helped de Predis, for during his time in association with Leonardo he produced his two best works, the portrait mentioned above and a portrait called *Bartolommeo Archinto*. Unfortunately, after he left Leonardo's studio de Predis' talents seem to have sharply declined, and he produced little of interest for the rest of his career.

Imitation as an Art

A similar story applies to many of Leonardo's other students. One of his more successful, Francesco Melzi, seems to have had a talent for copying Leonardo's paintings, but produced little of note on his own. Other students and imitators, such as Bernardini Luini, managed to portray the outer trappings of Leonardo's work in their own compositions, but their

paintings seem flat and lifeless when compared with the subtle complexity of Leonardo's works.

Perhaps Leonardo's genius was too great, or his talent too far-reaching, for him to truly inspire and train any artistic heirs. Many have tried to imitate Leonardo over the years, but with little to no success. The simple elements visible in his works—the enigmatic smile and the misty, fantastical backgrounds—are easy to replicate; however, the sense of depth and inner serenity of a work like the *Mona Lisa* is much more difficult to capture. Leonardo's paintings have an inner wisdom, as well as a darkness to them, which makes them more than just colors on a canvas—when you view them, they seem to come alive.

No records of Leonardo's methods or techniques as a teacher exist. It is possible to imagine that with his immense talents and natural abilities, he might have had difficulty explaining the basics. Concepts that were obvious to Leonardo were probably less intuitive to a group of talented (but not genius) apprentices. Though Leonardo tried, it doesn't appear that he was able to fully convey the nature of his work to his students.

QUESTION?

Why wasn't Leonardo a better teacher?
This is one of those questions to which there is no good answer. Perhaps his genius was simply not capable of being taught. As a result, though Leonardo worked with many aspiring artists over the years, he had no real artistic heirs. No one before or since has been able to produce the signature genius and mystery of a Leonardo original!

It's All in the Name!

Leonardo da Vinci is, for all practical purposes, a household name. In some form or another, his works have found their way into almost everybody's education. While Leonardo had a large number of lesser-known works, such as his inventions and sketches, his most famous works are extremely well known. In fact, *The Last Supper* and the *Mona Lisa* are two of the best-known paintings in history. Just check out the crowds of people in

the Louvre, surrounding a small painting encased in a huge bullet-proof, climate-controlled glass enclosure. Leonardo da Vinci's name and reputation have been co-opted in quite a few modern uses, some of which might have made the real Leonardo scratch his head in confusion.

Mona Lisa Smile

One recent usage of Leonardo's reputation can be seen in the motion picture *Mona Lisa Smile*. This feature film from 2003 is about a professor in the 1950s who used some unconventional teaching methods in order to encourage her students to think on their own.

Why did this movie choose to use the *Mona Lisa* as an analogy? One of the most powerful aspects of Leonardo's painting is the woman's smile; it is mysterious, inviting, and subtle all at the same time. Modern analysts believe that her smile and eyes are best seen when you are using your peripheral vision, which is why many people think that the *Mona Lisa* appears to follow viewers as they move around the room. Her smile appears to be hiding a secret, and the movie takes this idea and runs with it.

Similar to the subject of the title painting, the main characters in the movie, students at Wellesley College, seem perfectly behaved by all outward appearances. It turns out, however, that not all of them are who they appear to be on the outside. They, like Mona Lisa, convey a calmness that barely conceals the turmoil underneath.

FACT

Leonardo's name has even made it to the Baby Einstein line of baby DVD's. *Baby Da Vinci* is a video for wee ones that introduces the parts of the body. A far cry, perhaps, from Leonardo's anatomical studies, but the master probably would have been pleased to be included in the line of historical geniuses that the products in this series are named after.

On Broadway!

Leonardo's name also has made it onto Broadway! Well, off-Broadway. In 2003, Mary Zimmerman of the Berkeley Repertory Theater put on a

production called *The Notebooks of Leonardo Da Vinci,* in which she used bits of information about Leonardo's life to form a production based on both his career and personal habits as revealed through his own writings.

Zimmerman used writings from Leonardo's notebooks to show Leonardo da Vinci's incessant curiosity, as seen in his inventions, paintings, sketches, and other designs. She pieced together fragments of his life that are evident in his notebooks, capturing his most poetic moments and dramatic strengths. His life provided plenty of both!

The Real Deal on The Da Vinci Code

Leonardo da Vinci has been a fascinating character for centuries, but he has achieved a new degree of popularity recently, with the publication in 2003 of Dan Brown's wildly successful novel, *The Da Vinci Code.* This novel takes the reader through a historical murder mystery, with clues placed throughout various artifacts including the Holy Grail and paintings such as the *Mona Lisa* and *The Last Supper.* Brown asserts that these and other works by Leo-nardo are full of hidden meanings and cryptic messages. In addition, Brown explores an ongoing rumor that Leonardo may have belonged to a secret society that was devoted to hiding the "truth" about Christianity. While this book is entirely fictional, it certainly has spurred interest in the Renaissance master.

Of course, Brown's novel is just that—fiction. But many of the historical locations and works of art are real. This relationship to actual artworks and other artifacts has caused many people to wonder whether the whole story might also be real. Could there actually have been a conspiracy throughout the ages, and a secret society (of which Leonardo da Vinci himself was a member) charged with protecting secrets from Christianity's earliest days?

Real Life Mysteries

Leonardo would have been a prime candidate to leave historical clues to such a conspiracy, if it actually existed—he had a penchant for puzzles, a love of secrecy, and a superior intellect. Also remember that the works of art, as well as the secret societies mentioned in the novel, do actually exist. But there's a world of difference between their mere existence and the likelihood that they were combined into a conspiracy.

True enough, the societies mentioned in the book, including the Priory of Sion, the Knights Templar, and Opus Dei, are real societies that exist in the real world. But their actual historical roles are quite different from the way they appear in the book. There is no evidence of any sort that these societies were involved in a plot to conceal the Holy Grail. And while scholars have analyzed da Vinci's *Mona Lisa* and other artists' works for centuries, looking for hidden codes or other secrets, they haven't found any.

Leonardo da Vinci certainly was interested in codes and mechanical devices, so it's possible he might have invented a message delivery device such as the cryptex mentioned in the book. But there is no historical evidence that he did so.

Supper Guests

The secrets of Christianity alluded to in *The Da Vinci Code* are controversial, to say the least. For instance, the novel suggests that the individual to the right of Jesus in Leonardo's painting of *The Last Supper* is actually Mary Magdalene, and this notion has been a popular one over the years. However, most art historians believe that the disciple in question is actually John, depicted in the androgynous form favored by Leonardo in this and other works.

Not only is there no evidence that Mary Magdalene was included in *The Last Supper*, it's unlikely that Leonardo was attempting any allusion to her body as the Holy Grail by including her and not a chalice in his painting. In recent years, the Catholic Church has finally put a stop to Mary Magdalene's wrongful portrayal as a prostitute, but there is still no concrete evidence proving that she and Jesus were ever married. Additionally, a reference to Jesus and Mary Magdalene would have been contrary to the religious doctrine of the time.

While it is undoubtedly true that in a patriarchal religion like Christianity the role of women throughout history has been marginalized, it is unlikely that any plot or conspiracy was necessary to do so. History is written by the dominant forces of a culture, and women have been on the sidelines for millennia in most cultures.

Leonardo Misunderstood?

While much has been made of the supposed similarities between a self-portrait of Leonardo and the *Mona Lisa*, it's unlikely that Leonardo intentionally painted the famous work as a female self-portrait. More likely, da Vinci's painting and drawing style resulted in similar facial shapes and other characteristics between the *Mona Lisa* and his self-portraits, especially since a real historical woman is believed to have been the model. There is no evidence in any of Leonardo's writings that he intended the *Mona Lisa* to be a representation of a union of male and female.

Word Plays

Another so-called secret mentioned in *The Da Vinci Code* has to do with the role of anagrams in the name of Leonardo's most famous painting. The title of the painting *Mona Lisa* is undeniably an anagram for "Amon L'Isa"; however, it is also an anagram for "Man As Oil," "Animal So," and hundreds of other possibilities in various languages. In light of that, it's a stretch to think that Leonardo intended any reference to the ancient Egyptian mother and father gods. In particular, there is little or no evidence that Leonardo had any knowledge of such mythology. Remember, Leonardo didn't have much of a formal education, and he probably never studied Egyptian deities.

FACT

Tourists hot on the trail of *The Da Vinci Code* might be sorely disappointed not to find secret, invisible-ink messages written in the Louvre. Still, the reward of seeing artwork like the *Mona Lisa* in person should be ample compensation in and of itself. Specifics of *The Da Vinci Code* aside, the *Mona Lisa*'s smile is still as mysterious as anyone could ever want.

So it's important to keep in mind that although works like *The Da Vinci Code* are fun escapes from reality, they're ultimately just fiction. Of course, the interest that Brown's novel has sparked in general art history (and, specifically, Leonardo da Vinci) is certainly a good thing!

The Quintessential Renaissance Man

You can't have a Renaissance man without the Renaissance! Obviously the term was unknown before the Renaissance, and it slowly started to be used in the following centuries. Today it's a pretty well-known expression, and Leonardo da Vinci's name inevitably comes up when you start talking about Renaissance men. So, you might ask, what exactly are they? Was there an application to fill out? Did it require special licensing?

Medieval Training

Before the Renaissance, the medieval period (which lasted from about 1200 to 1450) had its own distinct culture. At that time, the arts were more generalized than they are today. There were no divisions between fine art, architecture, and other crafts. The apprentice-based educational system meant that artists learned a wide range of skills, rather than being pigeonholed. A strong architect was also expected to be talented in visual arts, tapestries, woodworking, sculpture, and all the other crafts required to create projects.

Unveil the Arts!

In the fifteenth and sixteenth centuries, as the Renaissance took hold, the division of arts became more pronounced. At the same time, though, general knowledge was still fairly limited compared to modern standards. Because of these limitations, people could be experts in many different fields at once. And this didn't just apply to artists. Even the general population was involved; as more was known and the general intellectual level of society increased, gentlemen, nobility, and courtiers of the day were expected to keep up with this rapidly growing cultural era.

ESSENTIAL

Expectations were high during the Renaissance, and most members of the upper classes of society could sing or play a musical instrument and speak different languages. They also had to earn a living at their day jobs, of course, so these artistic talents were in addition to becoming skilled at their chosen professions.

Quality over Quantity

Leonardo was considered one of the earliest Renaissance men because he not only studied a diversity of subjects, he become good at them, too. He wasn't just a dabbler in painting and architecture; he was a skilled designer who produced work that remains unrivaled. He was considered an expert in not just art, but also mathematics, invention, engineering, and construction. He was also clearly a talented writer; his own notebooks are one of our best sources of information about his life and career, as well as his ideas.

Leonardo's inventions may seem primitive in light of modern technology and science, but for the Renaissance they were utterly astounding. What is most unusual is that many of his designs were advanced enough to have been innovative even 500 years later.

Modern-Day Renaissance

Is it possible to be a Renaissance man today? One thing's for sure: it's a lot harder in modern times. In addition to there simply being more people in the world, the world is also a much larger place due to technological advances. In addition, free trade has resulted in exchange of ideas and goods with many more countries than Leonardo had at his disposal. We're more aware of other cultures, and we have a much larger skill base. Today, people are also generally more knowledgeable, and, as a result there's a lot more to know to become an expert in any particular field.

FACT

To be a Renaissance architect, you would have been apprenticed before transitioning into doing your own projects. Today, architects must be licensed; while the process still requires a four-year internship, it also requires four years of graduate school beyond college. All these requirements make it difficult to be good at just one field, let alone several.

Leonardo was certainly one of the great painters of his day, but did he really have the same amount or level of competition that artists today have?

How would he hold up against modern-day scientists? There's no easy answer there—nor do we need one. Leonardo's work speaks for itself. Even today, his breadth and depth of knowledge would set him apart. Given that, imagine what an astonishing figure he must have been 500 years ago! Suffice it to say that Leonardo was, in all respects, an original, and most likely would stand up well against any modern-day genius.

Da Vinci Timeline

1427 Ser Piero da Vinci, Leonardo's father, is born

1452 Leonardo da Vinci is born in Anchiano, Italy on April 15

1453 Leonardo lives with his grandfather and Uncle Francesco

1457 The master is denied formal schooling, which should have started in this year, because of his illegitimate status

1468 Leonardo begins an apprenticeship in Florence with Andrea Verrocchio

1470 *Young Christ* terracotta sculpture is started, finished around 1480

1472 Leonardo gains acceptance to the Florentine painter's guild, produces *Profile of a Warrior in Helmet*

1473 Leonardo creates pen-and-ink sketches of the Arno Valley

1476 Leonardo was accused of a homosexual affair with a male model, Jacopo Saltarelli

1476 *Baptism of Christ* is done collaboratively with Verrocchio

1477 Leonardo officially opens his own painting studio

1478– *The Annunciation* is painted. His famous
1480 notebooks were also started around this time

1479 Leonardo becomes interested in designing ladders to be used during military attacks

1480 Leonardo sketched ideas for floats so that humans could walk on water

1480 *Ginevra de'Benci* is painted

1481 Work on *Adoration of the Magi* begins

1481 Leonardo begins work for Ludovico Sforza in Milan, which lasts until 1499

1482 Sketches of a boat with a pointed hull are created

1483 The Louvre version of *Virgin of the Rocks* is painted; *Portrait of a Musician* is painted

1483 Honorary equestrian statue of Sforza is begun

1484 *Lady with an Ermine* is started

1487– Leonardo designed a triple-defense
1490 architectural system

1489 Leonardo begins a series of anatomical studies

1490 *Lady with an Ermine* is completed

1491 *Madonna Litta* is painted

1493 Famous sketches of an early bicycle are created

1495– Leonardo works on *The Last Supper*
1498

1495 Leonardo designs a mechanical robot

1495 *La Belle Ferronniere* is painted

1496 Leonardo befriends Luca Pacioli and illustrates his book, *Divina Proportione*: studies mathematics during this period

1499 Leonardo moves briefly to Venice

1500 *Virgin and Child with St. Anne* is begun

1502 Leonardo is chief military architect and engineer under Cesare Borgia

1502 Leonardo redesigned the medieval moat to include embankments and weapons

1503 Work on the *Mona Lisa* is begun

1503 Leonardo is granted a commission for *The Battle of Anghiari* in the Florentine Palazzo Vecchio; Michelangelo also commissioned for paintings there

1504 *A Grotesque Head* sketches are completed; sketches of Isabella d'Este are completed

1504 Leonardo's studio is visited by another great Renaissance artist, Raphael

1506 Work on the *Mona Lisa* is completed

1506 The London National Gallery version of *Virgin of the Rocks* is painted

1507 Leonardo is appointed the court painter for the French court of Louis XII

1507 Leonardo works on designs for an improved mountain castle with broad, steeply sloping walls at the base

1508 Leonardo moves back to Milan, begins accumulating sketches and notes into the *Codex Arundel*

1510 *Virgin and Child with St. Anne* is completed

1512 Leonardo paints his own self-portrait in red chalk on paper

1513 Leonardo opens a studio in Rome under the patronage of Guiliano de'Medici; lasts until 1516

1513 Dissections are officially prohibited by the Pope

1515 Leonardo is invited to live in Amboise, France with King François I

1515 Leonardo submitted plans for a city/palace at Romorantin, France

1516 *St. John the Baptist* is completed

1516 Bronze *Horse and Rider* sculptures are completed

1516 Likely suffers some paralysis of the right side; moves to Amboise, France

1519 Leonardo da Vinci dies in Cloux, France on May 2

1570 Francesco Melzi dies

1651 Bits of da Vinci's *Treatise on Painting* are published in France

1796 The *Codex Atlanticus* is taken to Paris when Napoleon conquered Milan

1851 The *Codex Atlanticus* is returned to Italy

1880 Jean Paul Richter discovered a large fragment of the text from *A Treatise on Painting* in its original form; re-published as *The Complete Notebooks of Leonardo Da Vinci*

1904 Edward Frost builds a full-scale model based on da Vinci's design for an ornithopter

1929 Cesare Mussini creates a painting showing the King of France visiting Leonardo's sickbed c. 1519, spawning misconceptions

1995 The *Codex Leicester*, written between 1504 and 1510, is purchased by software giant Bill Gates

appendix b

Glossary of Terms

Alberti, Leone Batista (1404–1472)
One of the earliest Italian artists to include perspective and architectural design elements in his painting

Ambidextrous
The ability to use both hands equally well

Anchiano, Italy
3 km from Vinci, may be the town where Leonardo was actually born

Archimedean screw
An ancient device, invented by the Greek mathematician Archimedes, that used a turning handle to pump water out of a well or uphill

Arno Valley
Subject of an early landscape sketch by Leonardo in 1473

Bacon, Francis (1561–1626)
Major philosopher of the English Renaissance, defender of the scientific revolution

Ballista
A mammoth seventy-six foot crossbow designed by Leonardo, which required six wheels to maneuver it

Baroque
A style of painting which dominated most seventeenth century artwork; its masters included Caravaggio, Velasquez, and Rembrandt, among many others

Bastion
An architectural fortification that projects out from a building, and creates a secure defense area for battling soldiers

Bellini, Giovanni (1426–1516)
Renaissance Venetian painter who was a mentor to Titian

Bipolar disorder
A condition where a person experiences alternating bouts of mania and depression; formerly called manic depression

Block printing
An early form of printing in which wooden blocks were carved by hand and stamped onto sheets of paper

Borgia, Cesare (1476–1507)
Duke of Valencia, patron of Leonardo, rumored to have murdered his brother, Giovanni, in 1497.

Botticelli, Sandro (1445–1515)
An Early Renaissance artist most famous for his paintings, including *The Birth of Venus* and the *Adoration of the Magi*

Bramante, Donato (1444–1514)
A primary Renaissance architect; official architect for Pope Julius II

Brunelleschi, Fillipo (1377–1446)
One of Florence's primary architects and sculptors in the 100 or so years before Leonardo da Vinci's rise to fame

Buonarroti, Michelangelo (1475–1564)
A High Renaissance sculptor, painter, architect, and author; best known for the Sistine Chapel ceiling (1508-1512) and a statue of *David* (1501-1504)

Byzantine
A style of art and architecture from the eastern Roman Empire; created between about 330 and 1540 A.D.

Calvin, John (1509–1564)
A major player in the Protestant Reformation who supported the views of Martin Luther

Chiaroscuro
Translated from Italian, means "clear/light and dark." Painting technique developed by Leonardo to contrast lights and darks to help create a truly three-dimensional image

City-state
A type of political organization used by cities that govern themselves and the territory around them; similar to a Greek polis

Classical
Pertaining to the ancient Greek and Roman empires

Cocles, Barthelemy
First published the theory of physiognomy, which stated that it was possible to determine a person's personality and character by his facial features

Codex
Collection of (Leonardo's) manuscripts, arranged into a particular volume

Colloid
A particular sort of emulsion containing solids (pigment) suspended in a liquid (oil plus binders)

Columbus, Christopher (1451–1506)
Discoverer of the New World and one of history's most famous explorers

Company of Painters
Florence's painting guild during the early Renaissance

Condottierei
Mercenary soldiers who fought in wars for the highest bidder

Copernicus, Nicolas (1473–1543)
Contemporary of Leonardo, put forth a heliocentric view of the solar system

Ctesibus
Engineer and inventor in ancient Greece, developed a mechanical water-clock design around 220 B.C.

D'Amboise, Charles (1473–1511)
King Louis' governor in Milan, requested Leonardo for court painter

Dante Alighieri (1265–1321)
Major author who studied ancient Greek and Roman writings, wrote the *Inferno*

Di Antonio, Ser Piero
Leonardo's father

de Medici, Giovanni
Son of Lorenzo the Magnificent, rose to be a cardinal in the Roman Catholic Church in the early sixteenth century, became Pope Leo X

de Medici, Lorenzo (1449–1492)
Son of Cosimo de Medici, ruler of Florence, patron of the arts and of Leonardo

da Vinci, Caterina
Leonardo's mother

Dent, Charles
American airplane pilot, sponsored modern recreation of Leonardo's giant Sforza horse sculpture

Desprez, Josquin (1440–1521)
One of Western music's leading musicians, became famous throughout Europe

Dufay, Guillaume (1397–1474)
Well-respected Renaissance composer

Dyslexia
A learning disability that affects one's ability to read and write; people with dyslexia often reverse numbers and letters

Einstein, Albert (1879–1955)
One of history's greatest geniuses, perhaps the greatest scientific mind of the twentieth century; best known for his theories that revolutionized the study of space and time

Embrasures
Openings for cannons at the top of a castle wall

Emulsion
A liquid suspension where oil and water are mixed together, suspending the oil in the water

Ermine
A small mammal also known as a short-tailed weasel or a stoat

Etruscans
Ancient Romans

Feudalism
Multi-tiered economic relationship between nobility (lords, kings, queens) and the commoners; a type of servitude for those in the lower classes

Florence, Italy
Italian city where much of the important art of the Renaissance was created

François I (1494–1547)
King of France, patron of arts and Leonardo

Fresco
A painting technique where a layer of wet plaster is laid onto the work surface, and paint is applied on top of the plaster before it dries

Freud, Sigmund (1856–1939)
Austrian psychiatrist who formulated several revolutionary ideas about the human psyche

Galileo (1564–1642)
An astronomer who, among other things, discovered moons of Jupiter, and proposed a heliocentric view of the solar system which he later recanted

Garzone
A type of servant; Leonardo was a garzone in Verrocchio's studio

Geocentric
A view of the solar system with the earth at the center and the sun and planets orbiting around it

Gian Giacomo Caprotti da Oreno
Also known as Salai, an Italian man who shared Leonardo's company for twenty-five years

Giotto (Ambrogio Bondone, 1267–1337)
Best-known painter of the thirteenth century, in the Byzantine tradition

Greek orders
Architectural styles that provided a clean way to organize form and structure; the three orders, Doric, Ionic, and Corinthian, are best known for the columns with those names

Guild
A club, or professional organization, with employment benefits for its members

Gutenberg, Johannes (1334–1468)
Creator of the first printing press, printed the Gutenberg Bible

Heliocentric
A view of the solar system with the sun at the center and the earth and planets orbiting around it

High Renaissance
The period between 1490 and 1527, ending when German and Spanish imperial troops sacked Rome; represents a culmination of all the ideas that had been floating around Florence in the previous years; this is the period when Leonardo did most of his work

Holy Roman Empire
Political entity, dominated by highly powerful emperors, in existence from 843 until 1806

Holy Roman League

Formed in 1511 by Pope Julius II; a political entity; one of its main purposes was to eradicate French leadership in Italy

Horizon line

Line in a perspective drawing which represented eye-level

Humanism

One of the Renaissance's most important conceptual innovations; helped spur the growth of philosophy, literature, and creative intellectual thought

Humanitarian

A person who devotes themselves to improving the quality of life of others; a person who reduces the suffering of others

Igneous rocks

Rocks formed by the heat of volcanic eruptions

Kite

A hawk-like bird

Leoni, Pompeo

A sculptor at the royal court of Spain in the seventeenth century who collected many of Leonardo's writings and organized them into the first codices

Linear perspective

The idea that it is possible to represent a three-dimensional shape (such as an apple or building) on a two-dimensional piece of paper or canvas

League of Venice

Created in 1495 by King Ferdinand of Spain, a political alliance between Spain and other Italian city-states

Louis XII (1462–1515)

King of France, affectionately dubbed "Father of the People," popular king who had a major influence during the Renaissance

Luther, Martin (1483–1546)

Started protestant reformation by nailing the Ninety-five Theses to the door of the Castle Church in Wittenberg, Germany

Lyre

Musical instrument which looks a bit like a rounded harp and consists of a hollow body with two semicircular arms connected by a crossbar

Machiavelli, Niccolo (1469–1527)

Renaissance writer and philosopher, author of *The Prince*, friend of Leonardo

Mannerism

The period after the Renaissance, main inspiration from Michelangelo and Raphael; mannerist art is characterized by an overdoing, or a hyperstylization, of Renaissance art

Marco Polo

Thirteenth century Venetian explorer, famous for trip to China to trade for spices and silk

Medusa

The mythological serpent-headed creature painted onto a shield by the young Leonardo

Melzi, Francesco (1491-1570)

Milanese painter and one of Leonardo da Vinci's favorite students and probable lover

Metamorphic rocks

Formed when either igneous or sedimentary rocks are buried deeply beneath the surface; the high temperatures and pressures found there cause changes in the physical and chemical nature of the rocks

Middle Ages

Historical period between 500 and 1450 A.D.; fills the gap between Greco-Roman events and modern European history

Ming Dynasty

Ruled China in the fourteenth century, closed trade with outsiders

Mollusk
A type of sea creature with a shell; a snail is a kind of mollusk

Ockeghem, Johannes (1420–1495)
One of the most influential Renaissance composers

Oil paint
A type of paint which uses oil as the binding agent; fundamentally different from water-based paint or acrylic-based paint

Ornithopter
An aircraft designed by Leonardo that was almost completely powered by flapping wings

Ottoman Empire
The geographical and political region controlled by the Ottoman Turks; had their heyday with the conquest of Constantinople in 1453

Pacioli, Luca (1445–1517)
Mathematician, at Sforza's court with Leonardo, wrote *Divina Proportione,* a book on geometry which Leonardo illustrated

Palladio, Andrea (1508–1580)
Influential Renaissance architect, author of *The Four Books of Architecture*

Papal states
Renaissance regions run by the pope, who served as the bishop of Rome

Perspectograph
A device similar to a mechanic's workbench, but for drawing; involved a table with a stand that had a cutout through which the artist could trace perspective lines of objects beyond the stand

Petrarch (1304–74)
Author who studied ancient Greek and Roman writings

Pier Francesco da Vinci (1531–1554)
Called Pierino, nephew of Leonardo (son of his half-brother Bartolomeo); talented sculptor, child prodigy

Pigment
Materials that provide the color to paints

Praetorius, Leonardo (1571–1621)
German composer, wrote a *Treatise of Music* in 1618

Protestant Reformation
Started in 1517 by Martin Luther when he nailed his Ninety-five Theses to the door of the Castle Church in Wittenberg, Germany; attempted to transform the Church by calling for a return to the Bible's teachings

Raphael (1483–1520)
Primary artist of the Italian High Renaissance; best known for his painting *The School of Athens*

Renaissance
A period in European history between the early fourteenth and early eighteenth centuries; characterized by a complete cultural rebirth in areas of art, science, music, and other humanities

Romanesque
A style of art and architecture between the ninth and twelfth centuries, characterized by heavy stone arches and elaborate interiors; the period preceding the Renaissance

Rustici, Giovanni Francesco (1474–1554)
Commissioned to create bronze statues for the church of San Giovanni, worked with Leonardo on them

Savonarola, Girolamo (1452–1498)
Philosopher who was responsible for the 1497 Bonfire of the Vanities

Sedimentary rocks
Rocks formed by the deposition of layers of material in water

Sforza, Ludovico
Duke of Milan, patron of Leonardo, warrior

Sfumato
Italian word meaning "vanished," used to describe a technique Leonardo developed to graduate color

values between parts of an object to make it accurately reflect the object's full roundness

Shakespeare, William (1564–1616)
Dominant literary figure of the English Renaissance

Siege warfare
A method of fighting that involves extensive military blockades and attacks onto a city

Single-point perspective
A style of perspective drawing that contains only one vanishing point, sometimes also called one-point perspective

Subduction zones
Places where the crust of the earth is destroyed when one plate slides under another

Tempera paint
A type of water-based paint that uses egg as a binding agent

Tintoretto, Marietta (1560-1590)
Daughter of the famous Venetian painter Jacopo Tintoretto; solicited to be the court painter for Spain under Phillip II

Titian (1490–1576)
A major Venetian artist of the Renaissance

Trivulzio, Gian Giacomo (1441–1518)
From Milan, a military leader during the tumultuous Italian Wars, subject of a sculpture by Leonardo

Tuscany, Italy
Region of Italy, of which Florence is the capital; famous for beautiful rolling countryside

Two-point perspective
A method of perspective drawing, uses two vanishing points along the horizon line

Uffiziali de Notte
An Italian "vice squad" that patrolled Italy in the 1430s; they wandered the streets rooting out homosexuality

van Eyck, Jan (1390–1441)
Flemish painter often credited with improving the art of oil painting by developing a solid varnish based on linseed oil

van Hemessen, Caterina (1527–1566)
Flemish painter, daughter of a well-known Renaissance artist, Jan Sanders van Hemessen; learned and studied in her father's art studio, and earned her own patronage from Hungary's Queen Mary

Vanishing points
Points in a perspective drawing that serve as connection points for all lines of sight

Vasari, Giorgio
First biographer of Leonardo

Venus of Willendorf
One of the earliest examples of a human statue; dates to 30,000–25,000 B.C.

Verne, Jules
Author of many books including *20,000 Leagues under the Sea*

Verrocchio, Andrea (1435–1488)
Master painter and sculptor in Florence, to whom Leonardo was apprenticed

Vinci, Italy
The nominal hometown of Leonardo da Vinci; currently home to the Museo di Vinci

Viola da gamba
An early predecessor to the violin

Visual rays
Lines drawn in a perspective drawing from vanishing points; through these rays, artists could create objects composed of right angles

Zimmerman, Mary
Put on a production of *The Notebooks of Leonardo Da Vinci* while at the Berkeley Repertory Theater

Index

THE EVERYTHING SERIES!

BUSINESS & PERSONAL FINANCE

Everything® Budgeting Book
Everything® Business Planning Book
Everything® Coaching and Mentoring Book
Everything® Fundraising Book
Everything® Get Out of Debt Book
Everything® Grant Writing Book
Everything® Home-Based Business Book, 2nd Ed.
Everything® Homebuying Book, 2nd Ed.
Everything® Homeselling Book, 2nd Ed.
Everything® Investing Book, 2nd Ed.
Everything® Landlording Book
Everything® Leadership Book
Everything® Managing People Book
Everything® Negotiating Book
Everything® Online Business Book
Everything® Personal Finance Book
Everything® Personal Finance in Your 20s and 30s Book
Everything® Project Management Book
Everything® Real Estate Investing Book
Everything® Robert's Rules Book, $7.95
Everything® Selling Book
Everything® Start Your Own Business Book
Everything® Wills & Estate Planning Book

COMPUTERS

Everything® Online Auctions Book
Everything® Blogging Book

COOKING

Everything® Barbecue Cookbook
Everything® Bartender's Book, $9.95
Everything® Chinese Cookbook
Everything® Cocktail Parties and Drinks Book
Everything® College Cookbook
Everything® Cookbook
Everything® Cooking for Two Cookbook
Everything® Diabetes Cookbook
Everything® Easy Gourmet Cookbook
Everything® Fondue Cookbook
Everything® Gluten-Free Cookbook
Everything® Glycemic Index Cookbook
Everything® Grilling Cookbook

Everything® Healthy Meals in Minutes Cookbook
Everything® Holiday Cookbook
Everything® Indian Cookbook
Everything® Italian Cookbook
Everything® Low-Carb Cookbook
Everything® Low-Fat High-Flavor Cookbook
Everything® Low-Salt Cookbook
Everything® Meals for a Month Cookbook
Everything® Mediterranean Cookbook
Everything® Mexican Cookbook
Everything® One-Pot Cookbook
Everything® Pasta Cookbook
Everything® Quick Meals Cookbook
Everything® Slow Cooker Cookbook
Everything® Slow Cooking for a Crowd Cookbook
Everything® Soup Cookbook
Everything® Tex-Mex Cookbook
Everything® Thai Cookbook
Everything® Vegetarian Cookbook
Everything® Wild Game Cookbook
Everything® Wine Book, 2nd Ed.

CRAFT SERIES

Everything® Crafts—Baby Scrapbooking
Everything® Crafts—Bead Your Own Jewelry
Everything® Crafts—Create Your Own Greeting Cards
Everything® Crafts—Easy Projects
Everything® Crafts—Polymer Clay for Beginners
Everything® Crafts—Rubber Stamping Made Easy
Everything® Crafts—Wedding Decorations and Keepsakes

HEALTH

Everything® Alzheimer's Book
Everything® Diabetes Book
Everything® Health Guide to Adult Bipolar Disorder
Everything® Health Guide to Controlling Anxiety
Everything® Health Guide to Fibromyalgia
Everything® Hypnosis Book

Everything® Low Cholesterol Book
Everything® Massage Book
Everything® Menopause Book
Everything® Nutrition Book
Everything® Reflexology Book
Everything® Stress Management Book

HISTORY

Everything® American Government Book
Everything® American History Book
Everything® Civil War Book
Everything® Irish History & Heritage Book
Everything® Middle East Book

GAMES

Everything® 15-Minute Sudoku Book, $9.95
Everything® 30-Minute Sudoku Book, $9.95
Everything® Blackjack Strategy Book
Everything® Brain Strain Book, $9.95
Everything® Bridge Book
Everything® Card Games Book
Everything® Card Tricks Book, $9.95
Everything® Casino Gambling Book, 2nd Ed.
Everything® Chess Basics Book
Everything® Craps Strategy Book
Everything® Crossword and Puzzle Book
Everything® Crossword Challenge Book
Everything® Cryptograms Book, $9.95
Everything® Easy Crosswords Book
Everything® Easy Kakuro Book, $9.95
Everything® Games Book, 2nd Ed.
Everything® Giant Sudoku Book, $9.95
Everything® Kakuro Challenge Book, $9.95
Everything® Large-Print Crosswords Book
Everything® Lateral Thinking Puzzles Book, $9.95
Everything® Pencil Puzzles Book, $9.95
Everything® Poker Strategy Book
Everything® Pool & Billiards Book
Everything® Test Your IQ Book, $9.95
Everything® Texas Hold 'Em Book, $9.95
Everything® Travel Crosswords Book, $9.95
Everything® Word Games Challenge Book
Everything® Word Search Book

Bolded titles are new additions to the series.
All Everything® books are priced at $12.95 or $14.95, unless otherwise stated. Prices subject to change without notice.

HOBBIES

Everything® Candlemaking Book
Everything® Cartooning Book
Everything® Drawing Book
Everything® Family Tree Book, 2nd Ed.
Everything® Knitting Book
Everything® Knots Book
Everything® Photography Book
Everything® Quilting Book
Everything® Scrapbooking Book
Everything® Sewing Book
Everything® Woodworking Book

HOME IMPROVEMENT

Everything® Feng Shui Book
Everything® Feng Shui Decluttering Book, $9.95
Everything® Fix-It Book
Everything® Home Decorating Book
Everything® Homebuilding Book
Everything® Lawn Care Book
Everything® Organize Your Home Book

KIDS' BOOKS

All titles are $7.95
Everything® Kids' Animal Puzzle &
 Activity Book
Everything® Kids' Baseball Book, 4th Ed.
Everything® Kids' Bible Trivia Book
Everything® Kids' Bugs Book
Everything® Kids' Christmas Puzzle
 & Activity Book
Everything® Kids' Cookbook
Everything® Kids' Crazy Puzzles Book
Everything® Kids' Dinosaurs Book
**Everything® Kids' Gross Hidden Pictures
 Book**
Everything® Kids' Gross Jokes Book
Everything® Kids' Gross Mazes Book
Everything® Kids' Gross Puzzle and
 Activity Book
Everything® Kids' Halloween Puzzle
 & Activity Book
Everything® Kids' Hidden Pictures Book
Everything® Kids' Horses Book
Everything® Kids' Joke Book
Everything® Kids' Knock Knock Book
Everything® Kids' Math Puzzles Book
Everything® Kids' Mazes Book
Everything® Kids' Money Book
Everything® Kids' Nature Book

Everything® Kids' Pirates Puzzle and
 Activity Book
Everything® Kids' Puzzle Book
Everything® Kids' Riddles & Brain Teasers Book
Everything® Kids' Science Experiments Book
Everything® Kids' Sharks Book
Everything® Kids' Soccer Book
Everything® Kids' Travel Activity Book

KIDS' STORY BOOKS

Everything® Fairy Tales Book

LANGUAGE

Everything® Conversational Japanese Book
 (with CD), $19.95
Everything® French Grammar Book
Everything® French Phrase Book, $9.95
Everything® French Verb Book, $9.95
**Everything® German Practice Book with
 CD, $19.95**
Everything® Inglés Book
Everything® Learning French Book
Everything® Learning German Book
Everything® Learning Italian Book
Everything® Learning Latin Book
Everything® Learning Spanish Book
Everything® Sign Language Book
Everything® Spanish Grammar Book
Everything® Spanish Phrase Book, $9.95
Everything® Spanish Practice Book
 (with CD), $19.95
Everything® Spanish Verb Book, $9.95

MUSIC

Everything® Drums Book (with CD), $19.95
Everything® Guitar Book
**Everything® Guitar Chords Book with CD,
 $19.95**
Everything® Home Recording Book
Everything® Playing Piano and Keyboards
 Book
Everything® Reading Music Book (with CD),
 $19.95
Everything® Rock & Blues Guitar Book
 (with CD), $19.95
Everything® Songwriting Book

NEW AGE

Everything® Astrology Book, 2nd Ed.
Everything® Dreams Book, 2nd Ed.
Everything® Love Signs Book, $9.95

Everything® Numerology Book
Everything® Paganism Book
Everything® Palmistry Book
Everything® Psychic Book
Everything® Reiki Book
Everything® Tarot Book
Everything® Wicca and Witchcraft Book

PARENTING

Everything® Baby Names Book, 2nd Ed.
Everything® Baby Shower Book
Everything® Baby's First Food Book
Everything® Baby's First Year Book
Everything® Birthing Book
Everything® Breastfeeding Book
Everything® Father-to-Be Book
Everything® Father's First Year Book
Everything® Get Ready for Baby Book
Everything® Get Your Baby to Sleep Book,
 $9.95
Everything® Getting Pregnant Book
Everything® Homeschooling Book
Everything® Mother's First Year Book
Everything® Parent's Guide to Children
 and Divorce
Everything® Parent's Guide to Children
 with ADD/ADHD
Everything® Parent's Guide to Children
 with Asperger's Syndrome
Everything® Parent's Guide to Children
 with Autism
Everything® Parent's Guide to Children with
 Bipolar Disorder
Everything® Parent's Guide to Children
 with Dyslexia
Everything® Parent's Guide to Positive
 Discipline
Everything® Parent's Guide to Raising a
 Successful Child
**Everything® Parent's Guide to Raising
 Boys**
**Everything® Parent's Guide to Raising
 Siblings**
Everything® Parent's Guide to Tantrums
Everything® Parent's Guide to the Overweight
 Child
Everything® Parent's Guide to the Strong-
 Willed Child
Everything® Parenting a Teenager Book
Everything® Potty Training Book, $9.95
Everything® Pregnancy Book, 2nd Ed.

Bolded titles are new additions to the series.
All Everything® books are priced at $12.95 or $14.95, unless otherwise stated. Prices subject to change without notice.

Everything® Pregnancy Fitness Book
Everything® Pregnancy Nutrition Book
Everything® Pregnancy Organizer, $15.00
Everything® Toddler Book
Everything® Toddler Activities Book
Everything® Tween Book
Everything® Twins, Triplets, and More Book

PETS

Everything® Boxer Book
Everything® Cat Book, 2nd Ed.
Everything® Chihuahua Book
Everything® Dachshund Book
Everything® Dog Book
Everything® Dog Health Book
Everything® Dog Training and Tricks Book
Everything® German Shepherd Book
Everything® Golden Retriever Book
Everything® Horse Book
Everything® Horse Care Book
Everything® Horseback Riding Book
Everything® Labrador Retriever Book
Everything® Poodle Book
Everything® Pug Book
Everything® Puppy Book
Everything® Rottweiler Book
Everything® Small Dogs Book
Everything® Tropical Fish Book
Everything® Yorkshire Terrier Book

REFERENCE

Everything® Car Care Book
Everything® Classical Mythology Book
Everything® Computer Book
Everything® Divorce Book
Everything® Einstein Book
Everything® Etiquette Book, 2nd Ed.
Everything® Inventions and Patents Book
Everything® Mafia Book
Everything® Mary Magdalene Book
Everything® Philosophy Book
Everything® Psychology Book
Everything® Shakespeare Book

RELIGION

Everything® Angels Book
Everything® Bible Book
Everything® Buddhism Book
Everything® Catholicism Book

Everything® Christianity Book
Everything® Freemasons Book
Everything® History of the Bible Book
Everything® Jewish History & Heritage Book
Everything® Judaism Book
Everything® Kabbalah Book
Everything® Koran Book
Everything® Prayer Book
Everything® Saints Book
Everything® Torah Book
Everything® Understanding Islam Book
Everything® World's Religions Book
Everything® Zen Book

SCHOOL & CAREERS

Everything® Alternative Careers Book
Everything® College Major Test Book
Everything® College Survival Book, 2nd Ed.
Everything® Cover Letter Book, 2nd Ed.
Everything® Get-a-Job Book
Everything® Guide to Being a Paralegal
Everything® Guide to Being a Real Estate Agent
Everything® Guide to Starting and Running a Restaurant
Everything® Job Interview Book
Everything® New Nurse Book
Everything® New Teacher Book
Everything® Paying for College Book
Everything® Practice Interview Book
Everything® Resume Book, 2nd Ed.
Everything® Study Book
Everything® Teacher's Organizer, $16.95

SELF-HELP

Everything® Dating Book, 2nd Ed.
Everything® Great Sex Book
Everything® Kama Sutra Book
Everything® Self-Esteem Book

SPORTS & FITNESS

Everything® Fishing Book
Everything® Golf Instruction Book
Everything® Pilates Book
Everything® Running Book
Everything® Total Fitness Book
Everything® Weight Training Book
Everything® Yoga Book

TRAVEL

Everything® Family Guide to Hawaii
Everything® Family Guide to Las Vegas, 2nd Ed.
Everything® Family Guide to New York City, 2nd Ed.
Everything® Family Guide to RV Travel & Campgrounds
Everything® Family Guide to the Walt Disney World Resort®, Universal Studios®, and Greater Orlando, 4th Ed.
Everything® Family Guide to Cruise Vacations
Everything® Family Guide to the Caribbean
Everything® Family Guide to Washington D.C., 2nd Ed.
Everything® Guide to New England
Everything® Travel Guide to the Disneyland Resort®, California Adventure®, Universal Studios®, and the Anaheim Area

WEDDINGS

Everything® Bachelorette Party Book, $9.95
Everything® Bridesmaid Book, $9.95
Everything® Elopement Book, $9.95
Everything® Father of the Bride Book, $9.95
Everything® Groom Book, $9.95
Everything® Mother of the Bride Book, $9.95
Everything® Outdoor Wedding Book
Everything® Wedding Book, 3rd Ed.
Everything® Wedding Checklist, $9.95
Everything® Wedding Etiquette Book, $9.95
Everything® Wedding Organizer, $15.00
Everything® Wedding Shower Book, $9.95
Everything® Wedding Vows Book, $9.95
Everything® Weddings on a Budget Book, $9.95

WRITING

Everything® Creative Writing Book
Everything® Get Published Book, 2nd Ed.
Everything® Grammar and Style Book
Everything® Guide to Writing a Book Proposal
Everything® Guide to Writing a Novel
Everything® Guide to Writing Children's Books
Everything® Guide to Writing Research Papers
Everything® Screenwriting Book
Everything® Writing Poetry Book
Everything® Writing Well Book

Available wherever books are sold!
To order, call 800-289-0963, or visit us at *www.everything.com*
Everything® and everything.com® are registered trademarks of F+W Publications, Inc.